The Ministry of Vincent Van Gogh in Religion and Art

The Ministry of Vincent Van Gogh
in Religion and Art

EDITED BY KENNETH L. VAUX

WIPF & STOCK · Eugene, Oregon

THE MINISTRY OF VINCENT VAN GOGH IN RELIGION AND ART

Wipf & Stock
An Imprint of Wipf and Stock Publishers
199 W. 8th Ave., Suite 3
Eugene, OR 97401
www.wipfandstock.com

ISBN 13: 978-1-62032-512-4

Manufactured in the U.S.A.

My deep gratitude to Diane Capitani, a colleague whose theological breadth and wisdom, along with extraordinary editing skill, has made a passionate piece one precise and accessible.

Contents

Introduction

... to those who in truth meditate on human life, death is the brief summary of life.

SØREN KIERKEGAARD, *WORKS OF LOVE*

LOVE IS LIKE LIGHT and life. An idea and concept—yes—and an emotion. But also a force in nature and history—time and space—humanity and divinity, love refracts into a prism and charism of multitudinous color. Its concourse bends against weight and speed. Other covariants include inertia, animosity, and finitude. Like the darkness, light and love never break and never end—in wave or particle or substance or spirit—for as the poetic imagination of Scripture discovers-"darkness and light are both alike to thee" (Psa 119). Love is infinite and ultimately of and from God—for God is Light, Word and love.

Love is active as gift and work. It is surprise, serendipity, and grace—undeserved and unconditional. Though it can be fickle and fleeting—however fragile, it abides firm and its fire-flicker can never be quenched. "Love never ends" (1 Cor 13). As task, it involves persistent endeavor—hanging and sniffing around-like a hound of heaven. It involves: 1) strategy, finesse virtuosity and skill—therefore, it is a labor of; 2) artistry—love works, if we of light, life and love let it, for God works it in and through us and God is love; 3) virtuosity—a man who was derisively called *fou, fou* (fool, fool)—sought to place love at the epicenter of his life and work. Therefore, let us consider Vincent Van Gogh and his ministry of religion and art—a ministry vital and true.

The real significance of what great artists and masters tell us in their masterpieces is that to lead us to God . . . one writes a book and another paints a picture (L155).[1] In an essay for a book on *The Theology of Light*

1. Vincent Van Gogh (L155 [c. 6/24/80, Borinage]). All references from

and Sight: An Interfaith Perspective, [2] edited with K. K. Yeo, I wrote about Vincent on Life, Light, and Love:

> In the Reformed Theological tradition, which I share with Vincent, we have not only Word and font and Scripture, prayer rug and Qur'an, but paint and brush, letter and homily. Actually, in theological purview, the preached word and painted picture may verge into one expression since God—i.e., all creative and destructive impulse—all speech, sound and scene are of One transcendent/ immanent substance. Physicists and theologians alike tell us that color and word, light and speech, are embraced into the same mystery. Sound and light fall together in the electromagnetic and meta-electromagnetic spectrum. Language, my linguist son tells me, involves mind and thought—which become articulate in sound—our composite natural, supernatural, and universal gift.

In the case of Light-achieving, receiving and transmitting this literal and ultra-physical light—the light of mind-brain or mind of God-providence—Rembrandt's *White Light* or Vincent's *Light from Above*—and in averting, besetting and bewildering darkness, like a favorite piece of his reading, Bunyan's *Pilgrims Progress*, the journey for Vincent, the lightscape and lightquest, involved resistance and great pain. Alluding to Scripture, life within God is ever agonizing, ever rejoicing.

Vincent knew, in his pre-scientific—at best, Newtonian way—that sound and light, hearing and sight, meaning and color, word and picture, emerged in our primordial complex of consciousness—subliminal and sublime—where speech and written word—art and music—converged into one original and ongoing divine-into-human display: ". . . there

correspondence are from the six volume edition, *Vincent Van Gogh, The Letters: The Complete Illustrated and Annotated Edition* (English), the Van Gogh Museum in Amsterdam and Huygens Institute in The Hague, 2009. All letters are written to his brother Theo unless indicated otherwise. The text quoted is most often from the best English text available before 2009 (Bullfinch, 1958; Little, Brown, 1978/2000) although when available, I did consult the original language of the letter—i.e., French or Dutch. To help with the confusion of various numbering systems and to retain the flow of meaning, I will indicate the date of the letter (i.e., 1/1/1890) and the place of origin (i.e., Borinage). This will tag the period and place it in my chronological/locational presentation. In some cases (e.g., in the chapter on Arles, where the conversion between numbers of letters in different systems is unclear), I enclose both Bullfinch and Museum designations.

2. Kenneth L. Vaux and K.K. Yeo, *The Theology of Sight and Light: An Interfaith Perspective* (Eugene, Oregon: Wipf and Stock, 2010), 85ff.

are things to be believed and loved—there's something of Rembrandt in Shakespeare and something of Correggio in Michelet, and something of Delacroix in Hugo and in Beecher-Stowe, something of Ary Scheffer. And in Bunyan there's something of Millet . . . there's something of Rembrandt in the Gospels and the Gospels in Rembrandt" (L155 [c. 6/24/80, Borinage]). As all nature and history exhibit a divine coherence and direction, so does all speech and literature.

Madness confuses and comingles things, so Vincent—seeing this in that, there in here and then in now—is a "Holy Fool"—for "Sacred Sanity" imagines and images both realms simultaneously in a "holy/worldly" whole. All reality—sacred and secular— is liminal and luminal.

His pilgrimage, into this primordial confluence—through dark valleys and brilliant fields—bears out Rachmaninoff's dictum, "no suffering, no melody." His heart ached to find ministry, until ministry found him in his artist's satchel. His epiphany was simple: "I took up my pencil to draw" (L136 [12/4/77, Amsterdam]).

Fortunately, for the world, he also kept his pen "to write," leaving one of literature's most celebrated portfolios of letters. Though rebuffed by the religious establishment—as is often the case with prophets and saints—his ministry—like those of Moses, Buddha, and Jesus has endured and flourished out into global history in spite of the detractors and persecutors and long after the conventional hackers—the yes-men, the institutional cons—are long gone.

Light is the leitmotif of the Impressionists and of Vincent Van Gogh, in particular. He loved the Light festival of Christmas. He knew Handel's dramatic text and tune: "the people who walked in darkness have seen a great light." His concept of ministry is mostly about bringing light to those who dwell in darkness—especially sailors (who may drown in the dark depths of the sea or like the 10,000, be swept away in the dark turbulence of the Japan Tsunami of 2011), or the miners in his own evangelical underground in the Borinage, or like those miners trapped beneath the earth's surface in Chile in 2010. Like his mentor, Rembrandt, he knew that God was in the light, twilight and dark, (think of "the house in Bethany" or *Flight to Egypt by night*); indeed, God is radiant in both *rayon blanc et rayon noir.*

This explication of Van Gogh is an attempt to deal with the Johannine mystery—God is Light (1 John 1:5). What on earth might that mean?

Vincent is not Zoroastrian, Gnostic or dualist: he is a biblical naturist. God is sublimely present in the manifestations of both history and

nature, of creation in all her dimensions, abstract, formal, virtual (arti-factual) and material. He took literally the wisdom of Psalm 119: "Your Word is a lamp to our walking and light for the path on which we move" (119:105). Thus, we have Vincent's comingled ministry of Word and Form, religion and art.

With pencils, chalks and colors, and with a God-attuned sensorium as he witnessed nature's scenes, Vincent would capture sermons such as the gnarled *Potato Eaters* (from the working hovels of Nuenen) and the glorious fields of blue *Irises* (from the gardens of his lunatic [moonstruck] asylum in Provence). The parable that arose from his palette was not Mi-chelangelo's idealized realism as in the *Mona Lisa* or Picasso's fractured cry of agony as in *Guernica*, but a mingling of respect for "the least of these" and a *chanson* of enduring hope—the "joy of suffering"—in his own words. Don McLean captures well the man, the anguish, the joy, and the ministry in this song:

> Starry, starry night, paint your palette blue and gray, look out on a summer's day, . . . with eyes that know the darkness in my soul. Shadows on the hills, sketch the trees and daffodils, catch the breeze and winter chills, in colors on the snowy linen land. Starry, starry night, flaming flowers that brightly blaze, swirl-ing clouds in violet haze, reflect in Vincent's eyes of china blue. Colors changing hue, morning fields of amber grain, weathered faces lined in pain, are soothed beneath the artist's loving hand. For they could not love you, but still, your love was true, and when no hope was left in sight, on that starry, starry night, you took your life as lovers often do, but I could've told you, Vincent, this world was never meant for one as beautiful as you. Now I understand what you tried to say to me . . . and how you tried to set them free. They would not listen, they did not know how. Perhaps they'll listen now.[3]

Vincent was one of the last men of the age of faith and one of the first of the age of anxiety. G-Albert Aurier, in the first critical review on Vincent, spoke of one "accursed, excommunicated . . . dragging like iron chains (Scrooge in Dickens?) the masterpieces the world does not rec-ognize." He was variously called "misunderstood genius, *peintre maudit*, saint, martyr, prophet."[4]

3. Don McLean, "Vincent," lyrics and music (1971). Online: www.don-mclean .com.

4. Kodera Tsukasa, *The Mythology of Vincent Van Gogh* (Amsterdam; Philadelphia:

He bore in his body and mind the stigmata of the Lenten admonition: "Dust thou art, to dust thou shalt return." Yet he cast his eyes to the sun by day and to the starry, starry sky by night. The ministry of Vincent Van Gogh offers a lens for us to view not only sight and light, but also interfaith theological insight. He bore the wounds of destitution and tribulation. As my Garrett colleague, Cliff Edwards, has ably written, Vincent's witness is a parable of the human spiritual journey (see *The Shoes of Van Gogh* ,Crossroad, 2004; *Van Gogh and God,* Loyola, 1989; and *Mystery of the Night Café,* SUNY, 2009).

Some decades ago, Ken and Sara Vaux, along with their friend, Jan Van Eys, a medical doctor at M.D. Anderson Hospital, collaborated at the Institute of Religion in Houston, Texas. At that time, we were involved in the construction of the Rothko Chapel. The Philip Johnson Chapel housed the famous murals of Mark Rothko—large panels of deep wine and dioxazine purple, burnt umber, and absorbing black—a foretaste of Rothko's own suicide (1970) and a blood-witness, like that of Vincent, to the deep pieties of faith and justice in an unjust, inequitable (meritocratic), homicidal, materialistic, persecuting and anguished world.

At the opening of the Rothko Chapel, whose art was torn from the soul of one whose people had become dust at Auschwitz, at the incinerating hand of a Eucharistic people, a largely Christian congregation joined the sponsoring family of Jean and Dominique de Ménil in a sacramental and Eucharistic contemplation—as if it were being held at Michelangelo's Sistine Chapel in Rome or the Matisse Chapel in Venice. Both sacred places were sanctuary models for de Ménil's and Rothko's visions. The dark colors of Rothko seemed profound and endless in the subdued lighting of the chapel, offering a profound mood for awareness and a deep space for meditation. Dominique understood Vincent's journey into impressionistic theology and art. Speaking of the iconoclasm of true icons, she said, "We are cluttered with images and only abstract art (and sacred theology) can bring us to the threshold of the divine. Dignified mute icons (Fr.: *nature morte*) are the only kind of beauty we find acceptable today" (personal conversation).

Outside Rothko Chapel, Barnett Newman's "Broken Obelisk," dedicated to Martin Luther King, Jr., stood in the courtyard. We still remember the dedication as we watched in the assembled congregation, with an occasional glance to the ramshackle white clapboard house next door.

John Benjamin Publishing Co., 1993), 113.

Here, a distraught "tea-partyer" of modern 21st-century day sat in his window holding a rifle, his contorted tribute to Dr. King. He eventually fired shots at this obelisk.

As the worship/dedication concluded, the choir of Houston Baptist University sang another prophetic song of those Camelot days of the 1960's: "When you're weary, feeling small, when tears are in your eyes, I will dry them all. I'm on your side. When times get rough, and friends just can't be found, like a bridge over troubled water, I will lay me down."[5]

Love is to lay down the bridge of one's life—Vincent and Rothko. The clue to this strange mélange of sadness, service, and salvation is the ministry of Vincent Van Gogh, a ministry of light and life. I think now of his work at Arles: *Le Pont-Levis Bridge* or the *Drawbridge* (1888). By way of introduction to this book, let us capsule this ministry we will seek to fathom and describe it in three movements—a triptych—the outline of which is elaborated in the eight ensuing chapters of this study:

- Coal-mine ministry and subterranean darkness and madness;

- Slash of ear, splash of color: psychedelics or *Geisteslebens*; and

- Glory and the illumination of the commonplace.

The Beginnings

As my Interfaith Project working team of three years planned and crafted Project Interfaith and sketched out an inaugural workshop on light and sight, several serendipitous developments cheered our work.

Ken's still-little brother and close buddy across the years drove out from Long Island, our family home and the location of our high school at Sewanhaka, in Floral Park. The island also was the sometime home of Rothko and Jackson Pollack (cf. Naifeh and Smith's two biographies of Jackson Pollack and Vincent Van Gogh).[6] Frere Richard crossed the glorious Appalachian Mountains to the Pennsylvania cabin that landmarks the long-ancestral homestead of the families of both our parents. It was Ken's 70th birthday bash. Having heard of our conceived Project Interfaith and the Light/Sight inaugural workshop we had in mind, Frere

5. Paul Simon, "Bridge Over Troubled Water," lyrics and music (1969). Online: http://sglyrics.myrmid.com/bridge.htm.

6. Steven Naifeh and Gregory White, *Van Gogh: The Life* (New York: Random House, 2011).

Richard offered to exhibit a set of his lightscapes (which give more precision to the word "landscapes") and archetypal landscapes. His latest work—much in the spirit of Russian icons (*e.g.*, Andrei Rublev's "Trinity") and Japanese rock-garden paintings—resonated beautifully with the motifs of the workshop and still grace of the gallery of Garrett Seminary.

I had already sought out experts on the work of Van Gogh and talked with Harvard philosophy professor Elaine Scarry, whom I had met at 2007 lectures at Cambridge, where she spoke on the "philosophy of color" (following her work on "the splendor of the human body"). I was especially moved by her talk on "Green and the Novels of Charles Dickens." Our fellow panelist, Bill Murphy ("Violence and Obscurity: Religious Cosmology of Seeing and Hearing in the West African Rainforest"), also shared with me the work of a University of Chicago physicist who had written on the physics and philosophy of light and color in Monet's series on Rouen Cathedral.

The thought of Van Gogh—and a several-year research undertaking on Vincent's ministry moment in Petit-Wasmes, Borinage, Belgium, very close to our daughter Sarah's home in Antwerp and workplace in Brussels—led us to explore a course at Yale and an unfinished project offered by Henri Nouwen on "the ministry of Vincent Van Gogh." This pioneer pastoral-theologian,[7] author of *The Wounded Healer* (1979), whom I knew from civil-rights marches and "Liberation theology" undertakings in the 1960's, had often found his way into Sara and Ken's teaching and into Jan's care for children with cancer. We asked ourselves whether our competencies and circumstances—theology, art, film, and ministry, plus a permanent free-bed-and-board in Antwerp—might allow us to give continuing life to Father Nouwen's wonderful project. The Light/Sight workshop reflection now extends into this sabbatical book on the ministry of Van Gogh, which has been encouraged and assisted by the Nouwen Archives in Toronto and is dedicated to Henri.

Darkness in Interfaith Purview (Coal Mines)

As I write today, Placido Domingo prepares to sing the "baritone" lead in Verdi's *Simon Boccanegra*. Not the *tenor Italien* or *heldentenor*, but the baritone! He comments before the performance: "In this dark opera, with

7. See Henri Nouwen, *The Wounded Healer: Ministry in Contemporary Society* (New York: Random House, 1979).

many voices of dark color, the only tenor (romantic hero) is a baritone" (the perennial fantasy of tenors!).

Last night, the Symphonic Wind Ensemble at Northwestern University considered the subject of darkness in four compositions. Included were Henry Purcell's *Music for the Funeral of Queen Mary* and *Et expecto resurrectionem mortuorum* by Olivier Messiaen. The program notes spoke of Messiaen as "seeing colors internally when hearing sounds" (cf., Torrance's connection between light and word). In the phenomenon known as "synesthesia"—". . . a major chord with an added sixth, for example, was always bright blue—the blue of Chartres, the Mediterranean, heaven." (Remember also that eternity for Hegel is art's "lapis" blue). This was the "music of the spheres" that Mozart heard and Vincent saw through his "cornflower blue" irises.

In his opening biblical Yeshiva on Hebrew scripture, Yohanan Petrovsky-Stern, Chair of Jewish studies at Northwestern University, showed how the Bible began with God dwelling in "great darkness," only much later positioning Godself in "blazing light" in the apocalyptic, Kabalistic and Hasidic movements of the tradition, during perplexing and persecutorial times. In this same ethos, the inner-sanctum of the Temple "Holy of Holies" radiates green, and then only in uncertain and perplexing times. It is in one of these periods and moods that the Christian Gospel arises in world history. From the historical enigma of Christian proclamation abandoning Arabia and much of the eastern Mediterranean world in favor of Europe, a spiritual crisis finally erupts in the seventh century, and arises in another mutation of monotheistic world faith—Islam.

Van Gogh's first sketches in his decade-long career were dark and muddy. We think of *The Sower* and *Evening Prayer* (early 1881). His early works, before the inspiration from the impressionists' color palette, were dark and brooding—emerging from his interest in form and content, but also influenced by the gloom of the coal mines. Vincent believed that "those who dwell in darkness will see a great light" and this commission would be the basis of his mission and ministry.

This was also the time of his early missionary impulses and experiences. To ground us as we reflect upon Vincent's life, with a life span from 1850 to 1890, we can divide it into two major parts: ten years of ministry and education, approximately 1870-1880, followed by ten years of an art career, 1880 to 1890. Before 1880, in the 1870s, Vincent was in England. Keeping these dates in mind should help the reader as we follow Vincent's erratic course through his troubled life.

Following his passion to "preach the Gospel everywhere," while he was free-lancing in art dealing in London, he became an assistant to a Methodist minister. Before 1880, he flirted with formal religious ministry. His father and grandfather were Dutch Reformed pastors. He articulated early that his life was about "a knowledge of the one true God," which, in good Calvinist tradition, was the source of "true knowledge of the self" (Book I, *The Institutes*). Again, in the Calvinist tradition of "calling," Vincent was obsessed that his life "have meaning," and that meaning was meant to arise in his work (vocation).[8] After failing in this institutional attempt to serve God (much like the proverbial ordinand who, after years of failure as a preacher, discovered that his youthful vision of a cloudscape forming the letters PC meant "plant corn," not "preach Christ"), Vincent found his genuine calling in the ministry of art. My thesis in this study of Vincent's ministry is that the expressed light of sermon, pastoral care and Bible teaching and of his drawings and paintings—all in the Borinage coal fields—offers a synergic ministry to that of Word and Sacrament— all within the same Transcendental reference of Good, Beauty and Truth.

When he returned home from the sojourn in England, Vincent worked in a bookshop in Dordrecht. More than selling books, he seemed to be busy translating Bible verses between Dutch, French, and English languages—the *vielsprachig* Dutch, Flemish, and Belgian church-folk have always been ideal Wycliffe translators. When I recently stopped in Dordrecht, I could still feel the wheels grinding. It was in this period that he seems to have conceived the sketch-book of Bible drawings which would inspire Chagall.

Vincent then went to Amsterdam to the university to study theology in the Reformed Faculty, but it didn't work. In my view, he was not so much a "learned Calvinist" pastor type, but more likely a pastor-missionary, a hands-on person, one for whom ongoing identity was not so much in the realm of ideas but in personal and interpersonal relationships—a light and sight ministry. Color and light would be his books, canvases, and sermons.

He would find out that insight often comes with frustration. At Borinage, he wrote to his brother Theo: "I must continue on the path I have taken. If I do nothing, if I don't study, if I stop searching, then I am lost, in misery . . . What is your final goal? You may ask. That goal is

8. Evert Uitert and Louis Van Tilborgh, *The Life and Work of Vincent Van Gogh* (New York: Rizzoli, 1990), 15.

becoming more clear, it will take shape slowly but surely, as the scribble becomes a sketch and the sketch becomes a painting."[9]

After dropping out of school, he did receive an appointment as an evangelist-missionary in a poor, coal-mining region (Petit-Wasmes in the Borinage sector). Identifying with the poor sheep of his flock, he slept on a bed of straw, gave away his food and clothes, and lived in a back room of a bake-shop. It was here that, at times, he was heard sobbing through the entire night. What afflicted him?

Depression, an hereditary neuroleptic focus, *Seele Schaden*, *weltschmertz*, artistic passion, dreams, broken dreams, rejection in love, dejection, twisted, castigating theology, authentic penance—all of the above: who knows? Though theories abound—most dwelling on the catastrophic—his life experience is much the same as that of all highly creative individuals who face destitution and illness. His sickness was "sickness unto life."

But Church officials saw this as an inexcusable breach of ministerial dignity—"conduct unbecoming a minister of the Gospel," as rectitude-obsessed Reformed clergy would have it—and they sent him packing. Actually, Vincent's ministry of Word and Sacrament (Calvin) would be realized in the synergy of the sacrament of art and the word. To his dramatic artistic oeuvre was joined his uniquely vivid and powerful cor-respondence with brother Theo and others—a correspondence which is just now, at the dawning of the 21st century, becoming one of the classics of world literature.

In reactive response to misguided church authority, Vincent's life and direction were about to change. Calvinists like myself might be tempted to see this as a turn of providence, but I find myself wishing that he had been appointed as a village vicar in southwest dissenter-England, doing art and ministry for a few more decades or emigrating to America as an artist/pastor in an industrial city like Chicago. How about a sketcher in the courtroom, I ask my bewildered self.

But—as destiny would have it—only a refocused ministry was in the works. He was not a well man—even early in life. Objecting to the accu-sation of sickness or madness, Vincent (according to biographer Robert Hughes and Cliff Edwards, our Vincent expert in the English language) was entering the period when he would experience the "height of his

9. Ibid., 15.

powers. . . . He was longing for precision and grace."[10] To my mind, it was here that Vincent was creatively transformed and his divinely-destined ministry was about to begin. The "light of life" now illumined his passionate mind and the virtuosity of the Spirit enabled his well-trained artistry. He was now able to see those faces of the poor and to capture their pain and hope for all time to come. Like bipolar persons many of us have encountered, he could see through walls, phoniness and duplicity, as well as smoke out other obfuscations and obstructions.

The light of God always shines through the eyes of "the least of these," his children. Anawim—broken spirits—Scripture calls them. Vincent was, like his Paris friend, Henri Toulouse-Lautrec, who saw through to the soul, able to see God in us, in indomitable humanity, in the midst of suffering, in poverty, in enduring the disdain and contempt of the world—in the dancers, the prostitutes, workers and the grotesques and people of the street. Lautrec's painting of Van Gogh shows him sitting among such street vagrants, an ashen yet resolute man. In the grand tradition of those who came before him, like Rembrandt, Vermeer, and Millet, Vincent perceived the shadows and the dramatic flashes of illumination and the *visio Dei* within the contrasts. Be it the Christ or the woman at the kitchen table, these mentors of bygone centuries, and now the angular irascible one with the red hair, saw the glory of God shining in the weary, working faces of the poor.

Artists, who use their God-given skills to convey their perceptions of the light of God, are great evangelists each in their own way. Yet, to tell us about their experience and of the truth of their visions, they must perceive the light of God themselves first and let that light permeate their own consciousness, their own souls. It is the creature's lot that humans must use their bodies and senses to perceive the light.[11]

10. Robert Hughes, *Nothing If Not Critical* (London: The Harvill Press, 1990), 144.

11. "The care artists give their bodies will always color and potentially distort their visions. Vincent was fond of absinthe, the now-banned beverage that was, in his lifetime, a popular drink in café society. The drink has a seductive visual appeal, undoubtedly attractive to a painter. When poured from a bottle, it is a clear, brilliantly green liqueur. However, because of its bitterness, the drink was traditionally diluted with a specified amount of water, poured through a slotted spoon wherein a sugar cube was placed. This dilution changed the appearance of the liquid in the glass from clear green to a beautiful yellow opalescence. The ritual of presentation of absinthe would be very attractive to Vincent, as it was to many artists; Toulouse-Lautrec was a habitual absinthe drinker, also. However, the chemicals in absinthe, especially the terpenoid thujone, wracked the brain, exacted a price, and shortened the life of the user. Because the mental distortions and convulsions from the terpenes can be alleviated

When we preach our faith, we preach our revelation. We ought to prepare ourselves to make our vision as pure and unobstructed as we can. Unfortunately, so often our behavior clouds our perceptions and presentations. We preach what we heard and not necessarily what the speaker intended. We paint what we see and not always what was created for us to see. Thus, even the greatest saints are also likely to be the greatest sinners, because they claim clarity while they may have fogged their vision by their actions. But precisely that realization makes their works the more powerful because we do not just recognize the light of God, but also realize our humanness by the brilliant imperfections in the artist's sermon. Even God—Vincent reflected—had mistakes in some canvases—and knew how to make them right.

Darkness as Light

When the earthly light was about to dim in the eyes of Martin Luther King, Jr. as he stood with the garbage workers in Memphis, he carried in his pocket a scrap of paper with words of Gandhi and then his own:

> In the midst of death, life persists. In the midst of untruth, truth persists. In the midst of darkness, light persists. (Mahatma Gandhi—after Christian and Muslim scripture). In the midst of darkness and death, whatever happens, give us faith to know that in God we are in light and life. [12]

Gandhi and King, Vincent and Rothko, knew this mystery of crucifixion—that darkness is light. Truth in interfaith purview—i.e., Jesus' faith hallowed by its Judaic and Islamic precedence and resonance—was spoken of by Dominique de Ménil as she dedicated the Rothko Chapel. Her message was Blaise Pascal's sheer word—a Jansenist *Logos*: "We are cluttered with images and only abstract art" (certainly not Mel Gibson's "Passion of the Christ") "can bring us to the threshold of the divine." Hebraic, Christian, and Islamic theology of light teaches us that images often obstruct rather than transfigure. Dignified mute icons may be the only kind of beauty that can convey light and word today. We thank Richard

with bromides and aggravated with nicotine use, Vincent was treated with bromides and cutting down on smoking during his institutionalization at Arles." (Van Eys article in Appendix).

12. Clayborne Carlson, *The Papers of Martin Luther King, Jr.*, (Berkeley: University of California Press, 1992).

Vaux's iconoclastic icons—his "lightscapes" that go beyond landscape—for lightening and redeeming our dumpster of poor words of our Light and Sight symposium. Our only retort is that of Vincent: words, for those who not only see but read reality (thank you, Jacques Derrida), are the canvases of Scripture, Shakespeare, Milton, and all masters of all cultures.

This is why, for the mystic in all traditions—Kabal, Hildegard, Julian, Teresa, Sufi—darkness is light. *Via negativa* is the way to go into light and truth.

The interfaith theological progression of premises goes something like this:

> The Truth and light Vincent saw, the dark world could not bear ("not comprehend"/ "we hid our faces") (Isa 53).

> The light John the Apostle and Seer saw "shone in the darkness and the darkness could not put it out" (Ch. 1).

> The Word that was God—eternal light, eternal Torah (Philo)—was life.

> Allah is the light of heaven and earth (Sura 24).

> In that light, *Logos*, was the life of all people.

> Glimpsing that light, we see that all are the children of God.

> We know that light—*Logos, Nor (Siraj) is eskanosen*—encamped next to us in the neighbor, the other—*Autre est Autrui* (Levinas).

> Light is reflected from The Light—which is reflected in the face of the other.

Slash/Splash

The second movement in the ministry of Vincent Van Gogh has to do with wound and healing and with Father Henri Nouwen's sublime oxymoron—"the wounded healer." Our global world today is the heir of two "Enlightenments"—those associated with the names of Kant and Wesley. These broad phenomena, one worldly, one religious, have been called illuminations and awakenings—*Aufklarungen*. How Euro-American culture extends to Africa, Asia, and indigenous America is an issue as

replete with controversy as is the connection of Van Gogh with his neighbor, King Leopold (Belgian Congo), the gruesome "hand harvester" who came onto the world scene just a few years after the death of Vincent.

Both enlightenments refer to the blind seeing the light and the dead rising to new life—wounds are transfigured into wholeness—resurrection and healing. Theologically, these historical moments are recapitulations of the profound spiritual/physical renaissance (a word embracing both awakening and arising), which is the scriptural charter of healing and the healer, present in all faiths.

Judaism first portrays this matrix of efficacy into the world as a universal phenomenon—a radiation of the One God into this One *oikumene*—one inhabited world. "Your descendents will be as the stars of the sky..." (Gen 22:11). Ironically, this passage is also that of the expulsion of Hagar and Ishmael and the double threatened sacrifice of the "beloved son." We learn about this complicated metaphor from Jon Levenson and his set of books on the resurrection.[13] Judaism inherits this matrix of divine power in the world from all primordial faith and ethics—especially from India, Egypt, and Persia. Its essence goes like this—the God of light is the God of life. This divine indicative grounds all human imperative: heal the sick, forgive sins, teach children, give sight to the blind, house the homeless, let the lame walk, liberate the oppressed, lift the poor, forgive sins, provide work to the unemployed, raise the dead, etc. There you have it—with myriad other interstitial ministries. The purpose of each human life is to reflect out into the world—onto fellow humanity—the light/gift/energy/*imago*/ that is in us, so that others receive glory and radiate that back on the Creator: "Let your light so shine that humans may see your 'good works' and glorify your Father in heaven"(Matt 5:16).

In this mission, there is no place for colonial condescension or Eurocentric arrogance toward the "benighted souls" of another culture. That would be as dangerous an arrogation as the denial that the blind possess their own special light and gift.

Interfaith ethics are all rooted in eternal and temporal Torah. This is the canvas, the tableau of all godliness and goodness. Torah (Law of Christ, *Taurut*) is revealed, then enunciated in prophesy and elucidated in Wisdom. It is the divine depiction (and human discovery) of the rule of faith and life—of "all righteousness" (Rom 8:4).

13. See Jon D. Levenson, *The Death and Resurrection of the Beloved Son* (New Haven, Conn.: Yale University Press, 1993). See also, *Resurrection and the Restoration of Israel and Resurrection in Judaism and Christianity.*

For Vincent, although he saw this serene picture of the mountain sermon—Sinai rehearsed—his life-pain, perhaps because of an overly severe childhood and disappointing young adulthood, would persist.[14] Just as God is unknowable, and light inaccessible—for now, the light would remain opaque—dim as in a mirror (1 Cor 13:12). Like Count Tolstoy—who tried to actualize the Sermon on the Mount with its perfections on his Russian estate—that estate would crumble—and Vincent would take his ear and then his life.

Yet he had seen the mountaintop. He emerged from the mud and dirt, from the *Bearers of the Burden*, the hard, bent-down miners carrying out the bags of coal (1881); he left the Borinage and ended up in Brussels. Now in the world of *perception Française*, he dreamed of *le pays des tableaux*—an envisioned canvas of beauty and color—the realm of imagination and possibility, the good world and the goodness of life, the domain of the poet and artist—the splash of color—as Jackson Pollack might dream, then toss. This possible, ideal realm slowly came into Vincent's view. This was the earthly paradise—the Kindom [*sic*] come on earth—Rousseau's *The Peaceable Kingdom*. Like Bach, he could almost see and touch it—yet not quite (see Hindemith's study of Bach[15]). *Ad majorem Dei gloriam* was possible, but not human apotheosis.

He threw himself into the role of novice artist, went to art school, and began the tedious discipline of seeing acutely, perhaps for the first time. The pointillism of human and animal anatomy, and the free yet mimetic technique of drawing, then coloring, became his gift. He was now noticing the Other. He was witnessing a solidarity with the creation, the whole human family—especially the weak and hurting. Such service, he discovered, would require discipline and sacrifice. He was discovering what the Sermon on the Mount portrays as discipleship. In his study of the *Bergpredigt*—*The Cost of Discipleship* (*Nachfolger*) (1937), Dietrich Bonhoeffer writes "when Christ calls a person he bids him come and die." Rabbinic formation is fine-grained, highly textured believing and action. It is "denying oneself" (first commandment) and, in the Jesus movement,

14. There was clearly an underlying hereditary disease in the Van Gogh family. The disease that best fits all symptoms, including intermittent mental illness, is acute intermittent porphyria (AIP). AIP and a similar disease, porphyria variegate, were found in the Netherlands. See Wilfred Niels Arnold, *Vincent Van Gogh: Chemicals, Crises, and Creativity* (Boston: Birkhäuser, 1992) and Geoffrey Dean, *The Porphyrias*, 2nd edition (Philadelphia: J.B. Lippincott, 1971), from Van Eys Appendix.

15. Paul Hindemith, *A Composer's World* (Cambridge: Harvard University Press, 1952).

it becomes following in the way of the cross. Vincent's cruciformed life now turned its gaze on the "least of these," his kinsfolk. "Blessed are those who are persecuted for righteousness sake—for theirs is the Kingdom of Heaven" (Matt 5:10).

The Bearers of the Burden (1881) was actually completed after a move to Brussels, during the art phase of his life. The missionary remained itinerant—with nowhere to lay his head. In the ancient great city of *Gaul Nord*, he undertook arduous studies in sketching, modeling, and drafting. The letters also suggest that Vincent is undergoing a transition in his understanding of theology and ministry—toward greater realism about himself and those people who would constitute his congregation. Though he wanted to present many sermons (canvases), he knew it was best "to do what was possible" and concentrate on what would be enduring—quality rather than quantity. In the end, we have perhaps 2,000 paintings and drawings and 1000 letters.

He was moving from a hands-on, evangelical ministry to one at large where he hopes to reach greater "humanity" (*anthropon*). Our suspicion is that a cardinal scripture of Reformed Faith—Matthew 5:19—takes on prominence in the mind and heart of Vincent. His vocation to "preach the Gospel" and "make disciples of all nations" (Matt 28) is now more the Sermon on the Mount:

> Let your Light shine . . . That anthropon will see your good works (oeuvre) . . . and reflect back glory on your Father, who is in heaven.

Evangelism (as his preceding Bible translation) has now mutated into publication. It is plausible that Vincent knew and loved (at least from his Methodist stint) the well-known Reformed hymn, "O Zion haste:"[16] ". . . Publish glad tidings, tidings of peace, tidings of Jesus—redemption and release."

At last, his calling into evangelical ministry was being realized. He left his formal academic studies to study *Dame Nature*—trees and fields, flowers and skies. His virtuosity was validated by his discovery in the early 1880s that watercolors were facile in the depiction of seas and skies.[17]

16. "O Zion Haste," words by Mary Thompson (1868, 1871); music by James Walch (1875). Online: www.cyberhymnal.org.

17. The Impressionist palette deals with light—the visible spectrum of red, orange, yellow, green, blue, indigo, violet. To the Impressionist, blacks, browns, and grays are achieved by mixing warm and cool colors. Every color has hue (warm or cool or in

As his work took on the dimension of holistic witness, he became one of the great artists of history—like Michelangelo and Mozart—who might be called evangelical or prophetic artists. "Good works," in the sense of Matthew 5:19, mingled Torah with the sense of task (*aufgabe*) and grace, Gospel, gift (*gabe*).

"Graceful work" is the insight of Jesus' Sermon on the Mount; the Letter of James, Jesus' brother; the enigmatic, ephemeral epiphenomenon of Jewish Christianity (which goes into underground Diaspora after the Roman Judao-Christianicide beginning in 66 C.E.); and this mood also gave rise to the *syneidesis* of early Christianity and the Islamic conjunction of *Taurut* and *Injil* (law and gospel). This elusive faith tradition is the gift to humanity of interfaith wisdom . . . that humanity may see your good works (faith-prompted *oeuvre*) and glorify your Father in heaven.

Faith and life, animated in the Torah-Spirit legacy of Pentecost, a recapitulation of Creation, where the Holy Spirit superintended the "Days of Creation"—is at work in the pain and passion that Vincent entered in 1880. In his stumbling way, he spoke of an overarching totality of his *oeuvre*—greater than any particular work. "What I am trying to do," he wrote in 1888 shortly before his death, "is to succeed in creating a coherent whole."[18]

Antwerp (Illumination)

Before the final moments of sacrifice and glory in Provence, severe chastening, maddening and trying years of vocational maturation occur in The Hague, in the parental parsonage of Neunen, culminating in decisive years in Antwerp and Paris.

The magnificent steeple of the Cathedral in Antwerp and the breathtaking Ruben's Christ oils –nativity, life scenes, crucifixion, and resurrection—captivated Vincent's imagination. To these, he added the museums, dock landings, landscapes, townscapes, seascapes, skyscapes—the vitalities of this vibrant city—which he found dramatic in their valences of light and color. Ultimate intrigue was found nevertheless—in the faces

between), tone or value (lightness to darkness), and intensity (brightness to dullness). The black and umber pigments are considered dark, dull colors—used often to subdue or dull other colors. Van Gogh's umbers were used this way in *The Potato Eaters*. When the Impressionist idea of painting light inspired Vincent, he began to use cool shadows in warm light (*The Hay Fields*) and warm shadows in cool light (*Starry Night*, R. Vaux)

18. Van Tilborgh, 16.

of people, especially the peasants and workers. Persons' bodies irradiated with the stigmata of smallpox and the beautiful heads of women in the Scala Café again, illumined by the stunning lightscapes—even at dusk and dark—riveted his imagination, his spectacular delight and his deep sympathy and compassion.

At this point, we might mention the series of Vincent's *Leben Jesus* works, some of which may take their inspiration from this pilgrimage in Antwerp. *The Raising of Lazarus*, an intriguing sower with a Jesus head and a bandage wrapping the ears (which some have called "Jesus Van Gogh"), *The Good Samaritan*, and *Pieta*—all marked by that tell-tale swath of sandy, red hair—suggest a Christocentric concentration of being, which Vincent, and many before and after, have experienced in the sacred spaces of the great Antwerp churches.

In Antwerp, fellow artists rejected his unrefined and bold style of sketching. The few models available rebuffed his crudity and scorned his candid portrayals. Soon, he packed his saddle-bags and headed for *la Belle Paris* which—with its cache of artists and critics, along with her distant suburbs in Provence—would be his Jerusalem.

Paris and Provence: The Dénoument

His face was turned to his destiny and there was no turning back. He was now the people's painter, and the priests and publicans would not put up with it. He would challenge the canons of art and the protocols and provenance of the artist. He knew Paris as the art capital of the world from his work in the world of the art-business. In Paris, he loved Montmartre and hung out with Lautrec. He also exhibited with Seurat, Delacroix, Signac, Gauguin, and Pissarro. He planned to work at Cormon's studio drawing nude and classical models. This proved to be redundant and too expensive, but it was a season of immense value. In a poor man's diversion, he did red poppies, blue corn flowers, white and glowing roses, and yellow chrysanthemums—trying to reconcile *les tons rompus et neutres*—intense and muted lights and colors. He was a reluctant adventurer, having become "a stranger in his own home and family," thus exemplifying another characteristic of early Christian ministry.

Since he viewed Delacroix's 1850 work, *Christ on the Lake of Gennesaret*, in Paris, it was only a matter of time until Vincent would seek the calming of the waters of his troubled mind by the master's words, "peace,

be still." He was now ready to venture into the Mediterranean waters of southern France, finally to execute his own *Fishing Boats at Sea* in 1888. His closing days in Provence were still marked by interpersonal and professional conflict, by advancing mental illness, by a serene recognition of his own gifts, his limitations, and his mortality. Still, this time is marked by a phenomenal flash and splash of light and color that still brings ecstasy and wonder to the world, 100 years later.

He rented four rooms in the Yellow House and assembled an impressive set of paintings to send to his brother Theo, a portfolio, which would add to the serious formation of a *Gesammelte Werke*, which we now measure as nearly 1000 paintings and a similar number of drawings. Vincent's goal of a coherent body of work that would present a witness to the world—a witness both esthetic and theistic—was taking shape, though, like other persons of genius—da Vinci and Michelangelo, Mozart, Schubert, and Beethoven—he never imagined or dreamed that such global reception was already underway.

The argument with Gauguin continued the Parisian critique, not only of the classical school but also of the Impressionist and Neo-impressionist movements of art. Vincent had been thriving as the summer light, color, and warmth took hold. *The Green Vineyard*, *The Night Café*, two *Night Scenes*, *Starry Night*, *Bedroom in Arles* (my own favorite, on my wall for 60 years) and the compositions of *The Langlois Bridge*, formed a colorful autumnal portfolio. By Christmas, the volatile tempers of Gauguin and Van Gogh had exploded, Vincent mutilated his ear, and was admitted to the hospital in Arles.

The Christmas-Eve mutilation surely came from a combination of his frustration and illness and mounting disdain and criticism. His neighbors objected to him living in the yellow house—a ne'er-do-well and consorter with derelicts and sinners. Who does he think he is, that clown of Georges Roualt—Jesus? No, Methodist and puritan asceticism never did work for him. Drink, cigars and prostitutes were his fare, and even his *Skull of a Skeleton With Burning Cigarette* (1885), sporting the burning butt of a cigarette—thumbed his nose at polite society. Yet, grace abounded with every sin as he learned in his Ramsgate sojourn in England as curate (parish assistant) to Rev. Jones.

In the asylum at St. Remy, he began his series on irises and lilacs. His garden with pine trees reminds this author of the woodlands garden south of his study with hemlocks, blue and green spruce, and a long-needle pine—evergreen tributes to friends for whom he has had the honor

of offering the services of death and resurrection. Later, Vincent would sketch and paint the enclosed fields and other Provençal montages. Finally, toward the end of his days, we receive the Dali-esque church and houses at *Auvers*. The scene is already Passover *Kadosh*—a scene of holy sacrifice. At the hospital at Arles, he meditated among the Moorish arches and pools reminiscent of the *Mesquite* at Cordova. The watercolors of budding peach trees portend the new life of his yearning and dreams.

Physician, Heal Thyself

When Paul Tillich was University Professor at the University of Chicago, he would consort with we who were his students at Jimmy's Tavern on 55th Street and Woodlawn. One could feel here the flickering twilight companionship of the Vincents of this world. At another time, when Tillich gave the graduation address to our class at Princeton Seminary, he introduced what would become a famous sermon: "Heal the sick— Cast out Demons." He posed the proleptic faith and hope of Vincent's tattered life and *oeuvre*. How poignant and powerful it is when Jesus' inaugural witness pertains also to himself—"I come to bring sight to the blind, good news to the poor, release to the captives and new life to the dying" (Luke 4). Vincent's intriguing physician in his last days—Doctor Gachet—could watch his patient ebbing, as new life was breaking out in and through him. Together, they walked out and made sketches, even as *dénouement* loomed.

Paradoxical mystery abounds as we contemplate the ministry of Vincent Van Gogh. We can only ask, "Can madness actually be sanity, schizoid insight, actually truth—foolishness, wisdom, suffering, health— death, life?" "They would not listen, they did not know how—perhaps they never will."

With the 20/20 vision of hindsight, we can see that Vincent's body and mind were disintegrating, even as his gift to the world was dramatically being born. Again, we are dealing with the biblical miracles: "He must increase while I must decrease" and "who saves his life will lose it and who loses his life for my sake—will find it" (John 3:30; Mark 8: 35).

When he painted *Still Life With Open Bible* (1885), with the Bible opened to Isaiah 53, "the suffering servant," he likely made reference to his Christology and his own biography. To compound the mystery, he placed alongside it on the table Zola's *La Joie de Vivre*. The text of Isaiah

speaks volumes: ". . . He was wounded for our iniquity . . . He is despised and rejected by men, a man of sorrows and acquainted with grief" and " He shall see his seed, be satisfied and prolong his days, . . . I will divide him a portion with the great." It seems that we are dealing with the para-doxical biblical miracles: "He must increase, while I must decrease" and "who saves his life will lose it and who loses his life for my sake will find it" (John 3:30; Mark 8: 35).Vincent once confessed to Theo that, although he didn't have children himself, his works—(and those born to light and life by the viewing)—were his children.

Concluding Thoughts

The reader may object that, in reflecting on a sublime theme like "the light of the world," we are confusing a secular phenomenon with a sacred process. The validity of that comment must be determined by examining the nature of what is called "the light of the world." In the aforementioned earlier symposium, we have explored extents, lineaments, and charac-teristics of that reality—scientific and metaphysical, secular and sacred, even physical and spiritual. Through the interfaith lens, we see that the "light of the world" refers to the Christ, to Word and Truth, to the radia-tion of God into the world and the reflection of humankind back to the light-source of all creation.

It also refers to the very secular vision of experienced light and color in the realm of human sight. We embrace a vast array of metaphoric meanings. If this breadth and range of meanings are valid, we have made the case that the ministry of Vincent Van Gogh participates in the "light of the world"—which is ministry in the life of God.

Van Gogh and Gauchet were fellow travelers in the parable of light and darkness, life and death, salvation and damnation. "He's sicker than I am," quipped Vincent, deluding himself that he was the sane savior and Gauchet the pathetic patient—and this is how he would picture him. As they made rendezvous near the Auvers Church, his precise line already showed a Dali-esque bent. The journey was already one of salvation and damnation. In the spring sun of Arles and the warmth of August at Au-vers (1890), if he knew the hymn, as he most likely did from his Method-ist time in England, the pastor would have hummed the hymn of color, light, and glory:

> In the cross of Christ I glory, Towering o'er the wrecks of time;
>
> All the Light of sacred story, Gathers round its head sublime.
>
> When the woes of life o'ertake me, Hopes deceive and fears annoy,
>
> Never shall the cross forsake me, Lo! it glows with peace and joy.
>
> When the sun of bliss is beaming, Light and Love upon my way,
>
> From the cross the radiance streaming, Adds more luster to the day.
>
> Bane and blessing, pain and pleasure, By the cross are sanctified;
>
> Peace is there that knows no measure, Joy that through all time abide.[19]

Vincent, with his blended or confused Arminian and Calvinist heritage, his Buddhist caste of spirit, his tension of humanist and theist values, his oscillation between health and illness, now faced his future and destiny with faith and foreboding. He was secure in his Savior, in the words of the Calvinist Heidelberg Catechism—"his only hope in life and death"—yet uncertain at the fate of his bodily and mental existence. In all, in the midst of death, he could begin to feel the possibility of an immortality rising from the gift of divine strength in his works. So, with the apostle, he was now ready "to work out his salvation with fear and trembling," knowing that it was God working within "to will and do His good pleasure." (Phil 2: 12–13)

To his worldly-dimming, and now heavenly-clearing eyes, he seemed to see only white fields outside the confining bars and walls of St. Remy de Provence. In these remarkable compositions (e.g., *Wheat-Field with Cypresses*, 1889), through the eyes of faith, we might envision those redemptive/evangel fields of that Galilean peasant preacher, perhaps looking out on crowds with their sun-drenched, Palestine headwear: "look on the fields, they are already ripe unto harvest" (John 4:35).

We have capsulated our thesis. Now let us unpack its density. We will seek to offer a new understanding of the synergic ministries of religion and art. In religion, God as feudal overlord full of rule and judgment—perfection of Deity in terms of medieval awe and terror—is added to the Reformation's strenuous demand and Protestant scholastic logic

19. John Bowring (lyrics, 1825); Rathbun (music, 1849), "In the Cross of Christ I Glory." Online: www.cyberhymnal.org/htm/i/n/intcross.htm.

and consistency. Beyond the imperfection of humanity, all is transfigured in Vincent's experience toward Georges Roualt's Christ of sorrows and the tender agonies of an outcoming Savior and liberator of the weak, poor and suffering.

In art, *Medieval idealism and formalism* (Golden Halos on the imperturbable saints of the Flemish masters), *Renaissance heroism* (daVinci with his mathematical and mechanical precision of sacred bodies) and *Exaggerated realism* (Michelangelo's *Pater Ancien* with the magic finger that will scold you if you fail to obey the program and protocol) and even early *Modern romanticism* (Rembrandt's so resplendent "waiting Father" greeting the Prodigal Son) are transformed into a *post-modern expressionism and post-expressionism* into which the soul of the artist is poured in all its passion and sympathy—its woundedness and hope.

As we begin our exposition from this point on, we must ask "What is sacred or holy art?" Van Gogh cries out with this plea from the axis of his volcanic and vicarious suffering and substitutionary pain, along with his moments of ecstatic epiphany within the realms of nature, as he walks along the parks in Ramsgate as grey dusk skies embrace the warm brown earth. Is sacred music better found in secular classics such as Brahms or Verdi's *Requiem* or Joan Baez singing her "God is God", or is it found in "Jesus and Me" elevator music praise jingles—what C.S. Lewis called "5th rate texts set to 6th rate tunes." Is an authentically religious film Mel Gibson's *Passion of the Christ* or Robert Bresson's *Au Hazard Balthazar*, the tale of a reviled and brutalized but ultimately redemptive donkey? What is the sacred scene—a Sallmannesque Jesus sweating blood under his radiant glow in Gethsemane's olive garden or Vincent's grove of gnarled olive trees groping alone against a turbulent El Greco sky? We now test the thesis that Vincent's earthiness and secularity is more profoundly spiritual than the pious convention-mongers of today's establishment

Reprise

In eight chapters, I will lay out eight dimensions of this ministry—his and ours. Under the rubric of *Aldersgate*, we will consider the evangelical (Reformed and Catholic) spirit, especially as captured in the piety and hymnody he learned in England; from *Amsterdam*, we will survey his home and early nurture and his acquaintance with, and alienation from, Dutch Calvinism; in the *Borinage* underground ministry, we see a new

theological vision of ministry—not one pompous and institutional, but one more like St. Francis of old or Toyohiko Kagawa or Mother Teresa—Vincent's successors; this theology of condescension (broken of haughtiness) and a brief but formative interlude in Paris (*Ansières*), where significant theological maturation occurs, leads us to my base of operations as I write this study—*Antwerpen*; in this city close to the Manse city of Zundert—a cosmopolitan and artistic yet colonial and arrogant (think of King Leopold and the spurting hand of the Plaza fountain) city, Vincent learned to draw figures and absorbed the grandiloquent glory of Reuben's sacred art; *Arles* is Vincent's spring of Buddhist wisdom—a glorious *Solarium Provençal*, still shedding light on Gautama's four personages of pity and compassion—poor and wounded, old and dying, provoking gay and constructive *insouciance* for his insistent and persistent work, albeit frenetic; *Auvers* culminates his *theologicum* and his *Lebenslauf*—in an amazing flurry of outpouring grandeur—a 70 times 70 (works and days) *dénouement* of *Gabe/Aufgabe*. An afterword on the miracle of *resuscitation* signaled *accession* and world blessing in Pentecostal revival as Vincent lights up and brilliantly colors the whole earth—this culminates the body of the work. Ministry Indeed!

I believe with Cliff Edwards, Louis Van Tilborg, Anton Wessels, Henri Nouwen, and others that ministry persisted into and through his art career. Wessels believes, from his post in the Free University of Amsterdam, that Vincent remained an evangelist even more intensely after Isleworth and Borinage into the art period. Though ". . . he was like most great men, not understood and did not understand himself . . . he himself was a missionary, teacher, healer of the sick."[20] His mission and ministry was irreducibly one of religion and art.

We have positioned a GPS of places and moments in the journey of Vincent's unfolding ministry. Working on site in Holland, Belgium, France, and England, we will diary his vocation and interpret its universal theological significance. The reader is now invited to journey along.

20. Antonie Wessels, *A Kind of Bible: Vincent Van Gogh as Evangelist*, (Amsterdam: SCM Press, 2000), 19.

1

Aldersgate

THE SWEET HYMNS OF ENGLISH EVANGELICAL THEOLOGY

THE SAGA OF VINCENT's ministry has its palpable beginnings and perhaps its apex in awareness of its calling as a youth in his early twenties in England. Much, of course, had transpired before those crucial years of 1873–1877, spent mainly across the English Channel from his native Antwerpen, Ostend, and Calais.

We will subsequently gather the formative stirrings toward ministry as a family of northern Dutch sophisticates is exiled to be southern hicks with strange dialects in Flanders—this appears within the next chapter under the rubric of Amsterdam. But it was these years in England which would prove vocationally decisive. With the exception of some interlude months in Paris before he finally wore out his welcome in the family art dealership (like the petulant waiter in the film, *Italian for Beginners,* scorning patrons when they would not want to purchase this or that particular work, realizing too late that candor in business is no virtue), he resided for almost three years beyond the white cliffs of Dover.

The Paris months were not lost in this formative moment in Vincent's heart, soul, and conscience. In those months in France, he took himself into a period of seclusion for Bible study (modeling Jesus in the temptation wilderness, Moses in the Sinai wilderness), formative months indeed, on which more light needs to be shed.

In London, then post-Paris in Ramsgate and Isleworth, mainly in Methodist, Dissenter and Puritan (Congregationalist) faith-settings, he cut his eye teeth on parish-based and evangelical inner city and rural ministry, preached his first sermon, taught religious lessons and rather unique Bible studies to those perennially unappreciative pubescent young people. He ventured into hands-on pastoral-care and enjoyed the heady, though intimidating, mantle of religious leadership. The notes in inconspicuous church records in Isleworth about an enthusiastic evangelist-Bible teacher are a foreshadowing of what will become the inauspicious tombstone in Auvers—the real story.

Puritanism in Van Gogh

We know that during Vincent's earliest working years in London, with side journeys to The Hague and Paris, he was fascinated by the Puritans. He pondered Millais, the Huguenot (1852) and Boughton's *Early Puritans of New England* (1867). To comprehend who Vincent was in soul and body—mind and art—we have to move back and forth across the English Channel from Puritan London and West Anglia to Holland and Belgium.

In Puritan and Wesleyan England, he found the theistic/humanistic groundings of his own soul. This historical-cultural context explains the phenomenal popularity of Vincent in America—which is sometimes called "the Puritan commonwealth." His soul was being shaped by the Puritan vision—as it was depicted in art—in the Dutch *Gesangbuch* and the English Hymnal (see L 96 [11/3/76, Islesworth])—all this working out in the spiritual crises and enactments in his own being—"Have thine own way, Lord, however dark it be," was his watchword.

To orient the reader to this critical chapter in Vincent's formation as a theologian and pastor, as well as his artistic temperament, I am guided by Martin Bailey's excellent study[1] which grows out of an exhibition at the Barbican Art Gallery in London (1992). Though Bailey accepts the prevalent caricature of Vincent as one who " . . . in England sank into deep depression . . . turning to Christianity for solace" (p.8 ff)—a view understandably held by Joanna and her son Vincent—but not corroborated by others, this author included, he does open up a vista of awareness of Vincent's complexity and sees the importance of this period in

1. Martin Bailey, *Van Gogh in England* (London: Barbican, 1992).

the life of " the only post-impressionist steeped in the English culture" and the fact that this was one of the richest times in his brief, scarcely two-decades-long, adult and productive career.

I write here in my old theological home in England, Cambridge, where for years I have struggled with the meaning of the East-Anglican theology, non-conformity, Puritanism, the escape of beleaguered Calvinist and Lutheran clerics to Belgium and Holland (e.g., William Tyndale)—even the Pilgrim exodus to the "New Land" of America from Port Voorhaven (after praying in the Oude Kirk). Of particular interest to me because of heritage (and to Vincent) has been the French Huguenots (Millais' engraving, [L 36 [6/29/75, Paris]).

I heard last evening a moving lecture by John Milbank, philosopher from New Castle, on Tyne defining David Hume's Scottish philosophy as a reflection of "melancholy," Anglicanism, Puritanism, perhaps even early Catholicism, one where deep emotionality has become a feature of reason and metaphysics itself.

And I think of Vincent—a near contemporary of Hume—yet in the same skeptical ethos—"wish I could believe and live happily without so much pain" (the problem of evil)—one similarly sublimely aware of philosophy and art, literature, history and theology—knowing that he had to speak and portray the truth—without being obsequious to conventional religion. Melancholy, rightly conceived, in other words, is the stigmata of earnest piety. Vincent was a Hume-like figure for sure. He said "We should not blame God for this world. It is a study that failed." (L 613[4/26/'88, Arles]); (See also Edwards, *Mystery of the Night Café* [SUNY, 2009, 56] and Naifeh and Smith, *Van Gogh* [New York: Random House, 2009, 627ff]).

It was like the mischievous children who smeared Vincent's drawings with their dirty hands. Christ, on the other hand, was the "greatest of all artists" (Letter b-8 to Barnard, quoted in Edwards, *Night Café*, 56ff).

Hume also shared Vincent's Scots/Irish irony on the theodicy problem: "Is the whole world visible to us?" It does not seem impossible to me that cholera, gravel, consumption (Theo), cancer are the celestial means of locomotion just as steamboats, omnibuses and railways are the terrestrial means. To die quietly of old age would be to "go there on foot" (Ibid., Edwards, 56).

One who, like Vincent, is hurting in the face of personal suffering, persecution and rejection, one connected in sympathy with the poor, the

struggling and pathetic of the world, like Lautrec's and his own *Café de la Nuit* people—is the truly human—the being-crucified one.

Though the Dutch and French influence on Vincent is far greater—it is London with its teeming four million destitute, yet such noble, simple folk—and England, that first recognize his soul, his penetrating gift—and his ministry of Religion and Art.

From the Calvinist-Puritan influence in England, added to that deep spirit in both Belgium and Holland—embodied in Rembrandt and Rubens—Vincent acquired a naturalism and empiricism (cf: reference to Hume). While in England, this feature of his imagination was intensified by his reading of the pre-Raphaelites and their mainspring: John Keats.

In this ethos, nature became sublime, and human simplicity revered. The religious source of this element of Vincent's aesthetic imagination is replete in the correspondence from England. In (L 23[5/16/74, London]) to Theo, he remarks, tellingly, "find things beautiful . . . most people find too little beautiful." Sight—only "beam-free" sight (Luke 11:34) can see the beautiful. After the Sermon on the Mount, only the ethical vision can see beauty. "It's so beautiful here, if only one has a good and single eye, without many beams in it" (purity of soul).

The ministry side of the England experience occurs after the art-business appointment, which was most unsatisfying in two assignments, which had exposed its lack of challenge. These ministry posts, by contrast, even though he had to shed his top-hat and work pro bono, proved exhilarating to him and edifying to his flock.

He became a schoolmaster in Ramsgate with boys who scarcely realized that in lessons in Bible and other languages, they were dealing with one who in today's modern world would be the pride of Eton or Phillips Academy—probably even Princeton or Cambridge—a budding polymath steeped in history and culture—well on toward memorizing (and translating) the Bible in the several languages in which he was proficient—a vividly erudite colorist and naturalist—and one not half-bad with the sketch-book.

Ramsgate Head-Master William Stokes transferred the school to Methodist pastor Thomas Slade-Jones in the London vicinity—Isleworth (now Hounslow, near Heathrow) and the Congregational Church in Turnham Green—which I was ready to visit last week when I arrived at Heathrow, until I discovered it had been torn down just a few decades ago, for a business complex—our all-too-prevalent sorry exchange today for art, faith and culture.

Actually, David Hume knew this penchant when he chided Protestantism for becoming the faith of commercialism—as did Vincent's near-contemporary, Max Weber, when he called the Protestants the epitome of the spirit of Capitalism. The one full sermon we have in the correspondence was preached by Vincent in these London suburbs, i.e., Richmond. This sermon has a simple message: ". . . you and I are pilgrims" ("in this barren land—but (God) You are mighty").

When Bailey claims that Vincent turned to faith for consolation after he failed at love and the art-business, he fails to remember that for the "sensitive," not "sick" soul, (William James, *The Varieties of Religious Experience*), such penultimate purposes in life never suffice. Granted the genius of Freud finds wholeness in "work and love"—but *vita activa* is never "all there is"—though we "keep on dancing" (Patty Page). In this age of prosperity-religion, when even good old Charlie Brown confesses to Lucy that he preaches in the town market, not for the people but for "the lettuce"—we need reminding that enduring *vocatio sub specie aeternitatis* ("while unending ages run") involves men and women being called into ministry-quite apart from commercial considerations.

The name of William James calls to mind the phenomenon of New England Congregationalism and Puritanism which must be mentioned as we explore Vincent's vocation. I would venture in the context of this chapter on England that Vincent was here touching a well-spring of spirituality, world view, sensation and virtuosity that had, and would for 37 years, form his very soul. His is the faith not only of Peter Paul Rubens, but of Rubens' evangelical Protestant father; of Luther, Calvin and Wesley; of the Protestant Reformation and the Puritan movement founded in places like the Moravian Palatinate, the Cambridge Platonist-Calvinists; of the flight of these persecuted souls from England—especially from London, Somerset and the West country, East Anglia and Scotland, to Holland and on to the "new world"; of the modern Dutch-Reformed Church of Vincent's beloved father, and his ancestry. In England, he glimpses his heritage—his soulful-self. Together with the underground ministry in the Borinage, this is his most affirmative moment in his watch. The remaining dozen years of his life—even the ferociously creative time in Arles and Auvers—is, in some sense, reminiscence.

Historians believe that Vincent was deeply moved by George Boughton's work-*Puritans Going to Church of* 1867. Why? To this depiction of simple faith and piety, we need to add an important writer in Van Gogh's English experience—Charles Dickens, a man whom one feels

restlessly and compassionately walking the streets of London just a few years before Vincent did the same.

In Dickens' comment on another of his own works—the crowded slums with people starving and shivering, hoping for work and warmth, for love and God—we may trust that Vincent looked on with his riveting gaze the painting of Luke Fildes: *Applicants for Admission to a Casual Ward*. The artist applied the writer's words after he had visited the Whitechapel workhouse:

> "Dumb, wet, silent horrors! Sphinxes set up against that dead wall and none likely to be at pains of solving them until the general overthrow" (Bailey, 57).

We know from his Richmond sermon (L 96 [3/1, 1876, London]) that Vincent, who likely visited the Royal Academy exhibition of Fildes' work, with the Dickens' quote attached, at the Royal Academy in 1874, conceived in his profuse correspondence at this time, that pilgrimage and being pilgrims was his portion in life as well as that of all men and women who walked through this "veil of tears" with him. Until the "general overthrow," which was not the proletariat revolution, but surely a more potent coming, as Kingdom erupted into, and then interrupted, the negligence and violence of this world, this would be man's lot.

In the Gronigen school of Dutch theology—often associated with the evangelical-social justice thought of Schleiermacher—redemption was beyond and within this world. As with the Puritans, a secular-worldly and earth-transforming mission was set in motion by the Hebrew prophetic and Torah way of God as creator and visitor to the human "cry of need" as this would deepen in the Christian exposition of incarnation where discipleship entails sacrifice, as we attend those in need by all the means (e.g., personal and political) at our disposal. This was the theology that the 23-year-old inherited in Holland and intensified in England and France.

Bailey contends that Vincent's favorite book in English—along with Dickens and Stowe—was George Eliot's *Felix Holt: The Radical,* which describes an idealistic youth who has chosen the simple life of an artisan—artist and aid to the needy. Here on the great Isle with the multiple outlets for ministry afforded by England's "green and sublime hills" and furious and degrading mills (Blake), an artisan ministry is being formed, one that will be sealed in the heart by Britain's greatest gift to the world— church music.

While an essential part of this refreshing experience of being honored and welcomed in ministry came from the fresh scenery ("A prophet is without honor in his own country—isn't this the youth of Nazareth whose family we know?—what good can come from there?"), much of Vincent's theological insight, I argue, came from exposure to the "amazing grace" heralded by English hymns—Reformation, Wesleyan, Victorian, Anglican, Welch and Scottish—a truly extraordinary body of work, beloved throughout the world, especially in their evangelical impulse. The undergirding piety of this hymnody among his friends in England also "strangely warmed" his being. I use the rubric of Aldersgate for this chapter to signal the Mecca of Wesleyan and Holiness impulse in the history of God within Reformed—especially English—piety and the formative theological influence this ethos had on Vincent.

Wesley

He may indeed have known St. Botolph's Church there at the gate where the heart of John Wesley was "strangely warmed" in his encounter with the Moravians as he listened to the scholarly words of Martin Luther's preface to Paul's letter to the Romans. This experience decisively enlivened his conversion and ministry. The Dutch knew well that Wesley came from Calvin who came from Luther who came from Hus who came from Wyclif—one big circle originating and ending in England. Perhaps that is why the same wretched bureaucrats who would later deny Vincent ordination in the 19th century would have, in the 16th century, after he was caught in Antwerp translating the Prophets into English, burned William Tyndale at the stake at Vielwoorden (six miles from Brussels).

Tyndale was the Oxford Don who wrote the first vernacular Bible in English. He printed it in Antwerp and shipped it back—with help from his fellow evangelical merchants and shippers—to the nascent Reformed centers in Cambridge, East Anglia and London.

Two hundred years later, from these now established evangelical centers, Vincent would be welcomed into ministry from the very places, such as Aldersgate Street, where the Wesley brothers and "the people called Methodists" would settle down to work in London inner-city ministry. Vincent frequented the evangelical halls of this vibrant ministry—Sankey and the Crusade preachers—concurrent to, and formative of, his own.

In his evangelical zeal, Vincent now began to express the simplistic and problematic view that the only spiritual and ethical professions were Pastor, School Master, and Artist. Though lawyers, haughty clerics and industrial tycoons vexed his ire, as they did his literary mentor and fellow London roamer by night—Charles Dickens—it is clear that to become a person of the cloth and collar was now his dream and ambition. In a letter that moves a fellow traveler in ministry to tears, Vincent writes: introducing himself as "a clergyman's son, who has had to work for his living, has neither the money or the time to study at King's College (London), a few years beyond the accustomed age, one who has not yet begun the studies of Latin and Greek—one who offers only an innate love for the Church and everything connected with it—'the Love of God and Man' " (L 81 ff [London]).

The critical issue, obviously, is to what vocation the Lord is calling this lad. Will his "watch in the night" be in the mines of Borinage or under the starry skies of Arles? What happens when a person is called to ministry and a given people need and desire such ministry, yet ecclesiastical officialdom proceeds to deny the post? As one who has served on the official bodies within the Reformed tradition which work with candidates for ministry in discernment and calling, I have felt acutely the holy terror of the maelstrom which whipped Vincent, that of sometimes accepting unworthy, and rejecting worthy, persons for ministry. Though my grounds are conjectural, I believe that hymns in particular fed Vincent's ardor for clerical ministry.

The sojourn in England is interrupted by a short interlude back home and then in Paris. It is a *kairos* season for Vincent's ministry, along with the Ramsgate/Islesworth assignment, which finally culminates in the Borinage call. The following moments punctuate the Paris months:

1. Occupying a small room in Montmartre, he read the Bible by day, and by night, he read it to his English house-mate—Henry Gladwell. The correspondence makes clear that his soul and mind are undergoing subtle changes. Though still actively involved in "romantic" literature, he is becoming an intense biblical scholar. His being is becoming captivated by the all-absorbing and surpassing Word of God. This is evidenced by frequent citations of Bible verses and Hymns (which at their best are poetic *midrash* on Scripture). Think of Charles Wesley's, "Amazing Love, How Can it Be," the finest exposition of the "descended into hell" clause in all Christian literature.

2. Excursion: The year in Paris 1875–1876 was spiritually and po-
litically salient. Though he knew Michelet and Hugo, Dickens and
Stowe, Vincent, like Jeremiah, Jesus, Paul and Augustine, finds the
theological and existential dimension of life-crisis more compelling
than the political. So Wesley and Edwards, on the one hand, and
Marx and Wilberforce on the other, both get it right.

3. An exhibition at Musée D'Orsay in my spring-summer sabbatical
in Paris looks at that political moment and springtime through the
eyes of Vincent's fellow- Impressionist, Édouard Manet. Following
the 1848 revolution and 1851 Coup of Napoleon III, Manet, and
writer Baudelaire, established the Salon which dealt with the intri-
cacies of religion, art and politics. Manet's provocative work, *Angels
at the Tomb of Christ*, in 1864, and *Jesus Mocked by Soldiers* (1865)
were all the talk of Paris the decade before the twenty-some year old,
very pious Vincent came to town. In 1870, Napoleon was defeated
at Sedan and in 1871, the Paris commune welcomed Manet back
after "Bloody Week." Revolution was in the air as was conservative
backlash. Such an historical period cannot have failed to influence
the idealist youth, to his envisioned "Commune."

4. Rembrandt's *Pilgrims at Emmaus* might signature this period. Here
we come upon food-famished, spiritually perplexed, pilgrim souls
coming down from Jerusalem from those confusing death/resur-
rection events. A traveler joins them—breaks bread with them and
much more. This seems to be a Lucan coalescence of the myriad
experiences of the primitive resurrection community "consulting
apostolic doctrine (*didache*) and breaking bread together" (Acts 2:7
ff). As this elusive One broke bread and Word with them—"their
eyes were opened"—a crucial breakthrough for the "light-discover-
ing" impressionist-to-become: Vincent. In the thrill and turmoil of
this Parisien "Emmaus," Vincent proclaims:

5. '. . . our love for Thee makes the bond, makes the earthly bond even
stronger (after Uncle Jan's death); ". . . life is short and fragile" (L 55,
56 ff [10/14/75, Paris]); "don't read Michelet or any other book but
the Bible" (a new, somewhat harsh concentration of attention?).

6. He departs from his absorption in nature to find "God" in the "Word."
He is becoming a "born-again" Calvinist Puritan. "Everyone has a
feeling for nature" (but) . . ." God is Spirit and they that worship

Him must do so in Spirit and Truth." The way leading to heaven is narrow—the wide road leads to death." (Ibid [L 50/ above]).

7. The same passage (Letter 54ff /also from Paris) signals his love of English Hymns—"Nearer my God to Thee"; "Thy way not mine, Lord"; "The Old, Old Story" (Sankey, 1866).

8. The enigmatic Jesus of the post-resurrection-pre-ascension window is here and gone—here and there. Seeing and grasping is ethical— when did we see you? In as much as you did it (feed, drink, visit) to the least of these, my brethren, you did it to me (Matt 25).Vision is now linked to compassion. He is beginning to see.

9. The ministry in Ramsgate and Islesworth evidences this biblical con- centration of Vincent's awakening soul—a new vision, contempla- tion and service—he sees with new eyes. Documents in this phase of his correspondence are epitomized in the "Pilgrim" sermon at the Wesley Methodist Church in Richmond. We have already com- mented on this pivotal text, which becomes an entire letter (L 96 [11/3/'76, Isleworth, "The Sermon"]).

10. Here are other insights afforded by the epiphany in England: His artistic eye is sharpened through his spiritual "eye opening". . . "we arrived at the last station before London as the sun rose . . . the bank of grey clouds had disappeared and there was the sun—simple and big as possible, a real Easter sun . . . the sky was light-blue, bur- nished without a cloud. Before the day was out, in the chapel of his new church, he read the placard—"Lo, I am with you to the end of the world." He sees the interior and exterior of the world. His sight is becoming empirical, eschatological, and ethical. In the storm I saw recently, the sea was yellowish . . . the wind blew the dust from the small white path on the rocks to the sea and tossed the blossoming hawthorn bushes and wallflowers that grow on the rocks . . . on the right fields of young green wheat . . . and from my window— the roofs of the homes . . . keep me from being a son that causeth shame" (L 92,93 ff [5/31/76, Ramsgate, London]).

11. Another clue to what is going on—"I regret not seeing Moody and Sankey in London" (Ibid.).

12. Then follows a set of apologetic letters, lamenting his faithless de- votion to his father, which was quite the opposite of the case; his unworthiness of the ministry which was as much a travesty of

ecclesial legality, as the first issue was a travesty of filial fidelity; and his fascination with London missionary work or sea-port ministry. The pathetic lament ends in a confession of faith and a cry for a call which might well have been a blended call to a ministry in Religion and Art. But God—as Hugo comments in his analysis of Napoleon Bonaparte at Waterloo—had other plans. This is what fate provided and the mingled ministry, only now, in our own times, finds effect and efficacy.

13. "Being a London missionary is rather special, I believe, one has to go around among the workers and the poor spreading God's Word, and if one has some experience, speak to them, track down and seek to help foreigners looking for work, or other people who are in some sort of difficulty . . . Last week I went to London a couple of times to find out if there's a possibility of my becoming one."

(L 85[7/4/76, Ilseworth, London]).

Preliminary Notes on the Ministry of Vincent Van Gogh

Before we get into the hymns and their theological meaning in Vincent's so vulnerable existence, let us consider the items which placed him on the black-ball list for ministry. In the first section of the correspondence, the editors set the stage for a century of misinterpretation of Vincent's worthiness to ministry by claiming that, in England, he was led into "religious fanaticism," even as they proclaim this period as the "happiest and most care-free time in his life." (*Complete Letters*, 1955 edition—Vol. 1, 7). At this point in his diary, Vincent seems to argue that his family had misdiagnosed his spiritual state and journey. Though Vincent believed that his family and friends thought that he should become a minister of the Gospel, they seemed, out of financial necessity, if not intention, to turn him out on his own, to cut him off from that course of life preparation, leaving him a vagrant, or in the words of Vincent's one and only sermon—reviewed in this section—"a pilgrim on the earth."

". . . Poor boy he does not take life easily," lamented a condescending mother, betraying as much a parental distance and apathy, as perhaps an "at your wit's end" exasperation, a "leave him to his own foibles" attitude. This is a sub-theme in her otherwise long-suffering care. She may have been—because of his persistent breach of decorum—like the imaginary mother of the Prodigal Son—"go ahead, 'Vince'—you'll see, you'll come

round home." But the departing son never will or can return. In terms of nurturing his freedom and responsibility in vocation, this ejection, from hearth and heart, was devastating.

Yes, he was an exasperating presence, as all testimonies report. He was dismissed from the business in London for being too harsh with the customers. Back home in the parsonage, when he knocked on the door, the kids screamed and the inhabitants shuddered at the ruddy, disheveled-haired (now in vogue in Amsterdam), flashing green-eyed-disturber of the peace and of the "decency and order" of the Calvinist manse. He was arrested for disturbing the peace at the "Yellow House"—a lynch mob gathered.

A prodigal son perhaps—but to parents who were seemingly oblivious to their son's beloved attraction to Rembrandt's hallowed rendition of that salient motif—they paternalistically coddled him in one moment, then in the next, rejected him from the household, consigning his profuse writing and sketching, now left in his garage studio, to the dust bin.

As parents of children who deserved fine educations far beyond the means of the salary of a pastor and school teacher, my wife and I, of course, can sympathize with the Van Gogh folks. Many an oft-absentee father, unable to pay for tuition into Kings', or any other fine college or university, at least can cry out with Billy Bigelow in the Broadway show, *Carousel*: "I'll go out and make it-or steal it-or take it-or die." Not here. They instead took the easy route and abandoned the son to the far country—except for that younger (not elder) brother who in this parable did not stay home grumping, but followed the wayward one into the far country—eventually to Paris, Arles and then back to Auvers, and to that strange conjoined *dénouement,* and his brother's and his own Siamese-monkey rope- entwined demise.

At the beginning of this chapter, several issues begged explanation. For a century since his death, there has been an unspoken consensus that Vincent was unfit for ministry. I will argue, in the tradition of Cliff Edwards—my mentor in my own nascent Van Gogh studies—that such evaluations deserve deeper scrutiny. Careful research into the full opus of Vincent—reading, writing, and painting—provides clear evidence that this is not a deranged mind. An eccentric—of course—unconventional and alienated in his society—yes. But was the pathology on his side or on the side of the family, society, and church that repudiated his vision and sense of call to ministry? Or did the one side call forth the other?

In research on the "suicide of society," one observer believed that Van Gogh was "the victim of the destructive forces of a society that no longer had a sense of myth and divinity."[2]

Looking back, labeling one "masochistic" who forsakes all and goes to the side of the destitute miners in the Borinage would seem to betray a shallow fathoming of what ministry is meant to be.

Vincent was also accused of "keeping bad company." Outcasts and widows, children and prostitutes, people of the night and the homeless, all were his constant companions. One would think that this was a tribute and commendation to a Jesus ministry, but to late nineteenth century conventional society, as in our day, so frightened by aliens, immigrants, contemptible, (Nussbaum) and odd-balls—rustic folks with hair-shirts, this was very threatening.

We may ask initially how this distorted cultural gaze on the Vincent Van Gogh phenomenon came about. With Cliff Edwards, I see it as the result of two blind spots in our knowing and evaluating—one secular and one religious. It is clear that there is precious little solid research and writing on Vincent's spiritual journey and ministry—or as I would put it—theological aspects of his life and work.

In the first place, from the beginnings of critical scientific research in the last century—including social and behavioral research—what the British call the human sciences, psychology, sociology, anthropology, and the like, we find a reluctance to grant reality to the spiritual (theological) and ethical dimensions of personal and collective existence. Since this realm is simply inaccessible to the epistemological and analytic method-ologies and tools of these very recent sciences—spiritual and ethical di-mensions of human and divine/human interactive life—are repositioned as matters of psychological, sociological, anthropological and economic reality, since spiritual and ethical phenomenon—unless reduced to these other empirical epistemologies—do not register on the instruments and measurers of knowledge. Vincent, and the transactions of his life (soul) and his actions of ministry, are thus reduced to a behaviorist bundle of phobias, a sociological range of precipitating causes and effects or con-struals—animal or tribal—rejection, frustration at love—of bizarre ge-netic or conditioned impulses.

Edwards—and I agree—also locates the distortions and amnesias as having theological roots. The modern penchant of theological research

2. Antonin Artaud, *Le suicidé de la société* (Paris: K. Editeur,1947),55.

to bracket thought (belief) and expression or word on one hand and art or action on the other—distinct from each other—disables modern religious scholarship from seeing thought and speech as holistic, finding expression in action and creativity.

Allow me an example: *The New York Times* reports today (July 5, 2010, p. A5) that a few fragments of the remains of one Michelangelo Merisi—better known as Caravaggio—have been received in Port Ercole—Tuscany. The "dramatic realist" par excellence, painter of the riveting composition of Herod, his wife and dancing-daughter Salome, with the head of John the Baptist and his equally well known table of the disciples, is said to be the conveyor of the beloved tradition of passion in the Italian soul, called that of "the damned artist" or "creative genius." Perhaps knowing and interpreting some phenomenon at the conjunction of art and religion is unfathomable unless we come up with some new visio-verbal categories—thus the attempts of Henri Nouwen, Cliff Edwards, Ken Vaux, and a few others (here note my appendices).

1. As we continue our inquiry into the credibility of the critique finding Vincent incompetent to enter ministry, let us look at Cliff Edward's focusing of the reservations offered by almost all authors after that of his sister-in-law—Johanna van Gogh-Bonger—that London was the scene when he fell into "religious crisis" that caused him to "seek refuge" in religion.[3] Ever since her diary in 1914, the phrases are repeated *ad nauseum,* phrases like "fanatical religious mysticism," "obsession with religion" and the like (15). Edwards proceeds to debunk this superficial, indeed false diagnosis, by citing the lucidity and rationally valid self explanations from Vincent in the letters and the fact that the experiences and events of England fit into a pattern of *kairos* and epiphany moments, moments of rich theological significance, convincing to all fair-minded observers, all except those few who can only believe that the calls of God to ministry—say of Moses, Isaiah, Jesus, Paul, Mohammad, Wesley and countless other prophets and saints—were mere hallucinations, detrimental to the recipient and to the parish, great and small, that each would serve.

2. He had been scorned in love multiple times and this—even for a gay or bisexual male—if he were such, as Nouwen seems to hint, took a psychic-neurological, even biological toll. In childhood, he was starved for affection and these deprivations and frustrations

3. Cliff Edwards, *Van Gogh and God* (Chicago: Loyola University Press, 1989), 15.

surely led him to find compensatory satisfaction in a vocation of ministry—that is the charge. Two comments: first, consider his life witness to his being as a joy-filled family man—one desirous of the marriage covenant and family nurture. Often the artist or otherwise creative genius–Caravaggio, Kierkegaard, Nietzsche, Edvardo Munch (b.1853 and artist of *The Scream* which recently sold at Sotheby's for 120 million dollars), along with Vincent, and many others, to name only a few from the homelands (and seedbeds?) of psychoanalysis—indulges in bizarre—even objectionable behavior. But what of Luther, Tetzel and Rasputin among those considered the more "orderly" crowd of clerics. On close examination of the record—both canvas and notebook—even the ear-lobectomy and fatal gunshot wound which we will examine as we proceed—show us one well within the parameters of an adequately sane and lucid person—creative and overly industrious—a worthy candidate for ministry.

I am fully aware that disfigured, mutilated, amputated, feminized persons (or actual females), even, in one early canon of admission to the priesthood, "persons who simply are too ugly," were often excused from ministry service. When I attended Princeton Seminary to prepare for ordination to the ministry in the Reformed and Presbyterian Church, it was the hey-day of what was called "muscular Christianity." This is evident as you look at the group photo of our entering class. With the possible exception of this author, the typical profile was male, tall, type A, of European ancestry, handsome (with well coiffed hair), all-American athletes (at least in one's own imagination). We were all possessors and heirs of the tradition and hope of what was called in a so-conventional CEO era of ministry definition "muscular Christianity."

We conveniently ignored the fact that by the late 19th century, industrial society, consisting of ethnic minorities, the children of laborers and grotesques of various minor and major flaws, women and eccentrics of every sort, were streaming into priesthood and ministry, as well they should, following in that train described by the Apostle: "We have this ministry . . . but we have this treasure in earthen vessels . . . we are troubled on all sides yet not distressed; perplexed but not in despair; persecuted but not forsaken; cast down but not destroyed." (2 Cor 4). This phalanx of fools makes clear, in the 20/20 vision of retrospection, that the rejection for ministry in the life-course and profound yearning of Vincent was therefore unconscionable and obviously short-sighted.

So much for the arguments that, for Vincent, disqualifications for ministry arise in the fogs of London. Here, in the shadows of Aldersgate, and perhaps in the wake of that spiritual wave of history, Vincent actually finds his first encouragement and success in ministry. At that point, if he could have emigrated to America and set down his preacher and painter roots in West Virginia, he would have been right at home among the wild eyed, roaring mountain-men hippies, settled down with some Hillbilly-Annie, having had a great family of kids, while rolling off some sketches to be lost in oblivion—blowing around in garbage dumps or perhaps shredded—as was the fate of perhaps 90 percent of Vincent's sketches in any case. Perhaps he could have become one of those courtroom sketchers whose drawings look suspiciously like those of Van Gogh or Roualt. But other tides were to flow into that one that rolled in at Aldersgate.

The judgments and tides of history are inexorable in determining the outcomes of occasions and events. While a champion of the dignity of simple laborers is being excluded from ministry to the poor by the ecclesiastical powers, another son of the Reformed Manse, Friedrich Engels, is offering indictment of the conditions of the "working class in Liverpool" and a revolution of the proletariat that will transform world history is being unleashed throughout Europe, Russia, South America and Asia. While one son of the German church speaks of the rise of the repressed working class, others, also of the Catholic and evangelical communions in the African and Hispanic world, write of the "wretched of the earth." Ethical transformation of consciousness is afoot. This may be Dickens' "coming revolt."

It will, therefore, take a half-century for that expressive ministry of this—one of the first modern "sons of the prophets," to add his voice to the uprising of the distressed around the world. Word and song, parable and picture, bread and hope have gone out and they "will not return void" (Isa 55:11). Look what happens. In the months approaching Vincent's controversial death, the French composer Gabriel Fauré introduced his *Missa de Requiem* in the Church of the Madeleine, Paris. A soprano aria extolled the "*Pie Jesu*," the simple and gentle guardian and rescuer of the poor and needy, and a recitative of baritone and chorus sung "*Libere me*," and all the world recognized a new song throbbing in one very old. Deliverance from death eternal (and now temporal) is the impassioned cry of the ministry at century's end. This vocation would grip the likes of Engels and Marx, Nightingale and Temple, Fauré and Van Gogh, Whitman and

Tolstoy, Keynes and Ramakrishna, Vaux and Olmstead and countless others—unknown saints and unnamed faithful.

And as the world turned from the 20th into the 21st century, we think of global Christianity—the demise of colonialism, the rise of global Islam, the spread of social democracy—the rights of widows and children, the poor and elderly, universal education—thanks to the passion of private, public and parochial sectors—and now, though late in coming to the U.S., universal health care. We still hear rants in my country about socialism, communism, collectivism—especially in the teeth of unsustainable benefit packages—and immigrants—and the unemployed, but—thanks be to God—the tide is irreversible. Vincent, at last, has his day. If you don't believe it, his last works sold at auction for 50 and 100 million dollars. If only those receipts could have gone to his beloved potato and coal diggers, the latter group in Bertrand Russell's famous couplet: "There are two groups of people in the world—those who move dirt from one place to another—and those who tell them to do it."

So we return to the great evangelical and equity message of the hymns. Vincent writes Theo in letter 64 from Ramsgate, now a one-day swim or a one hour train from Belgium: "One of these days you will receive some English hymnbooks; I shall mark a few poems in them. There are so many beautiful ones, and especially when heard often, one grows so fond of them" (L 64). One cannot help but hear in this, "tell me the old, old story, of Jesus and His love." But Vincent is uneasy, making one wonder whether he might bear in his body something we would now recognize as a congenital or genetic malady that he faced with foreboding, often finding expression in his writing (and perhaps in his frenetic painting), that his life would be short.

Excurses: Did Jesus know beforehand that he would soon die? Vincent is not a Jesus figure and he would object to this phrase sometimes applied to works of art (e.g. Roualt's or Pagliacci's clowns) or today to films. I will conclude this chapter by suggesting (then developing it further in the Arles chapter on the theology of vulnerability) an idea I learned from both Cliff Edwards and Henri Nouwen, that Vincent bore certain marks of what has been addressed in Scripture as a "Suffering Servant." Granted, the evangelists—especially the Synoptics—have Jesus clearly feeling premonitions that he must go to Jerusalem and there be killed as the Messiah who must suffer and die for salvation to ensue. Death, premonitions, even martyrdom, wishes like these are part of the subliminal and accessible consciousness of many people. The mind-set

41

verges on masochism and pathological *todeslieben*. It is also part of our fundamental desire as human beings not to die "in vain" without ever having contributed to God or our fellow humanity. The highest calling of human beings "in God" or "in Christ" or even as a fellow-human is to Love "with all our Soul" which, of course, means "to offer our Life." I interpret Jesus', and even Vincent's, death awareness not as "death wish" in the sense of any of the shallow meanings that the Freudian movement gives to those phenomena, but rather as an assertion of the *joie de vivre*— thanksgiving for the grace of abundant life, that is clearly documented in the words of each. Rather than yearning for death, Jesus pleaded that "this cup (be allowed to) pass from me" (Luke 22:42) and Vincent, according to Irving Stone, knew the same "lust for life."

This world history of anguish becomes Vincent's Diary of God's caring providence amid strife. With a haunting resonance to his own unfolding experience, Vincent writes on the sixth of October from sabbatical in Paris: "I have the Psalms" (the great master Lament/ Praise hymnbook) and "there are some very beautiful English hymns" (Letter 54 [10/6/1875, Paris].)

> Have thine own way Lord
>
> I dare not choose my lot; I would not if I might;
>
> Choose thou for me, my God: So shall I walk aright.
>
> The Kingdom that I seek is Thine, so let the way that leads me be Thine,
>
> Else I must surely stray.
>
> Nearer my God to Thee, Nearer to Thee, E'en though it be a cross, that raiseth me; Still all my song shall be, Nearer, my God, to Thee, Nearer to Thee.

Vincent's dear grand nephew continues in his interstitial commentary to the correspondence: ". . . as Mr. Stokes could not or would not give him any salary he left on July 1 (1876) for the school run by Mr. Jones, a Methodist clergyman." (see Appendix by C. Edwards), for whom Vincent served as a kind of curate. It is in this period of months of evangelical ministry that Vincent seems to be particularly strengthened by the *seelsorge* of English hymnody—the care and cure of the soul.

Vincent goes on in Letters 81 and 82 [5/6/76, Ramsgate]:

. . . by the same mail you will receive the two little books I promised you. I marked a few things in them, but you will find other beautiful ones besides (the town of Ramsgate) has something very peculiar about it (he was home without the castigation)—everywhere you see the influence of the sea—but you know that characteristic, too—finding it in The Hague and Scheveningen.

Here Theo remarks on one hymn that struck his fondness—"I am also fond of "tell me the old, old story." I heard it for the first time in Paris one night in a little church where I often went. I am sorry indeed that I did not hear Moody and Sankey (Moody's song leader/the Bev Shea of his day) when they were in London."

In one of the most famous of her novels, *Adam Bede,* George Eliot describes the life of factory workers who have formed a small community and hold their services in a chapel in Lantern Yard; she calls it the "kingdom of God on earth." There is "something touching about those thousands of people crowding to hear those evangelists" (Letter 82: Ibid).

May 1876—we are in the midst of what history will call the "evangelical revival"—the Second Great Awakening—*Aufklarung*, Enlightenment. The movement now is not associated with the names of Kant and Mill, Jefferson and Franklin, but Wesley and Edwards, Beecher Stowe and Dickens. It is a movement of spiritual and ethical enlightenment—one of equal profundity and transformative power to the secular awakening. It is a movement of social, political, and economic transformation. We think of the 1900 events in Azuma, California, at the time of the great San Francisco earthquake when the Pentecostal movement, today nearly one billion strong, began. Vincent is there at the edges of this enthusiasm— but his inspirational canvasses, eventually esteemed around the world, bring that great awakening—its spiritual heart—its ethical justice—home to human hearts from Capetown to Calgary, Singapore to San Francisco.

Hymns

"I am not worthy," Vincent confessed in the letter of June 17, "If I should find anything, it will probably be a position between a clergyman and missionary among the working people of London" (L 84, [Welwyn, England]). He appears to be moved by hymns like John Newton's "Amazing Grace," and Mary Johnson's "O Zion haste . . . 'publish glad tidings, tidings of peace, tidings of Jesus . . . redemption and release.' " Both were published in

Vincent's lifetime. Many of the late 19th century hymns are about sojourn in the wilderness, stories of trial and temptation—Israel in the desert, Jesus in the wilderness. To Vincent, these were spoken to him in his particular plight and quest. Think of just some of the hymns in the 1876 revision of John Wesley's *Collection of Hymns for use by the People Called Methodists*:

- "Afflicted by a Gracious God, And can it be that I should gain";

- "Guide me, O Thou Great Jehovah, Here, O my Lord, I see Thee Face to Face";

- "I Know not why God's Wondrous Love, Just as I am without one plea, Lead me not into Temptation";

- "Lo, He comes with clouds Descending, My sufferings all to Thee are Known";

- "Rock of Ages, Cleft for Me";

- "Saviour, Again to the Dear Name we raise, Thou Lamb of God, Thou Prince of Peace."

Much of this symphony of hymnody and piety was already known among Protestants on the Continent and even the distinctly Anglo-American material resonates with the European. From this glimpse of hymnody, we catch a picture of how Vincent is processing the anguish and comfort, the judgment and grace, in his soul and in a beckoning toward ministry. From this crucible, he is also fashioning the substance of what that ministry entails. That he allows so much of this inner and theological struggle to infiltrate the artistic, commercial, familial and societal aspects of his life expression, art and word, shows how prominent a factor it is.

The theological transformation found developing in this sojourn and the ministry implanted in England follows this pattern and these modes of being:

- Miner

- Liberator

- Consoler

- Shepherd

- Pilgrim

- Sailor

- Sower

Miner

A favorite hymn of Vincent was the last hymn sung as the Titanic heaved and then sank into the bowels of the North Atlantic some 40 years after his baptism by fire in Auvers. "Nearer my God to Thee" captures the sweet assurance amid acute crisis which surges through Vincent's life. This is the theological essence of his existential discovery. That discovery appears in his being in several dimensions. The initial theological dimension that Vincent fathoms is depth. He is a miner–a subterranean and submariner whose signature scripture is "the people who walk in darkness have seen a great light—to those who dwell in deep darkness the light has shined" (Isaiah 9:2). In (Letter 96 [11/3/'76,Isleworth]), he writes to Theo of the first sermon he was allowed to preach in the town of Richmond: "When I was standing in the pulpit, I felt like somebody who, emerging from a dark cave underground, comes back to the friendly daylight. It is a delightful thought that in the future, wherever I go, I shall preach the Gospel." The heliotropism of his impending career as an artist as he heads for the paradise of light and color in Arles here finds substance. He becomes the bold Icarus—the first bird not only to gaze at the sun but to paint her dazzling radiance which, like *Yahweh Adonai*, God, was not to be looked on and into directly. And this was before the Borinage.

As I write, the world has miners on the mind. A band of fellows find habitation deep in the earth in Chile. Already trapped deep in a mine some weeks and doomed to many more, they take their first food in all that time after having only nutritive tablets and high protein milk. Today, chicken and rice are transported through lengthy tubes, finally able to reach them—Eucharist to be sure. What would Vincent have thought of this, for surely he would have been one with them?

Vincent reflects in Letter 158 (9/24, 1880, Cuesmes):

> . . . the man from the bottom of the abyss, 'de profundis,' (Psa 130, Vulgate), that's the miner, the other one, with a dreamy, almost pensive, almost sleep-walker's air is the weaver.

Darkness and depth in Scripture—*de profundis*—has multiple meanings: It is the deep that calls to deep—God and the depth of the soul—the deeps of abandonment and association—the absence and presence of God. It is the dark places of danger, sin and death. In biblical language, it is the deep well, hole, abyss or chaos. Here are the great devouring beast, Leviathan, the lost and hopeless and those waiting in Limbo to

be led into the light. In Paul's image—this is a "captive-captivity," a triumphal procession led out and onward by the Captain of souls, the One given power over life and death. The dungeon of imprisonment is the fire pit of Gehenna—the furnace of child sacrifice on the "South Beach" of Jerusalem. On Holy Saturday—the epitome of the redemptive journey of the Messiah—the rescuer goes down into the depths—a liberator fish into the monster's lair. Vincent was also intrigued with Saul's (now Paul's) descent into the bowels of Arabia for some years—to fathom the light of the Damascus Road. (*Acts of the Apostles*, ch. 9).

In (L158), Vincent continues: "The miners and the weavers still constitute a race apart from other laborers and artisans . . . I should be very happy if someday I could draw them, so that those unknown . . . would be brought before the eyes of the people. The man from the depth of the abyss, de profundis."

Following the lead of the Psalm—"from the depths I cry to thee"—in this depiction, two images were central in Vincent's consciousness: first, there was Bach's *Christ Lag in Todesbanden*—"Christ lay in the bands and bonds of death"—until "he broke the bonds of death and triumphed o'er the grave." He certainly also knew Wesley's treatment of the same saving journey: "Long my imprisoned spirit lay, fast bound in sin and nature's night, Thine eye diffused a quickening ray, I woke the dungeon flamed with light, my chains fell off, my heart was free, I rose, went forth and followed Thee. Amazing love—how can it be? That Thou my God should die for me."[4]

Wesley also knew the Easter liturgy of the Eastern Church. Here on Holy Saturday, the critical hours of the redemptive process, the "having-died" Christ descended into the chasm of hell—gathered expectant humanity captive in his atoning death, then led—"first humanity triumphant—passed the crystal ports of light and seized eternal youth." The Son of Man/*Yahweh*—triumphed oe'r the grave—and led the victory procession down the victor's Champs Elysée. The conquered now become conquerors over all those principalities and powers—powers of darkness and defeat—all powers (*stoicha/* Colossians) who thought, erroneously, they had had the last word. Roman military metaphors are the most powerful images the Apostle finds to invoke, and the entourage of victory begins its parade with the captain—the lamb that was slain—who now assumes power and Lordship.

4. Charles Wesley, "Amazing Love, How Can it Be?" in *Hymns for the People Called Methodists*, 1780 ed., John Wesley (London: Wesleyan-Methodist Bookroom).

This song of soul and of the human plight and its deep-places rescue also tempered Vincent's view of ministry. Like the proverbial toxic-testing-canary, he volunteered to go down into the coal mines or undertake a seaman's ministry where people drowned or ships capsized. Sea and ship images from Genesis, Job, Jonah, Gospel resurrection, Epistle and Apocalypse now come into play. The seminary where I teach once stood on the cliffs overlooking the Great Lake Michigan. To be a seminarian in those days, you were on vigil day and night (a great excuse not to study: take note, Vincent), ever ready to cast the boats into the surf to rescue the perishing from drowning accidents or capsized ships. To be a pastor in those days, you literally had to be a life-saver. You threw life jackets or crashed the waves to hold up and to transport the imperiled to safety. Even faculty had to learn to swim. Floundering faculty—then and now—had little to offer.

There was also another meaning of the hell-hole. It is captured in the old cliché, "we have met the enemy and it is us." That opaque cave, according to Moses and Jesus, Plato and Marx, Rembrandt and Van Gogh, involved distortions and idolatries of our own making. Art, like life, is either idolatrous and immoral or True and Righteous, but that for another chapter. God often sends us to the rescue of his people from miseries we ourselves have created. Life-savers were to lift out—to lift a thrashing child from the pool—to rebreathe life into—i.e., to resuscitate or to resurrect—to see light where all was swirling, swallowing, down-whirling darkness. Prophets and priests, which Luther reminded us we all are, are those who reach down in order to lift up—to shed light and clarity. They are also to name the whirlwind, for the devouring depths are often of our own making.

Today, as I write, there is an oil rig lying at the bottom of the Gulf of Mexico, gushing oil—dare I say our "black gold"– which has been a fitting image of our own thoughtless greed. Remember this last century of frantic oil exploration and extraction, which began in Vincent's lifetime, began in the mecca of Reformed and Presbyterian faith—Western Pennsylvania—in places like Oil City, Pithole, Slippery Rock. It is in this wonderful region of the earth, rich in history and natural beauty, that we humans have done violence against God's "good earth." In arrogance, we demand something to fuel our easy ride toward depletion and destruction. Remember, it was Max Weber—at the dawn of last century—who suggested that this was the "Protestant way." As a Dutcher/Deutscher, Weber actually celebrated—perhaps prematurely—"the protestant ethic

and the spirit of capitalism." Vincent was warring against that ethos—protesting on behalf of the underground and undersea peoples—the down-under, down-trodden peoples of the world. We must ask today if we are still making a garbage pit of the world—and making it on the backs of the poor.

Is this a pit of our own malevolent making—the hole where the brothers threw Joseph, where Herod threw the Baptist and Caiaphas held Jesus? Here the Church held Bunyan, the Nazis, Bonhoeffer and the Birmingham authorities held Dr. King. Here the powers that be exuded defiant arrogance—thinking they had quenched the Messiah-movement's candle—apprehended the trouble-maker, locked the dungeon and threw away the key. Little did they know.

The God Father, of Jesus and Holy Spirit, of sacred Scripture, prayer, communion and of the entire tableau of Christian liturgy, resists such degradation that harms the human family, which for Calvin was the "Glory of God." Humanity free and fulfilled, he taught, is the Glory of God.

But the prophets, like Vincent, saw in the boiling cauldron of his own being, the incinerating prospects of the incarcerator's excavations. The hell-holes we make for ourselves and for each other are pits of our own making. As we say today in the U.S., on the Mexico-Arizona border, for every 10-foot wall of oppression, God provides an 11-foot ladder. This can be the wall of Arizona's animosity to refugees, apartheid barriers in Israel-Palestine or barbed-wire, cement cages running the spine between East and West Berlin. Even if we descend into hell or flee to the outermost edges, depths and distances of the earth to seek escape, convincing ourselves that there God can't see us or find us, "even there your hand reaches out and upholds me" (Psa 139).

Today we consign God's children to the deep pits of our own evil and injustice. In Congo, women and children are consigned to darkness by our greed and injustice. The prisons are diamonds/tin, tantalum and tungsten and gold to make cell-phones/rubber in King Leopold's colonial amputation of human wholeness/ Nigerian oil.

There are the punctures we make in the crust of the earth, the decapitated mountains of Bob Byrd's West Virginia, the gushing rupture from the floor of the Gulf; the ramshackle residences cons had built in Port au Prince—knowing well they would become tombs; or investment bankers' trick houses of cards on Wall Street—knowing full well that they will inevitably crash—especially on the poor. Then there is the starvation

and degradation in embargoed and bull-dozed Gaza, the sex trade around the world, the disgraceful charade of athletes and their agents to secure the first half billion dollar contract. Their perverse Gospel: "Business is business and the business (*sic* God) of America is business—I have to look out for my family"—Riiiiight! We have sinned and fallen short of the glory of God and there is no health in us. To whom shall we turn?

Against this strenuous indictment, Vincent offers the sweet song of God's approach even in His reproach, forgiveness, repentance, new direction and a new and better world. This is the "lodestone of life" he dredges up from the coal mines of au Charbonnage and Borinage.

On 13th October, from Isleworth, Vincent wrote to Theo: "last Monday I was again at Richmond, and my subject was "He has sent me to preach the Gospel to the poor." But he felt unease: "but whoever wants to preach the GOSPEL must carry it in his own heart first." The liberator sought the "*Libere me*" of the Gospel for himself. Here is where the great hymnody of the church breathed freedom into the soul/life of Vincent and he found strength to go on. He was self effacing in the face of much perplexity, much in the mode of Paul the Apostle or contemporaries like Mother Teresa, Thomas Merton, or Henri Nouwen. Paul phrased the anguish poignantly: "The good I will I cannot do and the wrong I abhor— that's what I do." "O may I find it," cried Vincent.

Consoler

Vincent's trust in God is grounded and buttressed by this devotional literature—especially hymns and poems. Just as art graces and edifies by its shape and color, sacred word engages the mind and soul through text and music. Resonating with the Victorian hymn, "I know not how your wondrous love to me has been made known, but I know whom I have believed," Vincent quotes the Dutch hymn—"*Ik weet an wien ik mij vertrouwe*"—"I know to whom I commit myself; Though day and night come and go, I know the rock on which I build, who oversees my salvation will never fail" (Letter 94: Ibid.). This is devotional, evangelical theology—impressive and expressive—inner and outer—grounding and animating ministry—word and sacrament—conception and art. Inner strength compels publication out into the world—to every last and least person and creature. Trust requires proclamation.

And that proclamation is "redemption and release to the captives." My teacher at Princeton—Richard Shaull—long-time missionary to Latin America—taught us that "God is acting redemptively in history to liberate the oppressed" (*Heralds of a New Reformation*, Orbis, 1985, p.6).

Long before Barth and Bonhoeffer, Cone, and Reuther and their protégée train in Europe and America, Asia, Africa and South America, Vincent knew this was the God of Scripture and song.

Shepherd

The God we know in Christ is Father and Shepherd. These are rather unique characterizations in the history of God and the history of faith, and even in the Abrahamic tradition of Jew, Christian and Muslim, though present in all these attributes, they find special concentration in Christianity. They rise especially in Scripture and sacred song. Psalm 23 stands in a central place:

> "My shepherd, Jehovah is his Name, He leadeth Me, O Blessed Thought, My Shepherd will supply my Need, My Shepherd is the Living Lord.

Vincent saw himself in ministry as a sub-shepherd. " I stand here, far below in the misery, but I strive for the Love of Christ and the Care of God—The Lord is thy Keeper, He is thy shade on thy right hand—and then in shades of Arles and Starry Night—the sun shall not smite Thee by day or the moon by Night." (Ref. Letter 82 [10/2-8,'76, Ilseworth]).

Van Gogh was chastened by his fellow artists for trying to paint the sun, moon and stars–these radiant scorchers were out of bounds, both by reason of their inherent divinity and their awesome threat. Both notions were rejected by Vincent, following his mentor, Francis of Assisi, for whom they were brother/sister congregants (to be preached to), as well as fellow ministers.

Pilgrim

The final set of modes of being and ministry—those which ultimately shape his life and death choices—are those of Pilgrim, Servant and Sailor. The only sermon on the permanent record blends these three models of ministry into one where God is a pioneer, pathfinder—*Yahweh*—perceived

obliquely by Moses as the one who leads out—"I am that am or I will be whom I will be." (Exo 3:14).

His biographical and hoped for destiny is capsulated in the message which is headlined by Psalm 119:19: "I am a stranger on the earth, hide not thy commandments from me." Here, his reading is John Bunyan's *Pilgrims Progress* and the hymn is "Guide me, o Thou great Jehovah—Pilgrim through this Barren Land."

A second-century writer, Diognetus, writes a tribute to Christians which could well apply to Vincent:

> There is something extraordinary about their lives. They live in their own countries as though they were only passing through. They play the full role of citizens but labor under all the disabilities of aliens. Any country can be their homeland, wherever it may be, is a foreign country. They pass their days upon earth but they are citizens of heaven. Obedient to the laws, they yet live on a level that transcends the law. Christians love all men but all men persecute them. Condemned because they are not understood, they are put to death but raised to life again. They live in poverty but enrich many. They are totally destitute but possess an abundance of everything. They suffer dishonor, but that is their glory.

> Stephanus, Paris, 1592

Vincent continues in this sermon written when he was 23 years old:

> We are pilgrims on the earth and strangers—we come from afar and are going far. We are not what we once were, we shall not remain what we are now. What must we do? We must love God with all our strength, with all our might, with all our soul (our life), we must love our neighbors as ourselves. (L 96 [11/3 '76, Ilseworth]).

The most basic virtue to fortify a ministry is pilgrim *askesis*. This ascetic purity—sometimes called holiness—is a quality of being that enables one to be unaffected by praise or castigation, abundance or destitution, health or distress, ambition or depression. The Beatitudes and the Sermon on the Mount depict the state of being as Vincent conceived it as a moral freedom, an abandon from the cares and frustrations of the world. Look at the *Water Lilies* Monet must have often pondered—they toil not or spin—but your father cares for each of them (Matt 6:28). This ethical stance allows us to be free to live concerned but unperturbed. As

a pastor, one must be free to speak the truth rather than being obsequious and pandering, which is the ultimate offense to one's parishioners. A chief complaint against Vincent by church authorities was that he was not politic, condescending, conventionally polite, and full of flattery. Only pilgrims together can escape these insidious and so very harmful pleasantries.

Sailor

Vincent's sermon finishes by moving from pilgrim to sailor. What else would one expect from a Venetian or an Amsterdammer? His New Testament text is John 7:17–21. The literature that comes to mind might well be Melville's *Moby Dick*; the Art—Delacroix, *The Storm on the Sea of Galilee*. The hymn perhaps might be "Be Still my Soul," but more probably Mary Baker's 1874 masterpiece that was sung around the U.S. when President Garfield was assassinated:

> Master the tempest is raging, the billows are tossing high, the sky is o'er shadowed with blackness, no shelter or help is nigh.
>
> carest thou not that we perish, how cans't thou lie asleep? When each moment so madly is threatening, a grave in the angry deep.
>
> The winds and the waves shall obey thy will, peace be still, peace be still.
>
> Whether the wrath of the storm-tossed sea, or demons or men or whatever it be, no waters can swallow the ship where lies
>
> The Master of ocean and earth and sky. They shall all quickly obey his will, peace be still.

Vincent's sermon is a masterful, personal-biographical, anticipatory, already- troubled, deeply biblical and trustful Lecture—as Calvinists call sermons:

> Have we not often felt as a widow, an orphan . . . truly our soul waiteth for Thee more that they that watch for the morning . . . We have spoken of the storms on the journey of life, now let us speak of the calms and joys of life . . . The heart has its storms, its seasons of drooping but also its calms and even its times of exaultation." (L 96).

The stage is set. A ministry has been tasted and tested. Storms will come—especially in the Borinage. The media of ministry will shift. But the turbulence and the tranquility will continue—and the still peace.

Vincent may have known Father John Henry Newman's prayer which made its way into all of the prayer books—composed in his own times. It reflects the *joie de vivre* and ardor of the earnest young years in England. It journeys through the turbulent passages of his coming years of learning and accommodation. It anticipates the anguish of that last decade and end—which was mystery:

> Lord, support us all the day long,
>
> Until the shadows lengthen and the busy world is hushed
>
> And the fever of life is over and our work is done
>
> Then in thy mercy, grant us safe lodging
>
> And eternal rest
>
> And peace at the last, Through Jesus Christ, our Lord. Amen.

2

Amsterdam

CONFRONTING AN IMPLACABLE DUTCH CALVINIST THEOLOGY

After opening this study in England—even seeing life-determining influence in the piety, theology and worship of that sister land in faith—we need to remind ourselves that Vincent was first and foremost a "Dutchman"—an identity which becomes more and more clear as we study his struggle to become a Dutch-Reformed Pastor and as he achieves remarkable success as an artisan-minister in that broader Christian and Interfaith tradition in the lowlands of northern Europe.

Vincent had to move out as an exile and missionary before he could realize the more cosmopolitan and co-mingled (Religion-Art) ministry back home. Indeed, in the end, he and Theo die and are buried abroad.

That he is *Nederlandisch* in ethos, through and through, to use the designation of Pieter Brueghel, the early master of the Antwerp Academy, is difficult for this author to comprehend and grasp—acculturated as he is in more southern and Western traditions. My esteem for the Dutch heritage is very great—especially in our modern quest for international learning and global justice.

From the solid rock of his provincial and extended family in the environments of Amsterdam, Vincent found strength to sojourn out to: 1) England for inspiration in ministry; 2) Belgium for brilliant artistic culture (Antwerp); and for the missionary-evangelical option of service (Borinage); 3) France (Paris, Arles and Auvers) for her virtuosity and

vibrant trade center of art, for evocative warmth to open up to art so as to discover its prerequisite passion; and finally 4) to his Jerusalem.

Back home in the regions of Amsterdam, he always carried Belgium, France and especially England with him. He actually remained involved in the English Church and its mission to which he would belong in heart and soul to his dying day—given her early recognition of his gifts and ministry. In Amsterdam, he attended the English Reformed Church in Begijnhof (now run by DRC and the sister-Reformed Church of Scotland). He also taught at Zion's Chapel for the propagation of the Gospel among Jews—a decision I wonder whether he regretted in his later years, given Amsterdam's historic receptivity to that community with their offer of refuge and sanctuary in earlier centuries, and the fact of the protection she would again offer 70 years hence in the Nazi occupation.

Toward the end of his short and turbulent life, he seems to have become a more interfaith figure. In one self portrait (1887), he is dressed as a Buddhist monk and Zen master. Even early in his days as a budding theologian, he showed tendencies of being interfaith-sensitive as well as a naturalist and universalist on the theme of soteriology (salvation theology). All persons and all nature were part of the divine panorama and work of the Spirit in the world. Conversion of the Jews would be awkward, we might think, although Vincent well might have shared the intense belief found in Luther and earlier medieval, Patristic and perhaps apostolic faith that the conversion of the Jews (and Muslims) was prerequisite to the return of Christ.

Studies for Ministry

The introductory note in the correspondence is telling: (written by editor-nephew Vincent)?

> Vincent's wish had now been fulfilled—he was to begin studying theology; but in order to be admitted to the university he had first to pass a State examination which required at least two years' preparatory study. The whole family was inclined to assist the young man in his plans.
>
> . . . He began full of courage—but Father and Mother anxiously questioned whether one who had never been used to regular study could acquire the habit in his 24th year. He struggled with Latin and Greek exercises for a whole year. At last it became too much for him; he longed for more practical

work. In the summer of '78 he gave up studying in Amsterdam, with his parents' permission, and returned to the parsonage in Etten (Vol. 1, *Complete Letters*, Bullfinch edition, 1958, p.115).

The quest to become a licensed, learned minister of the State Church was over. But the ministry was just beginning. What do I mean? From his youth, Vincent felt that ministry was a gift that embraced both religion and art. In his first letter to Theo from Amsterdam, when he begins to prepare for religious orders, he claims that we must all hold onto the faith of our ancestors : "the faith of old"—exemplified in Pa (clergy), uncle Jan and uncle Cor—(Navy and art) and Rembrandt and Millet (artists)— (Letter 114[5/19/77, Amsterdam]). Still the religious options for Vincent are closing out, which makes all the more startling my claim that he is among the most important Dutch religious faith exemplars of the 19th century.

My reflection: My first parish assignment was as a Church of Scotland (a State Church), student minister, serving in Mussleburgh Parish out along the coast, East of Edinburgh. I was the head pastor serving two schooner ships alongside the great mother-vessel (as the Bishop, Sidney Adamson would have it), Whitecraig, a small town, and Smeaton, a tiny coal-mining village of 13 "souls"—three of whom (teens) were killed in an auto crash in my third week on the job—my terrible baptism by fire!

I was struggling with Greek, just starting Hebrew and had yet to begin the ordeal with Latin verbs—which I would undertake only later when I began the Theol. Dr. under Helmut Thielicke—in the Lutheran State Faculty in Hamburg, Germany. The Hamburg *Hochhaus*—the academic center was only a bird's flight away from Amsterdam—is where Vincent would collapse under the strain of too little "*sitzfleisch*" to stay on the books while his eye and mind yearned to wander out into the fields with his easel and satchel rather than sit tight and master those Greek verbs.

In my now 50-year experience in ministry—spent mostly in the more voluntaristic ethos of American Presbyterianism (Reformed) and Methodism—I find that there are two styles or modes of ministry. One is that of a "learned teaching-Elders," academic professors and preachers at the "High Steeples." The other is the more "hands-on" parish pastor— often pedagogues, catechists, missionaries and deacons—who relish the daily life, sorrows and joys of a given congregation. Vincent almost made it into this latter company. In Calvin's Church Order—followed in the

Church of Scotland, Dutch Reformed and other Calvinist churches of the 16th century—offices in the ministry, limited to persons of intense study of the Word and of "purity of life," (Vincent may have had some issues here) included Superintendents (Bishops), Ministers of Word and Sacraments (Baptism and Lord's Supper), scholars and teachers and Deacons.

Most of us in group two ("learned pastors" and Rabbis, some now with six-figure salaries), and even a good portion of us in group one, finessed our way through the labyrinth of languages, the intricacies of philosophy and theology and the time lines and charts of history. In Calvin's nomenclature, Vincent probably was at home in the pedagogical and diaconal role but somewhat uncomfortable in the ministries of preaching and presiding at the sacraments. If reports from the Borinage bear any truth, he was not polished, smooth and political but rather brash and offensive—perhaps like Wyclif, Hus, Luther, Calvin, Edwards and America's modern day Jeremiah Wright.

On a totally different theme, as time went on, he also seemed uncomfortable with the matters of chastity and fidelity, which we will address in the Appendix on "Vincent and Sexuality."

When I preach or teach in the local church today, I mention these two callings and which in my mind has the priority. Here is what I say: "Jonathan Edwards . . . was a preeminent philosopher/theologian who was pastor at the Northhampton Puritan Congregation. He became alienated and was shipped to the Vermont border as an evangelist/pastor to the Native American community. When this also failed, he was called to what was the ultimate comedown for the preacher/pastor—an academic post—a teacher and President of the College of New Jersey—Princeton University."

Vincent was likely a type-two minister, one, who in the medieval Church of England, or even the Roman Catholic Church of Europe or the Russian Orthodox Church, might be placed in a rural parish—even though—unlike Vincent, he was linguistically and theologically illiterate. Here Vincent would have served away good years of service, loving his congregation, in Arles or the Borinage, perhaps collecting butterflies, observing the stars or painting the weary souls, struggling to wrest their bread from the earth, baptizing, catechizing and eulogizing generation after generation until he or she, like the forbearers, was joined to the ancestors in the cool brown earth, which was the ground of Vincent's very being. Like many such pastors, he might even have become a great scientist—Boyle, Mendel and Darwin; artist—George Herbert, Vaughn

Williams, Van Gogh; Musician—Palestrina or Vivaldi, or a writer or phi-lanthropist. One wonders whether such a path was open to Vincent or his sponsors and family, or whether a time-bomb was ticking in his mind, soul and body—one which could only be lived out as a driven, manic painter who would pass from this resplendent world at age 37, taking his life-saving little brother with him, only age 34.

Speculation aside—tempting as it is—let us now visit his youth, fam-ily, parsonage and other formative influences on his sense of ministry, in and around Amsterdam, to locate his unfolding call, if only to watch him come home limping and discouraged, after years of futile preparation.

In his diary at this point, he dwells on how hard theology is. He la-ments the ordeal—somewhat like his contemporary, Goethe's Faust, who wailed

> *Ich hab meine ganze leben studiert—philosophie, juriste, medi-cine—und leider—ach—theologie!*

Vincent invokes Scripture. He prays with Isaiah 35:3: "Lift up the hands which hang down, and the feeble knees."

> "My head is sometimes heavy, and often it burns and my thoughts are confused—I don't see how I shall ever get that difficult and extensive study into it" (Letter 117 [5/30/'77, Amsterdam]).

Vincent—and his family—knew that in each generation over cen-turies, one was raised up to wear the mantle of ministry (Letter 109 [3/23/'77, Dordrecht]). Though this designee might have been the first Vincent, who died in infancy, now this irascible replacement son, this one born out of season (Paul, the Apostle?) was to be raised as a "preach-er of the Gospel" in the Van Gogh lineage. His early piety and strenuous ascetic, even masochistic, dedication pursued this calling and commit-ment. We might assume that family resources would be marshaled to this end. He would have been trained with the necessary tools of the trade and his university studies would be underwritten through the resources of family and State.

What went wrong? In the reading of this observer, personality considerations, family poverty and other circumstances intervened and introduced certain impediments in the hoped-for life course. Ultimately, another array of gifts and passions, another *zeitgeist* of human need and sensibilities and another course of circumstances would present them-selves and pave the way for another calling. Cliff Edwards calls this *kairos*

moment the "conversion to Painting."[1] I see religion and art forming a synergic ministry.

Calvin's Theology

There are three movements in Calvin's theology which explain this circuitous course of providence as it pertained to Vincent's calling: 1) Renaissance and Reformation refreshment which includes the replacement of the ministry of Sacrament with the ministry of the Word; 2) the stultification of Protestant Orthodoxy; and 3) the new mood of global awareness. Vincent was thwarted by movement two.

In the 1536 edition of the *Institutes of the Christian Religion*, completed while he was minister in the French congregation in Strasbourg, Calvin, a Renaissance figure like Erasmus, reflected on the Church and the ministry. "The whole multitude of Christians, joined together by the blessing of faith, and assembled to be one people over whom the Lord Jesus is to be Prince and Captain, united into one body of which Christ is the head . . . through the ministers to whom he has entrusted this Pastoral office (to nourish and sustain life) and has conferred the grace to carry it out" (iv: 3. 1, 2). But such pristine Renaissance Calvinism was short-lived and was soon encumbered—as was the early church—by stifling organization and moribund theology.

Part of the crisis as it pertains to Vincent is the shift from sacrament to sheer word. Now biblical exegesis and exposition becomes the focal act of the ministry. The preacher must know Greek and Hebrew to read Scripture in its original tongue.

Strasbourg was filled with refugees from religious persecution throughout Europe. John Knox was there from Scotland, and multitudes of Huguenots streamed in from France. Banking and commerce, business and trade, were all thriving along the Rhine from Basel, through Strasbourg, up through France and Germany into Holland. Though purged from most of Europe, except eventually Holland, Jewish merchants and bankers thrived, and the crusades against the Muslims had burned out. On the great boats of Columbus, Drake and Magellan, precious cargo to the new world would soon include armies, priests and merchants.

Given this internal and external threat to the pure faith, vital Catholicism and Protestantism would soon lose the spontaneous *joie de vivre*

1. Cliff Edwards, *The Shoes of Van Gogh* (New York: Crossroads, 2004), 17.

and become hardened systems and go on the defensive. The Dutch went out to the Far East and to New Amsterdam. Lines and distinctions were drawn clearly at Trent and Augsburg, London and Edinburgh. Westminster Confessions were formulated by the Puritans in the 17th and 18th centuries following myriad Synods from Dort to the Westminster assemblies. Protestant Orthodoxy—a "system of doctrine"—would become a defensive theological movement which emerged within this time frame. These systems of mathematical and "propositional truth" sought to preserve truths which are seen to be threatened and combat certain dangers seen coming from without. It is a mood which lacks adventure and tends to eject the original and creative. Vincent fell into the negativities of this "circling the wagons" retraction, even though his calling was well within the parameters of original biblical-humanistic Calvinism.

As a seminarian at Princeton, I earned 500 dollars, that term's tuition, memorizing the Westminster "Shorter" Catechism (1647)—a leading carrot to this latter-day, would-be Puritan Divine.

The ministry, vis-à-vis Calvin, has one raison d'être—that is to further the Kingdom through the far reaches of the diverse peoples all over the earth. Through Word and Sacrament,—i.e., the thought, expression, elucidation and art of ministry—all given in the call (prompting) of God and in the need and reception of people—peoples of all ages are drawn into the company of the Kingdom of God.

Through member traditions in this overarching Spirit, Reformed churches were planted throughout the world from Switzerland to Holland, from East Anglia to Hungary, and eventually to Korea and South Africa. Vincent would be called to ministry within this particular ethos with roots in Holland and England and branches extending into France, Asia and America. But within the stultifying ecclesiology, oppressive theology, and absent eschatology of this strain of Protestant Orthodoxy, he would be denied a place.

Today, although the church appears to be in terminal coma in the cultures of Holland, Belgium, England and France, there are stirrings of renewal—perhaps inspired, in part, by the ministry of Vincent Van Gogh. Holland, through the *Nazizeit*, was a bastion against sick Nordic theology, especially with its Manichean penchant to demonize dark forces, say the Jews, with Denmark and southern France becoming protectors of this persecuted community ever threatened with extermination. *Judentum* was thought to be antichrist then and in certain other periods of theological history. Now we are more prone to think of church hierarchy and

bureaucracy representing antichrist. Holland now leads the nations of the world in advocating the rights and welfare of the poor nations and the Kingdom *Anawim*—weak ones like the blind, lame, crippled and poor at Jesus' table in Luke 14. Meanwhile, nations like the U.S. and China offer scant concern and help—at least as percent of public welfare funding per capita.

Dutch Reformed Theology in the 19th Century

One of these issues, which seem to have worked against Vincent, was the so-called distinctiveness and decency/orderliness of ministers. Calvin wrote—"The Church is the common mother of all the godly, which bears, nourishes, and brings up children to God, kings and peasants alike; and this is done by the ministry" (*Institutes*, Book IV, p.1015, *Commentary on Letter to Ephesians*). One can easily see the power of this notion and its danger. On the one hand, the democratic impulse—"kings and peasants" is impressive—certainly commends Vincent to our attention with his concern for the wretched, poor and vulnerable. On the other hand, the dignity and distinction of the clergy from common and working people can be seen as working against him. He is like the substitute Vicar Smallwood in Peter Seller's film, *Heavens Above!*, who opens the vicarage in the upscale village to the down and out, the unemployed, thieves, rascals and other riff-raff, until the bishops have to send him packing on an extraordinary ministry into outer space.

Vincent was aware of the long ecclesiological tradition where the prophet's mission was repudiated by the authorities and where the unsettlers of the status quo were summarily dismissed, if not banished:

> I must tell you that with evangelists it is the same as with artists.
> There is an old academic school, often detestable, tyrannical, the
> accumulation of horrors, men who wear a cuirass, a steel armor,
> of prejudices and conventions; when these people are in charge
> of affairs, they dispose of positions, and by a system of red tape
> they try to keep their protégées in their places and to exclude the
> other man (Letter 155[6/24/'80, Cuesmes-Borinage).

My thesis and diagnosis at this theological point is the same as that of the three leading religious scholars of Van Gogh in the English language—Cliff Edwards, Kathleen Powers Erickson and Henri Nouwen. This was an idiosyncratic moment in the Reformed (Calvinist) tradition,

meeting up with a peculiarly idiosyncratic Vincent Van Gogh, which led to severely distorted perceptions, grievous decisions and the fatal expulsion.

The phase of Calvinism which did him in was one of Protestant Orthodoxy verging on fundamentalism. Most of the theological commentators, at least in America and Britain, who try to decipher Vincent's "problem" see him becoming a pantheist, pagan, or Buddhist transcendentalist. In our view, Vincent was well within the parameters of the biblical- Calvinist heritage.

Fundamentalists and PO's reduce Calvin's very biblical thought to the acronym called TULIP—Total Depravity, Unconditional Election, Limited Atonement, Irresistible Grace and Perseverance of the Saints. While this variant is found in some of the heartland of the tradition—among the Puritans, Jonathan Edwards and even much of contemporary mainline evangelicalism—this view and conviction does not accord with the main heritage of the Calvin reformation.

There are several preliminary questions which this interpretation of Vincent Van Gogh begs. Was his family life and upbringing really within the theological system I label Protestant orthodoxy or was his heritage of home, parish and school already more progressive? Secondly, was his warm reception in, and welcoming from, the Methodists and Congregationalists in England already indicative of some Armenian influence? And what of what one author calls his entanglement in "the Groningen branch of the church" and Theo's wife Johanna's suggestion that he was steeped in the substance and ethos of the Walloon Protestant church—(*La Confession de foi des églises reformées Walonnes et Flammandes*, c.1580). This was the heritage of his immediate ancestors in the late 18th century; that persuasion perhaps came to the surface again when he went to work in the Borinage.

First, there seem to be deep tensions between the generation of his parents and Vincent himself. The tension with the father—a love-hate affair—is evident through the correspondence. The sense we have from the sisters, brother and mother is more conflicted. There is much affirmation of his struggle in the correspondence of Theo and the sisters—Wil in particular. We eagerly await Cliff Edwards' study on the Vincent/Wil correspondence. From his mother, we get a disturbing signal. Vincent seems to feel from her also a rejection of his faith formulation and his choice of relational styles—even his art commitments. There is no "my son, the preacher, or my son, the football player." In the area of personal

relations, there is a palpably deep rift. There is horror about Kee, Sien, the rumors about the woman found pregnant who appears in the potato eaters, and the girlfriend in Arles. But on faith we are puzzled. His love of God and the neighbor are compelling—perhaps to the point of offense. In Vincent's words: "Ma is unable to understand that painting is a faith; It 'makes a mock of the holy trinity of duty, fashion and solidity.'"[2] He caricatures her faith as she seemed to have done his.

Second—so what of the Calvinist TULIP? Is orthodoxy thicker that blood for mother as well as father?

As far as we know, Vincent never painted a vase of tulips—perhaps a hint at his attitude. Numerous commentators on Vincent's theology and ministry, even myself, to some extent, feel that he was repudiating a TU-LIP kind of Calvinism and was actually affirming a more liberal, vision-ary, revisionist—or as is my penchant—a more classical form of natural law Calvinism. Others see him way over the top and already imbibing the Pagan liqueurs of Pelagianism, Arminianism, protocommunism, Tahiti-Totem worship, Buddhism or worse.

TULIP may be the standard orthodoxy of Wheaton College, Trin-ity Evangelical and Gordon-Conwell Seminary. It is very close to the Christian Reformed Church in America (Calvin College). A quite vital kind of protest-orthodox Calvinism is found in some of the conservative offshoots of American Presbyterianism—e.g. "the Orthodox Presbyte-rian Church" and some portions of the Korean Presbyterian church. The tenor of thought and way of life is quite distant, however, from today's Dutch Reformed Church in Holland and Belgium, the Reformed Church in America, Hope College, the New Brunswick Reformed Seminary, near Princeton in New Jersey, and the Dutch Reformed traditions of South Africa, along with the vast array of Reformed and Presbyterian churches around the world.

TULIP is a body of doctrine which contends that Scripture contains a "Body of Doctrine" and that "system" can be read as what Protestant Orthodoxy formulated in the 16th, 17th, and 18th centuries. It is a philo-sophically coherent and consistent theological system—perhaps to be compared with Cardinal John Henry Newman's rendering of Thomistic Catholicism or Benjamin Warfield's or Gresham Machen's rendering of Protestant scholasticism. The lead theme is anthropology—one which argues that sin is an unremovable taint on the human soul which renders

2. Wessels, *A Kind of Bible*, 19.

impotent any kind of faith/works synergy in the way of righteousness, nearly rejecting all forms of Anglicanism, Lutheranism, Eastern Orthodoxy, Wesleyanism, Roman Catholicism—and certainly Judaism and Islam. The view largely transforms Hebrew Scripture, the Gospels and Paul, even the Apocalypse, into a throw-forward which lands somewhere between Bishop Usher, Darby, Schofield and founding Fuller Seminary President Harold Ockenga into an 18th century kind of Protestant Scholasticism. The system finds broad acceptance in the radio and TV evangelists, the Independent Bible churches, Presbyterian and Baptist Orthodox churches and Fox News constituencies.

The system of Doctrine takes the born-again, conversionist strain of Protest piety and ignores the parish doctrines of the priesthood of all believers, infant baptism and "wheat and tares together sown until endtime" doctrines of Luther, Calvin, Cramner, Zwingli, Bucer, Knox and other Reformers. Atonement is offered (successfully) to only a rather select company and grace can only grab *you* and not you *it*—you are helpless to take or make it. The Grace/Works synergy of the biblical tradition is completely suppressed, especially in the corporate dimensions, into an individuality and subjectivity. The radical universality of the righteousness offer and the clear and compelling vitality, viability and accessibility of the Torah is negated. Perseverance displaces provenience so that if you're in, you're in and if you're out—too bad.

Vincent was stricken with the crazy Jesus notion that "prostitutes go into the Kingdom before . . ." and that those whom the Protestant Ethos (Weber) extolled—the prosperous and elect—seemed lost, and the derelict, wretched of the earth were undeniably God's children and Christ's *companiera*. One commentator from a TULIP orientation found Van Gogh's painting disorderly and "chaotic." In light of an air-tight system like TULIP, much abstract and impressionistic art, even post-impressionism, likely portrays a disheveled and unredeemed soul.

That's the issue! When Rothko (who also [actually] took his own life—surely proof of his reprobation) spoke of modern art, he said that depiction of the sacred could no longer be literal and positive in precision (photographic). Could it be possible that Vincent's work is not "chaotic" but abstract—even mythic (simulative of genuine truth and beauty) and therefore, not chaos but more highly ordered than perhaps a carbon dated, singed shroud of Turin or a splinter of the Ark? In the same way, Protestant orthodoxy and scholasticism lacks theological depth and power. Vincent knew this but was too vulnerable to resist the onslaught of

the God-squad. Friends and fellow ministers should have sponsored this great soul and carried him through to efficacious vocation. In the end, only the "Man of Sorrows," perhaps in the depiction of Georges Rouault, transported his ministry through to amazing achievement—in the same restricted time allotment of his Lord, three decades.

Reprise of Theological History That Formed the Church in the Lowlands

Vincent's *muttersprache*, birth ethos and formative culture was in the Netherlands. The significant years in the Brabant, The Hague, Drenthe, Neunen and Etten—we subsume under the rubric of Amsterdam. In The Hague—where he often escaped to a kind of second home—he worked with and learned from young painters with Mauve. Here, he studied peasants and weavers—here he learned *Potato Eaters*. Here, in 1880, he resolved to become an artist. Here the relationship with Sien occurred— the sick prostitute who gave the family so much grief—and Vincent so much *Sorgen*, deep and abiding care. Though his body lies in Paris, his soul and abiding presence hovers here in Holland from where it radiates around the world.

Vincent is born into the Zundert parsonage 300 years after great church turmoil in the Netherlands and Belgium. Spain had occupied these lands and was seeking to eradicate any signs of the Luther/Calvin "heresy." Intrigues run across the English Channel, because it was here to the Lowlands that evangelicals fled for protection, forming a London community of exiles. Decades before (1526-36), English evangelical William Tyndale had translated his portions of Scripture, printed his first English Bible in Germany and was finally apprehended in Antwerp, where he was translating the prophets, but not before he had shipped the revolutionary document secretly through Protestant merchants back to London, Cambridge and East Anglia where the Puritan revolution was thriving. Following the French Confession of 1559 (at the time of St Bartholomew's massacre), the Belgic Confession articulated evangelical-Protestant values—sola scriptura, sola fide (faith through grace alone, not works), new birth and the evangelical virtues and values of freedom of religion and conscience, political democracy and religious diversity.

In the lowlands, these Protestants faced the fiercest persecution the church had yet faced, through sword and flame, with more persons

killed than that which occurred in the primitive church under the Roman Empire. From evangelical beginnings in the 1520's, the martyr's church grew until the new faith was formalized in the Synods of Antwerp (1566), Wesel (1571), and Dort (1574).

After adding the Heidelberg catechism and canons (cf. Schleiermacher), these became the standards of evangelical religious orthodoxy in the lowlands from 1619 until today in the Reformed (Calvinist) communions of Holland, Belgium and America. Here, not coincidentally, are the receptive seedbeds for Vincent's theology, art and ministry—even today.

Schleiermacher and Van Gogh

Steeped in this broad and deep heritage, Vincent experienced another naturalistic revival much in accord with the world view of the Puritans and Calvinists, and this can be seen through the influence of Friedrich Schleiermacher. Ann Murray writes: "Van Gogh's reverence for nature as the one place where he might experience God . . . was conditioned by his religious background. Van Gogh was not reared according to the strict Calvinist creed of the Dutch Reformed Church but according to the moderate Groningen branch. By the early 1880's, he had turned to nature as his sole source of spiritual fulfillment, with ideas derivative from Friedrich Schleiermacher (1768–1834), who is credited with introducing Romantic thought into theology."[3]

Overdrawn—but on target. I sat one of my doctoral oral exams on Schleiermacher's *Weinachtsreden*. This intriguing text is set at a Christmas dinner as family become interlocutors about the grand and mysterious dimensions of the Christian faith. Schleiermacher's wonderfully original theology—Enlightenment, Reformed (Calvinist) and Natural—is exposited in a profound memorial symposium. Resonant with the Groningen School of thought, the observer feels the concourse of reflection moving into theological depths where the colors and vibrancies of the natural world—which is the "Theatre of God's Glory" (Calvin)—are revered and celebrated. This heritage is part of Vincent's nurture but it, regrettably, was not enough to counter the more prevalent Protestant scholasticism and fundamentalist Orthodoxy that would bring him down.

3. Ann H. Murray, "The Religious Views of Vincent Van Gogh and its Relation to his views on Nature and Art," *Journal of the AAR*, 1978, XLVI (1):66.

My own interpretation of Vincent's theology was that he remained thoroughly evangelical and Reformed in the tradition of the biblical Calvin but not it terms of Protestant Orthodoxy or fundamentalism. During a close look at the scrutiny leveled at him, it was not theology at all that was the criterion of rejection but more conventional manners, decorum and appearances. He was probably admonished in private about what so many occupations offer today in place of genuine integrity and ethics— "avoid the appearance of impropriety—and go ahead and do what is expedient, undercover."

He was not a roaring mystic or pantheist. He was not an Enlightenment Liberal but rather a pious and evangelical lad. He also labored under some syndrome of deprecating and flagellating self-esteem. Pulpit committees want to see a sense of confidence, which, of course, comes easier to the ignorant, parochial, and self-deceived. A "sound mind in a beautiful body" will insure your installation and insulation at First Church, i.e. "the best one in town." All of this was exacerbated by gnawing poverty in professions (ministry and art) which required at least moderate resources—usually from some patron. Theo attempted such sponsorship but he was underwater himself. Today, at my seminary, students graduate with an average of a $70,000 debt with the promise of only $30,000 in salary from their first job.

I subscribe to the thesis forwarded by Cliff Edwards, Henri Nouwen, and others—especially European and Asian protégées and scholars of Van Gogh: that Vincent was a pioneer on the religious and philosophical frontier moving toward an "Interfaith Faith" or a new "Faith beyond Faiths" or "Universal Faith." Though his deep anthropological insight and his theological vision begin in a pietistic and somewhat repressive Calvinist heritage in Northern Europe, he arrives at a new vista of "Natural Theology" where art and faith, ethics and hope coalesce into a new philosophy of life. The heart of that new vista is a fresh insight into an ancient wisdom which sees God as One who suffers gladly and helpfully for the poor and vulnerable of the world—"the least of these." The great "Transcendentals"—the loci of all Religion and Art—Truth, Good and Beauty—are advanced into world cultural history in his short and seemingly tragic 37-year lifespan.

Despite this, from even the short retrospective of 130 years, we see clearly the shaft of "White Light" and the glimpse of the "High God" that he, in all his poverty and suffering, was able to see more than all of his generation. To borrow a tribute paid him from the world of art

history—he saw light and color as it had never been seen before. To this author, Vincent was able to discern the *"Visio Dei"* that his neighbor, Martin Buber, would describe poignantly and painfully, 50 years later, in *The Prophetic Faith* (Harper Torchbooks, 1949). Here, from the same frightening historical milieu, we see "the God of the Sufferers" reaching out into the affliction of humanity, the "Despised" coming to the world's "Despicable" as One Human and Divinely appointed *Ebed Yahweh*—Suffering Servant—bringing peace and the Song of *Limmud* (toiling deliverer/man of sorrows) to earth's distant shores. This mood also resonates with the Indoeuropean and Buddhist "love force" of *Satyagraha*.

I will develop this *Akedic* (Suffering Servant/"man of sorrows") aspect of Vincent's theology in the next section on his evangelistic endeavors in the coal-mines deep in the Walloon regions of Belgium. Here we can reflect on his rejection, revision, and re-appropriation of Reformed (Calvinist) faith, which both art and religious commentators find as the essence of Vincent's mission and lasting contribution. The new faith borne into the world through his agony and ecstasy follows these contours:

Edwards distills the move—"Vincent suddenly and unexpectedly broke away from the narrow path of religious exclusivity (Calvinist election?) and described a new path that saw not threatening distraction but strength in "loving many things."[4] Drawing his temporary theological exuberance and excitement achieved in England, into the present trying study program in Amsterdam, Edwards sees "His practical experience in England contrasted with a year of cold, academic plodding exploding in a new confidence, a faith in love, work, and the wisdom of the ordinary."

His discovery, suggest countless critics, is less about art and anthropology and more about theology and ministry. This spiritual and ethical transformation will, in turn, affect a cultural and artistic revolution. As one young musician, who calls on us, as my son and I sit on our porch discussing this book, comments, "The striking impact of the companion exhibit[5] was the unique originality, insight, and power" of Vincent's rendition of the chair, flower vase, bedroom in Arles, starry night, etc. Casting off the contorting religious cataracts, he now sees light and color, persons and actions, in new beatific (theological) and beatitudinal (ethical) vision.

4. Edwards, *Van Gogh and God*, 34.
5. Studio of the South, *Van Gogh and Gauguin at the Art Institute of Chicago*, 2001.

Vincent thus resides at the "Holy of Holies" of religious insight, seeing "all things new" (Isaiah) prophetically—how things ought to be seen and proleptically—how things could be seen—or simply authentically, realistically and radiantly. There at the altar, "even the sparrow has found a nest" and "all is made plain" (ref). Cliff Edwards puts it succinctly with Teilhardian wisdom: "Seeing the world aright equals seeing the resurrected Christ" (a synthesis of the perceptual theologies of Rembrandt and Dickens; (see letters 132, 133 [10/21/'77, Amsterdam]). "When seen and painted from the depths of the creative soul, even a tree or rock is a living and luminous center of Christification." (Edwards, *VanGogh and God*, p.28). This at once modern-scientific and ancient-sacred way of viewing things is the remarkable penetrance of Vincent's vision.

At age 24, living in Amsterdam with relatives, Vincent was struggling with the Providence of God, his human perception of that grace of life and the pertinence of that provision for his own call into ministry: ". . . there may be good days in store for us, If God will grant us life and bless what we undertake. Will you ever hear me preach in some little church? May God grant it" (Letter 114 [5/19/'77, Amsterdam]). The mediation on that cornucopia of providence—which Calvin saw in creation as the theatre of "God's Glory"—all color, light and radiance—was through human acts of love. This mediation was conflicted in Vincent's experience. He knew the graceful and sacrificial love of Vincent, Rev. Jones, Uncle Stricker—even imperfectly refracted by mother, father and his sisters. But his father seemed to hold Vincent in a bind of mingled demand and contempt. He called him home from England rather than continuing subsistence/subsidy by seeing his budding ministry there as one of being a "handyman" of sorts, working without remuneration. "Get a job, son— he chided." "We have done for you what we could—have you honestly tried?" (L 117[5/30. '77, Amsterdam]).

The clan apparently were part of the climbing poor—*nouveaux riches*, or perhaps worse, "those who had once been affluent." Vincent abhorred this as the worst kind of materialism—"swine and company"— Zola. But he did not have a leg to stand on. Father was not Thomas Jefferson, who quipped that "the fathers are engineers so that the children might be poets." Calvin—at least as mediated by Max Weber, though a just and political soul, had a more insidious notion—that the poor and destitute were laggards and that the righteous surely enjoyed the stigmata—not of misery but of prosperity (The Protestant Ethic and the Spirit of Capitalism). Actually, Calvin believed strongly in the particular gifts and

reciprocities within. But in industrial Europe, this impulse of poverty as moral failure was strenuous and surely felt by Vincent.

Poverty scraped his soul and nearly obscured his gift. He was not a skilled politician—like Rubens. He had a few supporters but no patrons. He was brusque and off-putting. He was not a good salesman and had certain impediments keeping him from "working his way through" to an education and career—even in the more conducive scene of northern Europe.

We may hope that today he gazes across the starry nights from eternity and takes a certain satisfaction in ultimate divine vindication and Grace as he sees at least five of his works—15 *Sunflowers, Portrait of Dr. Gachet, Irises, Portrait of the Artist without Beard,* and *Wheatfields with Cypresses*—all selling at auction at or around 100 million dollars (2010 dollars). If only Vincent had had some power to back-mortgage.

Imitatio Christou

The signature book which leaves its message on this phase of Vincent's developing theology and ministry (identified with Amsterdam) is *The Imitation of Christ* by Thomas à Kempis.[6] It is found on Vincent's meager shelf next to the Bible and has been read, stanza by stanza in Latin as well as other tongues. His first attempt to memorize it was through copying out the French edition.

The medieval brothers of Deventer—along with Nicholas Cusanus—Brethren of the Common Life—were well known throughout the lowlands. The School portrays a theology and a derived shape of ministry which would mark Vincent for life and death. Themes such as Dying for God, Man of Sorrows, Taking up the Cross, Finding and Staying on the Narrow Way, Divesting from this world while Investing in the world to come, recurring themes in the meditations, all resonate in Vincent's existence.

Thomas à Kempis (1380–1471) was born along the Rhineland—the salient center of a stirring piety as well as religious and philosophical depth. He died at Zwolle—50 miles northeast of Amsterdam, where he was sub-prior of the Augustinian Convent. A postulate of the Deventer School of the Brothers of the Common Life, he was a mystic-activist who had copied the entire Bible (Latin Vulgate) at least four times—a monk

6. Thomas à Kempis, *The Imitation of Christ* (Filiquariam, 2007).

living an "Into Great Silence" (as in the film about Carthusian monks) solitude and profound scriptural absorption, an art now lost to Christianity but sustained in Islamic Madrassas and Jewish Yeshiva.

The Imitation of Christ is a unique and powerful meditation on existence grounded in Christ. In four books and 126 chapters, he unfolds a manual for holy being, living and dying in the best tradition of the Rhineland mystics, Thomas Aquinas and Augustine's *Confessions* and anticipatory of Ignatius Loyola's *Exercises*, Merton's *Meditations*, and Henri Nouwen's *Devotio Moderna*. The work enticed Vincent Van Gogh's consciousness through his many deep valleys of despair and supplied the wisdom and truth for what I am calling his renovation of tradition into a new quality of universal spiritual-aesthetic consciousness and conscientiousness—a ministry of religion and art.

A scan of the early portions of the work clearly shows its pertinence to the enigma of Vincent's theology and ministry. From "Thoughts Helpful in the Life of the Soul," Kempis calls for imitating Christ while "despising all vanities on earth." Put another way, we are to seek the Kingdom of Heaven through contempt of the world. This is contempt for the riches that perish: vanity, pride, honor, lusts of the body, visible things, the insatiable cravings of the eye (think of Vincent's love for the beauties of the fields); in profound paradox is the richness and sustenance of God.

In chapter 2—"Having a Humble Opinion of Self"—here, Vincent can identify with the underlying spirit of Aristotle and Augustine concerning knowledge by affirming that "a humble rustic who serves God is better than a proud intellectual who 'neglects his soul to study the stars.' " Vincent's biography throbs with what one can only imagine was a terrible tension of forsaking all, and with his love for the resplendent world of beauty. In chapter 3, "The Doctrine of Truth," we learn that Truth is simple Trust and Virtue—not elaborate speculation. We feel the pain of Vincent as he struggles with the Amsterdam Faculty—who hold the key to the door to ministry—especially in light of the Apostle Paul's teaching to Corinth: "Where are the wise scholars of this age?' (1 Cor 1:20) [*Imitation of Christ*, Book 1, Ch.1, 2, and 3].

Later in the chapter on Arles, we will see this same ascetic impulse shaping his experience of looking beyond into the heavens—even as he stares—without benefit of special eclipse glasses—into the sun and stars. Victor Hugo offers the same serene view amid the tumultuous events of history in *Les Misérables* in the next chapter.

3

Au Borinage

A KENOTIC THEOLOGY—DESCENT INTO THE COAL MINES TO LES MISÉRABLES

IN TWO MOVING LETTERS to Theo from the Borinage mining district (L 148–152), Vincent has discovered the Thomas à Kempis' paradox where a humble rustic overcomes a proud intellectual and a widow's mite has made trivial the impressive gift of the exalted Pharisee. Vincent learned early in Amsterdam that sorrow purified so that the poor could see God. In Hugo's memorable picture—"who loves another has seen the face of God."

In this chapter, we will chronicle how he deals with the loss of a scholarly call to ministry, throws himself back into the maelstrom of hands-on ministry and ministry through art, starts to draw, and draws instruction from servanthood ministry and the blessing of serving *Les Misérables* in such ministry.

> There are many little protestant communities in the Borinage, and schools. I wish I could get a position as evangelist . . . preaching the Gospel to the poor—those who need it most and for whom it is so well suited—and then devoting myself to teaching during the week" (L 153, 154 [9/5/'79, Cuesmes]).

Now the ideas of Kempis' common-life brother—Nicholas of Cusa's Learned Ignorance—*Docta Ignorantia*—take hold in his heart and vocation as a holy wisdom is found in the humiliation of the riches of

poverty—of paradox and contradiction. This "Great Reversal" where the lowly are lifted up—the Biblical Song of Hannah and Mary's Magnificat (2 Sam and Luke 1, Sura 3, Qur'an), has obviously touched Vincent's soul. He is also yielding peacefully to his inevitable mortality.

"I felt more cheerful and alive than I have for a long time, because gradually life has become less precious, much more unimportant and indifferent to me." This may be French *insouciance* or German *Gelassenheit*—letting go (L 154, Ibid.). The life-affirming side of this conviction resonates with that of the 1657 hymn of Georg Neumark, set to the Cantata (#93) by J.S. Bach: "*Wer nur den lieben Gott last Will . . .*" which Vincent could have heard in divine services in Holland, Germany or France.

> The one who leaves all to the power of God, and hopes in His unwavering love,
>
> He'll give him strength whatever comes along.
>
> Who trusts in God through all his days, builds on the rock that none can move.
>
> Only be still and wait His leisure, and do thine own part faithfully . . .
>
> God never yet forsook in need, the soul that trusted Him indeed.

In his commentary on this Cantata, Albert Schweitzer calls the trusting posture—"*gay insouciance*," the kind of abandonment which brings creativity grounded in Grace.

Contours and Conditions of Ministry

Vincent had flunked out of his prep studies for the Amsterdam Theological Faculty. He had applied for Missionary Training School in Brussels, with field work assignment in the coal mines of the Borinage. He was first rejected for "neglect in his person." Having failed in academic theology in Amsterdam and in his application for formal evangelist studies in Brussels (as he would eventually in the Academe in Antwerp), he now pleaded to go to the Borinage as a preacher/teacher/deacon—a volunteer-missionary to the poor.

First in Paturages near Mons—lodging with the peddler, Van Der Haegan, it was said that "everyone knew him—he comforted the sick and read the New Testament to them." The evangelistic committee then sent

73

him to Wasmes. Before long, he had given away to the needy all of his few coins, his clothes, even his bed, and he wore a rustic shepherd's shirt. Finally, the powers relented and gave him a six-month temporary appointment—at no stipend. We have the documents of this appointment and can only wonder whether the Presbytery asked, "After all—what can we lose with these wretched slaves down under the earth?"

One observer said that Vincent felt he had to follow the first Christians—to sacrifice everything. He preferred to go to the most unfortunate, the injured, the sick. His only reported conversion occurred in a man who cursed his abstinence and asceticism. The alcoholic, unbeliever, blasphemer was converted by Vincent's surpassing kindness. When the *Comité d'Évangélisation* found his behavior beneath dignity and out of order, they prepared to sack him. Papa came down from Nuenen and he found his boy emaciated, sick and starving. He led him out as a little child in front of a large group of starving and suffering faces—who had come to love him.[1]

J.B. De La Faille, in his early first-hand recollections book, *Vincent Van Gogh*—published in French from Belgium—vividly describes the scene of the coal mines:

> There are signs of subterranean activity on the surface: huge cages, large pyramids of coal, twice as high as houses, reddish glowing lights in front of which float the gray vapors and heavy smoke. In the evening the windows of the public houses are lit up while the house-wives are busy in the kitchens behind. (10)

> Embarrassed by his comforts he took over a hut made of boards, slept on the bare ground, smeared himself with coal-dust and day and night he cared for miners with typhoid, those who had been burnt and wounded by fire-damp. His preaching did not move them and his appearance shocked them. Having no gift of speech his appointment was not renewed—He had to leave, went off on foot, a bundle on his back—arrived exhausted at the home of Pastor Pietersen in Brussels—of the evangelical committee—then to the Pastor in Cuesmes—then home to reproach in Etten. (11)

1. Wessels, *A Kind of Bible,* 56, 57.

Excursus: A Critical Consultation

We now know, thanks to the searching scholarship of Jan Hulsker, of a critical consultation at the time of his dismissal from the "Evangelist's mission" in Borinage which may have influenced his future course. Here is my dispatch from the Antwerp Academy on April 5, 2011, with the assistance of Research Librarian, Josephus Van Gool:

After the dismissal from the evangelist's ministry in Wasmes, Vincent walked to Brussels to consult the Rev. Abraham van der Waeyen, 35 years Vincent's elder, who was Parson in the Flemish town of Maria Horebeke, later to become the city architect in The Hague. Jan Hulsker—eminent Van Gogh scholar—finds the records clearly showing that this consult was not so much to commiserate on the ministry but to explore Vincent taking a mantle—similar to that of Pieterszen—as an artist-theologian—which is irrefutably where his ministry went. This interdisciplinary field may indeed been the subject of the Parson's instruction in the Hochschule (Art and Theology).

A graduate of the Antwerp Academy, he was an accomplished artist—focusing on landscapes in Antwerp and Brussels. Vincent places his work in the tradition of Shelfhout or Hoppenbrouwers (Natural/Humanist) painters and "one who knows a lot about art" (L 153, Ibid.).

Father Abraham, it seems, like Father Millet—if Hulsker is correct—were like those mentors of Saul, the tentmaker (become Paul, the Apostle—a textile artist, evangelist)—in those years in Damascus (Antioch) and Arabia—helping Vincent comprehend and claim his emerging synthetic ministry of Art and Faith.[2]

Vincent had given a vivid description of life in the coal-field. He had been down in the mine for six hours:

> It was Marcasse, one of the oldest and most dangerous mines
> in the neighborhood—many perish—going down, coming up,
> poison air, fire-damp explosion, water seepage, cave-ins, etc."
> Most of the miners are thin and pale from fever; they are tired
> and emaciated, weather-beaten and aged before their time. . . .
> the women are faded and worn.(L147)

2. Jan Hulskar, "The Borinage Episode of Misrepresentation of Vincent Van Gogh and the Creation of a new Myth," in Tsukasa, *The Mythology of Vincent Van Gogh*, 309ff.

> . . . when they come out of the dark mines into daylight, they
> look exactly like chimney sweeps. Their houses are usually small
> and might better be called huts; they are scattered along the
> sunken roads, and in the wood, and on the slopes of the hills."
> (L147, 148)

Yet he finds hope and nobility: "the coal-miner is a type unique
to the Borinage; daylight hardly exists for him, and he scarcely enjoys
the sun's rays except on Sunday. He works with great difficulty by the
light of a lamp whose illumination is pale and feeble, in a narrow gallery,
his body bent double, and sometimes forced to crawl . . . the little lamp
guides him in the darkness and he entrusts himself to his God Who sees
his labors and Who protects him, his wife and his children." Vincent's
Weltanschaunng is still shaped by "the truth of the Gospel and the entire
Bible—of the Light that dawns in the darkness" (L 146, Ibid.).

In spite of the desperation, he found beauty in the place and the
people. "There was snow in these last few days, the dark days before
Christmas . . . everything was reminiscent of the medieval paintings by
Peasant Brueghel. The region is very picturesque there, standing on the
high slopes are old houses like the huts in the dunes . . . one sees people
doing all kinds of farm work, sowing wheat, lifting potatoes, washing
turnips . . . it looks like Montmartre." (L 149).

In terms of ministry, he gave lessons in religion and sermons. He
loved the pastoral ministry. They hold evenings in the miners cottages—
Bible classes. I spoke of the parable of the mustard seed, the barren fig
tree, the man born blind . . . at Christmas, it was the stable and peace on
earth (L 149).

Vincent gave away all that he had, to the poor. One observer said he
wanted to follow the teaching of Christ in the most absolute way (Wes-
sels, 56). The religious officials found each more exacting expression of
ministry a more offensive breach of decorum. In a very telling memoran-
dum in the official administrative records in Brussels, we read:

> The examination has been made to determine whether to ac-
> cept the services of a young Dutchman. Mr. Vincent Van Gogh,
> who thought he had been called to evangelize in the Borinage,
> has not produced the expected results. If the admirable qualities
> which he showed towards the sick and injured, the dedication
> and sacrifice of which he gave many proofs, devoting sleepless
> nights to them and giving them most of his clothes and linen,
> had been associated with the gift of the word, indispensable for

anyone who is put at the head of a community, then Mr. Van Gogh would certainly have been a successful evangelist . . . But it is certain that the absence of certain qualities can completely ruin the exercise of the prime function of being an evangelist. Unfortunately that was the case with Mr. Van Gogh—He will no longer be retained. (Wessels, 58)

Similar rejection notices throughout church history put it more simply—"He is a good social worker—not an evangelist of the Christian Gospel." Today we would not put it so starkly. One must first prove that one loves his people—then he has earned the right and will be invited to share the Gospel with them.

Becoming a Worker-Priest

Considered in a more positive light, if the austerity of Kempis' *Imitatio Christou* animated his ascetic style, he was also moving away from conversionist evangelism and academic ministries, such as preaching and teaching, to more hands-on work, such as first aid (accidents and sicknesses), consoling the dying, counseling and advocating for men on strike (worker rights and justice). His call was being realized to the ministries of virtue and value—ethics and pastoral care—all to workers in distress. He was like the pastor's son, Friedrich Engels, among the workers of Liverpool or young Pastor Reinhold Niebuhr, in the sweatshop factories making automobiles in Detroit. In a deeper sense, my argument—with Wessels—is that he is becoming an evangelist-painter.

He draws on 19th- and 20th-century France, which always had lively traditions of "worker priests." One can be a doctor, lawyer, or laborer-priest. Art and Music, Science and Business are naturals.

More work remains for careful consideration of not only the Borinage ministry but on the connection of the work of Vincent, Anton Boisen, and Henri Nouwen—which I will only touch on in the last chapter of this study.

Vincent reflects on the exhilaration which comes from being helpful to others and the lasting fear that this gift was too good to last and even this would be taken away. "When one lives with others and is united by a feeling of affection, one is aware of a reason for living and perceives that one is not quite worthless . . . but perhaps good for something. We need

each other to make the same journey as travelling companions." (L 155 [6/22–24/80, Cuesmes]).

Vincent's theology of care (Love/Goodness) is rooted in his underlying theology—his understanding of God. In L 155 he affirms that:

> . . . everything in men and their works that is truly good, and beautiful with and inner moral, spiritual, and sublime beauty. I think comes from God . . . I'm always inclined to believe that the best way of knowing God is to love a great deal . . . you must love must always seek to know more thoroughly, better and more. If one loves Rembrandt that man will know there is a God, he'll believe firmly in Him. (L155)

Here we find a doctrine of philosophical transcendentals blended with Christmas Virtue theology in which all excellence is found in God—in God's all surpassing providence and care and in the derivative outgoing justice and compassion toward the poor and needy in the life of humans. This is the *raison d'être* of Vincent's going to the Borinage and, more generally, the purpose of his gifts and vocation.

We now see "ministry" taking shape in his mind, heart and will—a conjoined ministry of faith and art—one which will remain with him through that fateful walk in the fields near Auvers—and beyond. At this point, he had nowhere to go but art.

Servant Ministry

A servant ministry is most complicated, whether offered by a man of means or "a man of means by no means"—such as Vincent (American 20th-century country ballad: "King of the Road"). In the first instance, there is the danger of condescension, narcissism, paternalism and self-gratification. Care can be roundly rejected, especially if the Pastor/Missionary withdraws at evening from the scene of misery to his comfortable lodgings. On the other hand, what does a fellow-pauper bring if there is no learning to share, no resources to help, no personal health to fall back on. The first skill necessary for a life-saver is to be able to save oneself. In Vincent, there was profound identification and sympathy, accompanied by a frenzied mind and a spirit verging on masochism—a lethal combination.

In the Borinage, he begins to draw like mad. Perhaps he was a martyr of "divine madness" or, in the words of Robert Bresson, suffering "the Holy Agony" (*Curé de la Campagne)]*.

Yet the self-insight and sharpening discernment of vocation achieved in the Borinage proved to be decisive. Vincent is learning about ministering and being ministered-unto—the gifts of Truth and Goodness; and of creating and appreciating art—the gift of Beauty. All the Transcendental gifts of the One God are being comingled in his mind and *techne*—his heart and energy. He is becoming a theological and aesthetic pioneer of the human race.

The persistence of calling into ministry that we recognize in retrospect, with the benefit of a life *oeuvre* of religion (Letters) and art, was intensified in the Borinage. Edwards, Nouwen and I reject the dominant thesis that sickness, insanity and fanaticism are manifest in that brief foray into ministry, and that after Borinage, he begins his art career—a clean break, discontinuous from this brief moment of ministry.

We reject the thesis that Borinage exhibits ever-deepening pathology. We concur with Cliff Edwards that we find here a sublime evidence of a healthy and exemplary move into a lucid and luminous "Servant Ministry." With Vincent, that ministry remains fully prophetic—out of joint with all conventions and expectations.

I propose now to further this interpretive tradition by centering the analysis in a theme of my own systematic theology in which I characterize God as a suffering companion to humanity (after Buber, Van Buren, Levenson, et al.). In *Jew, Christian, Muslim* (2003, Wipf and Stock), and in *Journey into an Interfaith World* (2010), I show how a common theology of *Akedah* (Abraham/Isaac, Jesus, Ishmael) is the central redemptive metaphor in the three monotheistic faiths. In this theological purview, ministry is conceived as "Servanthood."

Edwards moves in this direction (*Van Gogh and God,* p.11) as he lays out his servant thesis. In my view, this perception of ministry begins in a primitive notion in Vincent's experience—the underdog, "runt," "sissy"—who will eventually be vindicated from the "schoolyard bully" by a kind of natural justice. Vincent's irrepressible belief that this rough, ugly, stammering peasant boy would eventually win out over the well-tailed, smooth talking, conventional ordinand is slowly refined into one more like the sublime suffering servant image of biblical wisdom.

After his father died and Vincent received his Bible (1885), he opened it to Isaiah 53, placed a tattered text of Emile Zola's *Le Joie de*

Vivre alongside it, painted it and passed it on to Theo. Edwards suggests that beyond the "ugliness/deformity" idea with which Deutero-Isaiah depicts the servant as "despised and shunned," a "leperous" figure—a "pure-lamb led to the slaughter—an offering for sin" (53:7)—"pouring out his soul for many" (53:12), the noble and exalted Lamb—once immolated, becomes, in the Book of Revelation, the splendid King of Kings reigning on the throne of the universe (Rev 17:14).

Here, in definitive servile ministry, condescension is rewarded by sublime elevation and He is given the "Name above every Name" (Phil 2:10). This kenotic theology is the ultimate triumph of Vincent's life and art, suffering and death. Within this *Akedic* company, Vincent joins Jesus and Buddha, St. Francis, Mozart and Sister Teresa. He now belongs to the magnificent train of unnamed faithful, and we delight in their triumph within and beyond history.

Commentators focus on the Borinage period as one of continuing fantasy and frustration about "ministry"—one totally devoid of art. On closer look, one finds an important artistic component and a very important synthesis of the conjoined ministries of Religion and Art.

The Art of Borinage

The Art of the Borinage period includes the following list among many other works that one might assume were undertaken. In retrospect, we only know of a scanty art accumulation and ten brief letters over a span of nearly two years. The art consists mainly of drawings of persons working hard while living out simple faith amid sufferings:

- The Little Drawing, *Au Charbonnage* (Nov.1878) . . . a small inn joined to a coal mine (Vol. 1, *Letters,* 178)

- *Miners Going to the Shaft* (Sept. 1880)

- *Bearers of the Burden* (coal, coke carriers)

- *A Digger* (pencil, chalk and water color)

- *At Eternity's Gate* (earlier, *Worn Out*)

- Early version of the *Night Café* (from Cliff Edwards)

- Multiple copies of Millet's Drawings: *The Sower* (1881), *Evening Prayer* (in field), *Angelus, Reapers Binding Sheaves, Woodcutter and*

His Wife in the Wood, Young Farmer, Les Travaux des Champs (10 sheets), *The Four Hours of the Day.*

> 'I must continue the path I have taken now,' writes Vincent, 'If
> I do nothing, If I don't study, If I stop searching then I am lost
> in misery. The goal is to become more clear, it will take shape
> slowly but surely, as the scribble becomes a sketch and the sketch
> becomes a painting' (July, 1880, L155 [from the Borinage]). . . .
> It is true that my needs are greater—infinitely greater—than my
> possessions.' (L 155)

The work and the mood reflect toil and care. It is the mundane wea-
riness of Old Man River (recall he was reading at this time Dickens' *Hard
Times* and Stowe's *Uncle Tom's Cabin)*—lyrics fill our mind and despite
these few hints of the pictures that fill his mind and spirit, our clearest
look into his life in the Borinage comes from the few letters.

Wonderful insight on the Borinage period comes from Henri Nou-
wen's notes on "the ministry of Vincent Van Gogh (from his hand-written
notes in the Nouwen Archives at St Michael's College, Toronto and the
margin notes in the three volume *Letters* now in the Trappist Monastery
in Geneseo, New York). "*The Bearers of the Burden* (actually completed in
Brussels) shows that Vincent had undertaken arduous studies in sketch-
ing, modeling, and multiple drafting" (Nouwen's notes). This period
seems to be one of translating visual material from the Borinage experi-
ence into his studio exercises now in Brussels which is some 30 miles
from the mining area where Vincent was living and working. Brussels
and Antwerp, our next chapter, were the great academic training centers
for artists between Paris and Amsterdam—and in some sense, for the
whole world. They were also the epicenters for the monumental evils that
now stalk the world—the colonialization and exploitation of the poor
peoples of the world (e.g., King Leopold). Here Vincent would further
hone his skills of conscience and canvas.

In my reading of these crucial months, it seems that a transition is
underway in Vincent's sense of theology and ministry. He is moving to-
ward a greater sense of realism about himself and his constituency (Con-
gregation). He had been assigned a certain parish in the Borinage which
included some sets of homes, some working mines, a chapel or small
Protestant church and a religious school attached. Beyond the practical
"hands on" ministry out in the working fields, he was expected to give
some services and classes for the parish. We must remember that here in

the Walloon, the Protestant churches were responsible for the spiritual life of the region (*Gebiet, Gemeinde*). It is still the era of *Corpus Christianum*—Christian Society, where all people in a given parish (region) are under the jurisdiction of a particular communion—be it Lutheran, Reformed or Catholic.

At this time Vincent is making an even greater move. The parochial (parish) focus is moving in his consciousness toward one more universal. He now seeks to serve Humanity (*anthropon*). A signature verse is Matthew 5:19 . . . "let your light so shine that *anthropon*—humankind—may see your good works and glorify your Father who is in Heaven." To this end, he has left his formal academic studies to study *Dame Nature*—the trees and fields—laborers and children—flowers and skies. Meanwhile, he is learning the amazing power of sketching and water colors to capture those living—ever moving realities.

Vincent reflects: ". . . to us who are also laborers and workmen—each in his own sphere doing the work to which he is called" they are saying—"Work while it is day: For the night comes when no man can work." He then pictures an old white horse while he is walking home from the mines. In the series of prints called "The Life of a Horse". . . in his collection "we see an old white horse, lean and emaciated and tired to death by a long life of heavy labor—work which was too much and too hard. The poor animal is standing on a spot utterly lonely and desolate, a plain scantily covered with withered dry grass, and here and there a gnarled old tree, broken and bent by storms. On the ground lies a skull; at a distance in the background, the bleached skeleton of a horse near a hut where a horse-knacker lives. The sky above is stormy; the day cold and bleak; the weather, gloomy and dark. What lies beyond is a great mystery which only God comprehends—*que la fin de la vie humaine, ce sont des larmes ou des cheveux blancs/* "the end of human life is tears or white hair." The only meaning in this real-life drama, the art and word-parable—is that God has revealed absolutely through His Word that there is a resurrection of the dead" (L 126).

Work and the ordeal of life—with its suffering, sickness, frustration of circumstance and its seemingly premature finality—is always a "veil of tears" within which we give thanks—"sorrowful joy." In faith and art, Vincent is brilliant on this score. To live out a "natural" or "normal" life is the blessing of the privileged few.

The Common Good, Social Justice and the Poor

Vincent lived at the end of a feudal, wretched, and cruel age and at the dawn of an age of some semblance of a commitment of social welfare for all persons. This was an age when it suddenly became evident that the well-being of all was the precondition for the happiness of all. Justice for "the least of these" became the guarantor of peace for all. The socialist-humanitarian revolution in Europe—owing much to the ethical vision of the Methodists, Puritans, Catholics, Muslims, Jews, Marxists and Secular Humanists—had begun to take hold—creating democratic welfare states in Germany, Britain, France, Belgium, Scandinavia, Eastern Europe and Russia. Long before America's turn to become an egoist-materialist nation—one where enemies were thought to be hiding under every Bush—in America we were much like the primitive Christian community where "all things were held in common" (Acts 2) and the general welfare of the commonwealth held top priority.

Vincent was caught in the vise of the lingering feudal state. The Wesleyan-Calvinist (Pre- Adam Smith) community of "Common Good," that was called for by Schleiermacher, Engels, Marx, Hugo, and Dickens, was just dawning. He was trapped. In final agony, it was his life or that of tiny Vincent—Theo's son. The people still had no political mechanisms to sustain the basic human rights of every person—shelter, food, health care and a basic income necessary to pursue one's calling, in Vincent's case, the few francs needed for art supplies until he could get his practice going.

Vincent was undergoing a profound ethical, theological, existential and socio-cultural crisis. In notions I have used in my philosophy of medicine with work concerning persons with HIV and Alzheimer's disease, autism and post-traumatic stress syndrome, hypersensitivity and homosexuality, Vincent was bearing in his own body and spirit the pathological quaking and proleptic awakening of the new age. As he reflected in his own meditation, he was a pioneer and pilgrim—inaugurating a new humanity. In terms of a life-identity, vocation and ministry, he was discovering a new synthesis of Art and Theology—of artist and priest.

In incisive interpretations of this moment of Innocent's vicarious awakening of a new and more humane civilization—listen to Cliff Edwards, a theologian, and Meyer Shapiro, an art historian:

Edwards headlines his interpretation of the historical significance of Vincent with the biblical passage of 2 Corinthians 6:4–10:

... as servants of God we commend ourselves in every way; in great endurance; in troubles, hardships and distresses; in beatings, imprisonments and riots; in hard work, sleepless nights and hunger; in purity, understanding, patience and kindness; in the Holy Spirit and in sincere love, in truthful speech and in the power of God; with weapons of righteousness in the right hand and in the left; ... sorrowful, yet always rejoicing; poor, yet making many rich; having nothing, and yet possessing everything.

Vincent chose the words "sorrowful, yet always rejoicing" as his favorite expressions for the paradoxes hidden in the mystery of a life animated by laws. "Sorrowful, yet always rejoicing" became his description for his own life as aspiring pastor, failed evangelist, spiritual pioneer, avid reader, viewer of art and artist.[3]

What makes Van Gogh a unique artist is his power giving us at the same time a most vivid sense of the qualities of things and an equally compelling revelation of his own feelings ... He achieves this high expressiveness by a daring use of color, more intense than in previous art, with new and surprising harmonies; and also by the vigor of his brush strokes and lines. In all the elements of his art we experience the forces of his conviction and his exaltation before things ... The familiar objects he paints belong both to nature and to loving, desiring, suffering man. It is art which springs from a great faith in humanity.[4]

After England, it is first in the Borinage that Vincent sees his scriptural proclamation-ministry—converging with the song of his artistry to bring light and color to "the people who walk in darkness." "When I was in England, I applied for a position as evangelist among the coal miners . . . you know how one of the roots or foundations, not only of the Gospel, but of the whole Bible is 'Light that rises in the darkness—from darkness to light' . . . Experience has shown that the people who walk in the darkness, in the center of the earth, like the miners in the black coal mines—hear and believe the words of the Gospel." (L148, [c.11/16/78, Laken]).

There was no Louvre, Vatican, Hermitage, or Royal Amsterdam in the Borinage—no pictures—except the country itself. ". . . the country itself is very picturesque . . . everything speaks . . . Lately, during the

3. Edwards, *Mystery,* 72.

4. Meyer Shapiro, *Vincent Van Gogh: Art Treasure of the World* (New York: Whitney, 1952), 1.

dark days before Christmas, the ground was covered with snow; then everything reminded one of the medieval pictures by Peasant Brueghel." (L149 [12/26/78, Wasmes]). Recollection of these masterworks of Pieter Brueghel—the war scenes, the winter scenes during "the little ice age," c.1565, and the scenes of peasant life—*Wedding Feast, Peasant Dance*— all evoke the work of a Master who had a heart of compassion toward the simple folk. The master of the Antwerp Guild of artists depicted the demons whose malign force could threaten God's lordship and good providence over the vicissitudes of human existence. He also captured memorably the Tower of Babel and many biblical scenes which would be the blessed gift of the Flemish School, leading ultimately to the sacramental masterpieces of Rubens, which now grace the Antwerp Cathedral. The profound influence of this work on Vincent's theology and vision of ministry will be reviewed in the next chapter.

Vincent sees in this artist's look into the heart of the poor and suffering of the world a call to come over and come down. In this same letter (L 149, Ibid.), Vincent calls to mind Acts 16:9 where Paul receives a vision from a man to come over to Macedonia and "help us." "We must," conjectures Vincent, "think of him as a laborer with lines of sorrow and suffering and fatigue in his face—without splendor or glamour, but with an immortal soul." The man who appears and calls is Jesus the Master— himself the great Man of Sorrow—who knows our ills." Then amazing and insightful words: "I have already had occasion to visit some patients, as there are many sick people here." Visage and vision—calls to help and to heal—are arising in the groping of his own tormented soul.

Les Misérables

Victor Hugo, with Zola, Vincent's favorite author, writes in the telling preface to *Les Misérables:*

> So long as there shall exist, by reason of law and custom, a social condemnation, which, in the face of civilization, artificially creates hells on earth and complicates a destiny that is divine with human fatality; so long as the three problems of the age—the degradation of man by poverty, the ruin of women by starvation, and the dwarfing of childhood by physical and spiritual night—are not solved; so long as, in certain regions, social asphyxia shall be possible; in other words, and from a yet more

extended point of view, so long as ignorance and misery remain on earth, books (and art) like this cannot be useless.

Hauteville House, 1862

To summarize the vital insights received by Vincent in the Borinage, let us reflect on what was a crucial reading in this period—Victor Hugo's *Les Misérables*. Vincent had the great joy to read this volume for the ages in French. We also know that he read at this time Hugo's other classic— *Le Dernier Jour d'un Condamné*. In these works, Hugo and Van Gogh are reflecting somberly on the experience of being "oppressed"—"in a hole" (The Baptist at Herod's compound)—incarcerated, trapped—with no exit. They also reflect on the powerful liberation theme in Abrahamic scripture: "I come to set the captives free"—Exodus and Jesus. Van Gogh also meditated on this theme in his drawing and painting. While he himself was in prison, Vincent's mentor, Delacroix, painted scenes of the "condemned."

He loved Bunyan's "prison literature"—especially *Pilgrim's Progress*. His theological substance is derived, in large part, from the Apostle's prison epistles. But *la pièce de la résistance* is Hugo's *Les Misérables*—perhaps this greatest *Akedic* writing in history—apart from Scripture. The religious masterpiece is fundamentally a gloss on the Bible passage, "If the son shall set you free you shall be free indeed" (John 8:36). Biblical theology—from Moses and Jeremiah to Paul, Bunyan, Bonhoeffer and King—proclaim messianic liberation as an essential quality in the being of God—"I have heard their cry and have come down to rescue my people"—Exodus 3:7. *Shemah*—Resurrection—*Allahhummanshurrill* (Qur'an, Sura 94:5/"God with humanity")—are vivid descriptions that God sees, hears, answers and comes to help.

The final verdict rising from the Borinage is expressed by Wessels, quoting Jansen. In sum, Vincent's dismissal was a moral outrage:

> Because the missionary society thought that Vincent was interpreting the Gospel in too radical a way ("Sell everything you have and give it to the poor—take up your cross and follow me")—he was finally removed from office. Isn't it remarkable that someone who declared himself so truly to be in solidarity with the most exploited people of the 19th century should have been removed from office? [My aside—you'd have to do away with St. Francis, Kagawa, and Martin Luther King—in that judgment.] The history of 20th-century Christianity also shows that anyone who tries to bring the parable of the Good

Samaritan up to date himself becomes extremely vulnerable, and that his vulnerability becomes a threat to the status quo of church and society.[5]

Here the theme of the "Vulnerability of God"—the "Passion of the Christ"—comes into play. If we demand that our puny power and pop prosperity be written large into some Mighty and Provident God—even if the Reality of God defies our projected attribution—then our God is "too small" and this facsimile will atrophy away. This has arguably been the story in Western Europe and American Christendom.

This correction of the course of church and state rather expresses that hope lies in the serene trust that " . . . there is therefore no condemnation to those who are in Christ Jesus—for the law of the Spirit of Life in Christ Jesus has set me free from the law of sin and death" (Rom 8:1, 2). In the words of perhaps the greatest *Akedic* (redeeming sacrifice) text in the New Testament—God loved the world so that he gave *monogenos/agapetos*, the only son, the one so loved. God did not send the Son into the world to condemn the world (*kosmon krine*) but that the world through Him might be rescued/ healed (*kosmos soothe*) [John 3:16, 17].

Les Misérables is one of the world's masterpieces dealing with the redemptive sacrifice offered by the divinely chosen one for the world. It is one among thousands of parables about this sublime theological mystery. It is about the crisis at the membrane of Law and Grace. On the one hand, justice in the figure of Javert pursues with relentless passion the condemned criminal—the Christ Figure, Jean Valjean—for stealing bread to feed his starving sister and her family. In paradoxical tension, we have the mercy and forgiveness of Bishop Myriel who saves Jean by protecting him after he has stolen the Palace silver—adding grace on grace by telling Javert to take along the candlesticks which he also meant to give him. The vast and complex saga woven by Hugo is about the miserable and poor of the world who are daily sacrificed for the avaricious sins of the wealthy and violent, indeed, the godless world—sheep for the slaughter—who, like Valjean saves others (lifting the heavy cart off the trapped body of Fauchelevent), all the while laying down his own life to condemnation and death. "Greater Love has no one than to lay down his life . . ." (John 15:13).

Which brings us back to Vincent in the Borinage. In his own mind and soul, he is suffering at the hands of the world to bring light to the

5. Wessels, *Mystery,* 193.

blind and release to the captives. The images of the kenotic Christ from à Kempis and Hugo inform his understanding of ministry. The sojourn in this misery-torn region of Belgium has sharpened his theological sense so that he now needs enhanced skills of artistry to further the "old, old story of Jesus and His love."

4

Antwerpen

THE "ORDER" THEOLOGY OF LINE, COLOR, FORM, FIGURE, AND MOVEMENT

SO HE NOW SETS out to enhance those skills—our pilgrim-prophet-painter.

Antwerp was a short interlude or intermezzo after the Borinage (Paul in Arabia) and before the *dénouement* and beginning of the final journey to his Jerusalem—Paris. Like Jesus in Caesarea Phillippi, he knew he was now homeless—nowhere to lay his head; the serenity and verdant Green (Dickens) of Galilee had ended and he had been ejected from home and manse. He set his face toward the city where any artist—or prophet—would have to stand and fall and—per chance—to rise.

Vincent writes ". . . it feels like returning from exile." After the wilderness, he needs the city. Here his vocation will meet the ultimate test. As capital of the 19th-century world and culture, he must come to Paris. He had met Millet's test of artistic truth—the rustic imagination. Now with *Potato Eaters*, he was ready to test urbane society's sense of artistic truth.

To accomplish that destiny, he must undergo a short novitiate in Antwerp. Under the "presiding spirit" of Rubens, he absorbed the revolutionary aesthetic insight of "subtlety and allusiveness" of the master and his "modest means and swift touch" (L 552 [1/12-16/86, Antwerp]). As Vincent sketches his "head of a woman with loose hair," he is mimicking the novel reds and white streaks of Ruben's skin tones, adding his own "vigorous, if not violent brushwork." He is also on a deeper mission to

discover his own *"Haut Gout"*—that equipoise of "delicacy and distinction." This is nothing less than the inviting mystery that led Hindemith to search out that "curtain" at the outer edge of Bach's oeuvre—beyond which even the master virtuoso could not go, a theological, aesthetic moment which constitutes the essence of what humanity seeks as "Beauty." This is Ralph Vaughn-Williams' poignant "Ascent of the Lark."

"There is a tide in the affairs of men . . ." it is said—and J.R. Lowell saw a scaffold being erected in the world—by malice, neglect, injustice and violence—human to human. "Yet, that scaffold sways the future for behind it standeth God keeping watch over his own" (Hymn, "Once to Every Man and Nation"). For Vincent, living and working in the same ethos and time warp as Lowell—one must side with the working man, knowing that prevalent injustice will be rectified in this world and the next. Vincent knew "that the bourgeois do not have fate on their side. The lark ascending in the spring sky is the greatest optimist" (L 723).

Activities and the Academy in Antwerp

During the 16th century, Antwerp was the art center of northern Europe. In 1560, at the height of the Reformation in Europe, which ran from England through the Lowlands to Germany and Bohemia—south to France and Italy—there were 300 artists in Antwerp. By 1620, the names of Peter Paul Rubens and Anthony Van Dyck were at the cutting edge of creative work and training. At this time and relevant to the *Geisteslebens*—spirituality and art—Antwerp was Europe's center of trade and banking. Beneath and beyond the commercialism and militarism, the Guild of St. Luke fostered painting, rhetoric, music and other arts and humanities which allowed artists, artisans and philosophers to enrich the public with their virtuosity and, happily, to avoid guard duty.

The age of Erasmus becomes the age of Rubens and Rembrandt in the lowlands and a new way of life and culture is being formed. The Academy patronized artists and academicians under the tutelage of Luc—evangelist, physician, historian, even iconographer (see De Vos—St. Luke painting of the Virgin Mary, 1602), enriching the life of the city and the rest of the world.

Sculptors, engravers, painters, architects and printers in their great Guild Houses looked after preparations, production and public reception of the arts and crafts—and the transcendental Good, Truth and Beauty

these works made manifest. When Vincent came to town, he was surrounded by these Guild Centers as he studied Ruben's ascent and descent beatifications of Christ in the Cathedral and he was transfixed and transfigured by their beauty. As I now live in Antwerp for a season at Lent and Easter, I receive the same gift—now including diamond cutting, chocolate, glass, fabrics, lace and myriad other things of beauty and goodness to enhance the life of the common people—and Vincent looks on with pride.

Beauty also skirts with "the ugly." The other signature work of the Antwerp period is the skull with lighted cigarette. Mocking the pendants and pedagogues who would instruct him, he mocks the skeleton as medical students often mock the cadaver who becomes their instructor in gross anatomy. Only later will Vincent come to revere the "living dead" as medical students who come to wear their cadaver's tag around their necks in respect. The *todestanz* and Hans Holbein's woodcuts not only admonish us to respect the powers of aging and death but to honor God's power over destruction and death. As Vincent would later preach to those frail of faith and trust—persons like himself—"Why do you search for the living among the dead—He Is Risen!" As Vincent knew so well and often said in stammering confession—"the grain of wheat must fall to the ground and die if it is to come to life." To this theme, we return at the end of this chapter.

Richard Baseleer, a well-known marine painter and fellow student of Vincent in the Antwerp Academy, leaves us reminiscences of those three crucial months in Vincent's consolidated (religion and art) ministry—late 1885 to summer 1886.

Vincent enrolled in the "classical statues" drawing class at the *Koninklijke Academie voor Schone Kunsten:*

> . . . He (Vincent) followed the evening classes of Eugene Siberdt—drawing after the live model, and of Franz Vinck for the drawing of ornaments . . . and day classes led by Piet van Havermart, for drawing from life and antique subjects. (He also attended the sessions on painting given by Academy Director Karel Verlat). Apart from the Academy he also drew at two evening clubs. One of these drawings was of the Winkler's house in the High Market (*Grote Markt*) which he also drew as foreground to the Tower of the Cathedral.[1] (Marc Edo Tralbaut,

1. Marc Edo Tralbaut, "Vincent Van Gogh in zijn Antwerpse Periode," quoted in Vol. 2, Bullfinch, *Complete Letters*, 504, 505.

The Ministry of Vincent Van Gogh in Religion and Art

Vincent VanGogh in zijn Antwerpse Periode, quoted in Vol. 2, Bullfinch, *Complete Letters,* 504–505.)

Vincent soon ran into controversy with the instructors, especially on the issue of whether drawing started with the overview outline or with the core foci. He chose the latter over against the orthodox school of the masters. Before long, he decided he would learn for himself with models, casts and eventually sketching in the Louvre, in Paris.

Certainly we see a new intensity of training and learning. Of course, there is always the question of whether education enhances or retards knowledge and competence. Educators ply and advertise their trade, trying to convince us to consume their services. But many years of miseducation have shown us that the ancient models of teaching/learning in the Medieval Sorbonne with volunteer disciple groupings probably provide the best models where students can coalesce around a tutor and contract to get exactly what they need.

There is widespread argument about whether—in Vincent's case— education helped or hindered the development of his profession and mission—especially regarding his vision and style. Many art commentators feel that the repetitive drawing exercises posed a danger to his creative genius. In my view, though he was most fragile, Vincent knew what worked for him. In fact, he came out fighting against all posed and imposed authority—feigned or genuine competence. In art, as in religion, he instinctively knew that much tutelage was misguided. He could have seconded the wise advice (and confession) of Derek Bok—the former President of Harvard—in remarks to graduates: "We know that half of what we have taught you is wrong—and we're not sure which half."

Vincent's great challenge was the enormous expense involved securing the tools of the trade—color, brush and canvas. It was clear that the only way this ministry could be activated was family subsidy, begging for patrons or demonstrating prodigious gifts and output which could then sell produce to the cultured elite or at least in the market-place.

There was money in the family. Uncle Cor owned a great castle villa in Baarn called Jovinda. It seems the family didn't even see father Theodorus as worthy of the ministry—let alone the rascal (Mozart) Vincent. The best they could hope for—even in the family appraisal—was work with the "down and outs" in the Waloon. Some of the clan (this is obviously conjecture) seemed to despise the ministry, per se, finding it beneath the dignity of any Van Gogh.

Frere Richard, my brother, as noted earlier, is an accomplished art-
ist—having placed works in important sites around the world. A major
work is in the great glass dome in the Osaka Airport. A second celebrated
work—an iron framed multi-layered vinyl skyscape—celebrated on the
cover of Art News—stands in our home in Evanston. For years, he was
forced to do rapid-fire watercolors of cathedrals and other scenes for
pocket change, an occasional hot dog and meager supplies. Writers, po-
ets, musicians and artists—the world over, throughout time, know the
ardor and accomplishment required of one who would convey Truth,
Good or Beauty—the Transcendental cosmos—in Paul's words, "penny-
less they own the world."(2 Cor 6:10). Here remember Vincent's signature
verse: 6:10, "sorrowful, yet always rejoicing."

One is struck by several things at the outset of the Antwerp period:
1) Vincent's thought and speech has moved off of the subject of religion;
2) He is dirt poor, his health is failing and he is unable to engage in pro-
found thought—even though he continues reading; and 3) He is anxious
for the chance to live with Theo in Paris and so begin that sensed penul-
timate phase of his maturing work.

Vincent's colleagues and instructors in the Academe, where I now
write, called him the "savage Dutchman." As with the little girls who
called at the parsonage door—when Vincent answered—they screamed
in horror, so now other students, and models, would recoil in horror
when he appeared. Why was this wild-wolf (he called himself a mad dog)
appearance such a big deal?

As W.C. Fields quipped, "any guy who scares kids and kicks dogs
can't be all bad." Actually, Vincent also gained many fast friends—es-
pecially among the English—who sensed his brilliance and virtuosity.
"With those who understood him, who had an inkling of his growing
genius, he showed himself communicative, enthusiastic, fraternal. Very
often he spoke to them about those rough and kind-hearted miners of the
Borinage, whom he had catechized and cared for and helped and nursed
(*Sorgen*) with so much love. His heart melted at the memory and they
were moved to tears as well. They were discovering the deepest beauty
and truth of art and theology. During the tragic strikes of 1886 he even
wanted to go back to that black country" (Bullfinch, 508).

But that was not to be. Five years had passed and the haunting vis-
age of those faces and their toil, their labors and simple joys, their suffer-
ings and dyings, were still very much with him. Whether he sojourned
in Etten or The Hague, Drenthe or Neunen, his religious and artistic

ministry continued to unfold—grounded in this imagery. Not only does his correspondence chronicle this journey but a quick scan of his drawings (even a few paintings) which survived corroborate the thesis that ministry is growing rich and deep. We can only regret the loss of such treasure—similar to the ancient classical library in Alexandria—that went into the trash-bin or was carted away from the parsonage before and after his father's death in1885. We'll never know what we lost.

Calling to mind drawings created between 1881 and 1885 gives insight into what is going on in his heart and will.

- *Worn Out* (Old Man in caned chair, 1881); *Old Man Putting Dry Rice on the Hearth*(1881)

- *Woman Sewing* (Black Chalk and Water Color, 1881); *A Girl Raking* (1881); *Wind Mills at Dordrecht* (1881)

- *Fish-Drying Barn at Scheveningen*; *Sorrow* (Agony of a woman's soul)

- *Sien with a Cigar by Stove* (*with Cradle*); *A Potato Field in the Dune* (1882)

- *Old Woman with Walking Stick and Shawl*; *Peat Diggers*

- *Landscape in Drenthe*; *Weaver* (1883); *A Man Winding Yarn*; *Demolition Sale*

- *Peasant Woman Carrying a Sheaf of Grain* (1884, 1885)

- Works in Antwerp: roofs of the city, skull with lit cigarette, Head of a Woman with hair loose, sketches with the Cathedral in the background.

At this juncture in his self-perception of his calling and the shape of that ministry, he seeks to bring "Good News" to the poor—which has come to mean light, color, redemption and recognition of "the least of these"—basking in the great Light that only "those who walk in darkness" can see. As a child of his age, Vincent believes that somehow the vulnerable and oppressed and societal care for these "least of these" hold the key for public illumination—"in as much as you did it to the least of these, my brethren, you did it to me."

Spirituality and righteousness itself were embedded in the dawning age of human consciousness and justice toward workers. In America—as I now write—tea party, no-government advocates scorn unions and the workers with a venomous rage which first occurred during Vincent's

latter years in violent scenes such as the Haymarket Strike in Chicago in the 1890's. Vincent wants the world to see what he has seen. He wants the world to recognize the plight of the needy and to respond in help. The church ought to be in the fore-front of this revolution of concern. Regrettably, as Reinhold Niebuhr in Detroit and Karl Barth in Safenwil, learned at the dawn of the 20th century—the church was a big part of the problem.

This upsurge of vision and value was very much the meaning of modern history—of the secular and spiritual Enlightenment—of worker's rights, and his comingled message of color and conviction was a great part of that Awakening. In Antwerp, we glimpse the diary of his soul as its drama unfolds in letter and sketch.

We review Vincent's Antwerp passage in four movements:

1. An overview of experiences and events

2. Line, Color, Form, Figure and Movement

3. The influence of mentors such as Pieter Brueghel and Peter Paul Rubens and

4. The meaning of this moment in developing a ministry—one religiously reformed and aesthetically glorious.

Here again we will attempt to show that rather than rejecting one calling and moving to another, Vincent is consciously weaving together a theology that is artistic and an art that is religious. One can see the colored threads intertwining as with his Nuenen weavers.

Overview

"I am in Antwerp. I have taken a room for 25 Fr. a month # 194 Rue Des Images." (In 1952, this changed to 224 Lange Beeldekenstraat) (L 544 [11/26/'85, Antwerp]). He visits Ley's Dining Hall with such celebrated works as *The Walk on the Ramparts, The Skaters, The Table*. There on a panel between the windows was *St. Luc*. Vincent is caught up in the rush and bustle of life on the City Hall frescos—the woman near the baker's shop, the bird's eye view of the city—Antwerp's towers and roofs against the dramatic sky, skaters on the moat. Here and in real life he sees the pouring rain—dawn and dusk—yellow and grey—soil and sea in all shades.

In his mind he is back in England—at Ramsgate and London— wandering and watching. Here in Antwerp, the docks and quays, the English girl looking out the pub window, the Chinese woman waiting in the café, the sea and sand and the peasant villages, Flemish sailors and the Antwerpers eating mussels, ". . . at the end of all this tumult—at the landing—where the Harwich and Havre steamers are moored—with the city behind—one sees only an infinite expanse of flat, half-inundated fields, awfully dreary and wet, waving dry rushes, mud, the river with a single black boat, the water in the foreground grey, the sky, foggy and cold, grey—still like a desert (L 545–547, Ibid.). One sees and smells, feels and tastes but so much more, when it is translated into word and work. We are in the presence of Rembrandt and Vermeer, Brueghel, the Flemish Masters and the Antwerp Academy. History and nature resound. Time and eternity protrude. God is here in His creation, ever-before, now and ever-after.

Art Lessons: The Academy and Antwerp Environs

Vincent reflects on this whirl of life and whirlwind of color, line, plane, and movement that is the Antwerp urban environment. "One finds no rest for the eye, and gets giddy, is forced by the whirling of colors and lines . . . when one stands on a spot where one has a vague plot as foreground, then one sees the most beautiful quiet lines." (L 546). Art, like poetry, has the power to make the moment stand still. Faust, in the rendition of Goethe, seeks that the moment endure which flirts with the terrible metaphysical temptation to make time stand still—or to steal immortality from the gods. Still life also conveys peace. This is the power of the flowers in the vase. Those resplendent creatures—blue cornflowers, like Vincent's eyes—blazed gloriously by day and then receded to nestle and rest by night or in the scriptural parable of all life: "flowers of the field which today blossom and tomorrow fade, dry and blow away" (Psa 103:15). The portrayal of nature as life-stilled condemns and comforts. Vincent apprehends eternity within the forms of space and time.

Delacroix wrote the manual on color and had been his dominant mentor. Now, for the Antwerp moment, that role shifted to Rubens. Delacroix showed, and Vincent believed, that the "so - called drab colors" were actually quite dramatic and luminous. A dark color may seem bright— reddish grey, slightly red can become dark—yet luminous when changed

by red ochre. Blue and yellow are the same. Tonists are actually colorists (L 555, Ibid.). Black—for example–can really be tinted toward red, yellow or blue. New combinations now present themselves—greenish-reds, yellow-greys—mostly colors that have no name. The bedrock aesthetic knowledge acquired in Neunen is assimilated and applied in this period of intense practice in Antwerp. The collateral experiences of Rubens, Van Dyck and other great colorists and tonists in the museums and churches of the city—enrich his pallet.

Along the quays and fields, Vincent's spirit, now near Antwerp's East Gate, may have wandered to Aldersgate, London—and those moors, coasts and docks of England. Perhaps he recalled the words of the Quaker John Greenleaf Whittier's hymn of 1872.

> Dear Lord and Father of Mankind, forgive our foolish ways,
>
> Reclothe us in our rightful minds, in purer life thy service find, in deeper reverence still.
>
> Drop thy still dews of quietness, till all our strivings cease,
>
> Take from our souls, the strain and stress,
>
> and let our ordered lives confess, the beauty of thy peace.[2]

Vincent is a Pythagorean and da Vinci-like soul. Reality all around him is conveyed through his sensorium into his mind through ideas like line and color, form, figure, faces and movement. He sees that his only financially viable future is in figures, portraits, the kind of art skills which come from perspective—line, outline, stillness and rest—tension and movement.

He is also coming alive to shading and color. "Antwerp is beautiful in color, and it is worth-while just for the subjects. One evening I saw a popular sailors' ball at the Docks"—colored dresses, smocks, hats. He also feels the coming to life of Delacroix's "symphony of color" (L 552, Ibid.).

But there is also discernment and discrimination. " . . . when I look into real life—I see people in the street but I think the servant girls are so much more interesting and beautiful than the ladies, the workmen more interesting that the gentlemen; . . . in those common girls and fellows I find a power and vitality." "Beauty," it is said, "is in the eye of the beholder." But beauty in "the eyes of this world" (finery and elegance) has always been different than beauty in the eyes of God. Vincent is seeing

2. John Greenleaf Whittier, "Dear Lord and Father of Mankind," 1872.

things *sub specie aeternitatis*—*sub ration dei*—and he invites the world to this different gaze of "the other"—who might otherwise go unrecognized. "I'd rather paint people's eyes—the common people—this is the real cathedral" (L 548, Ibid.)

Very few can draw the figure of a person or an animal. He knows the frightening and fascinating depiction of the founder of the Flemish school—Hieronymus Bosch (c. 1500). In Pieter Brueghel, Vincent sees the teeming, colorful mass of humanity—say in the Peasant paintings or in the *Netherlandische Proverben*. In Rubens—perhaps the greatest Antwerp Master—he finds movement. "Like Delacroix . . . who makes us feel the life of things—the expression and movement" (L 551, Ibid.), Rubens, too, captivates our imagination with a sense of movement.

Many commentators find Vincent's genius in his appreciation and application of color. Albert Aurier, in his *Oeuvres post Humes* (1893), sees Vincent as "the only painter to perceive the chromatism of things with this intensity, with this metallic, gem-like quality, his research into the color of shadows, the influence of one tone upon another, of full sunshine, are highly unusual."[3]

The color brown, as in the *Potato Eaters*, had the force and solidity of the ground. He wanted to paint the quality of eternity—symbolized by medievalists with halos, then, in Vermeer and Rembrandt, for example, in the "white light"—now "in the radiance of our coloring." He lyricizes on the color yellow: ". . . it is as if nature starts to burn . . . in everything there is old gold, there is bronze and copper, yellow—sulphur yellow, soft yellow, lemon yellow, gold—how beautiful is yellow. Theo, those who don't believe in the sun are infidels" (L496, 497 [4/30/85, Nuenen]). "Antwerp is beautiful in color—especially the boys and girls at the sailors balls—the sea captains the red and blue and green—scarves and hats."

"Perhaps I can paint signposts for these delightful shops—'fishmonger—still life of fishes; flowers, vegetables.'" (L 546, Ibid.). One thinks today of the bustling and colorful Antwerp Saturday market with the cosmopolitan clientele—Asian and African—Muslim and Jewish—with tourists and business people from all over the world.

"I go often to the Museum and admire the heads" (portraits and miniatures were the main sources of income). "Rubens can draw the head and the hands" with unique line, figure, color and movement. "He does faces with streaks red—also the hands." Influenced by Rubens, Vincent

3. Henri Nouwen Notes (unpublished) in the Nouwen Archives at St Michael's College, Toronto.

"brought lighter tones into the flesh, white tinted with carmine, vermillion, yellow and a light background of gray-yellow, from which the face is separated only by the black hair. Lilac tones in the dress." Rubens painted with the simplest means: "I love his work—he expresses a mood of cheerfulness, of serenity, of sorrow—by the combination of colors—the somber surroundings are enormously rich because of the various low-toned harmonizing masses of red, dark green, black, grey and violet—he paints with a quick hand and without any hesitation" (L 547, 548, Ibid.).

Reflections

How shall we reflect theologically on this obviously new and creative phase of Vincent's art career and his undergirding vocation of ministry? At this time, he is reading Zola, the French naturalists and the social realists. As we noted earlier, there is a strong "natural theology" bent in the French (and Flemish) Calvinist tradition. Though severely near-obliterated in the brutal persecution of the Belgian Protestant Church and the St. Bartholomew's massacre of August 24, 1572, the Protestant (Calvinist) impulse in France remains vital in Vincent's day and into the modern period of the wars in Europe. The naturalistic mood—anchored not only in Calvin's love of the Roman philosophers—especially Cicero and Seneca—and the centrality in his thought of the Christological doctrines of creation and incarnation—he also resonates a clear simpatico with the Jewish people—created a unique dimension of the French cultural ethos—especially among the workers of Paris, in the Mediterranean cities of Montpellier, Carcassonne, Le Chambon-sur-Lignon and the similar—Huguenots' remnant—and merchants and vintners along the Rhineland in present day Strasbourg and the Alsace.

Calvin taught that the universe was the theatre of God's Glory. This metaphor of color and light—creation and incarnation—of the face and the figure—is felt in the background of Vincent's change of mood from severity (also Calvinist and Puritan) to simple joy and celebration. In Letter 291, he identified his mission as "making figures from the people for the people." "It is useful and necessary that Dutch drawings be made, printed and distributed which are destined for workmen's houses and for farms, in a word, for every working man . . . " (L 291 [12/4-9/82, The Hague]).

Peter Paul Rubens and Van Gogh

Though a devout Roman Catholic, a Romanophile with years of careful study and practice in Rome and an artisan at the service of Church and State, Rubens was baptized Lutheran and his father was a strenuous Protestant witness at the agonizing time of the Spanish rule in the lower low countries. A close reading of his impact on Vincent, both in theology and ministry, and in artistic concept and style, focuses in Antwerp and provides an inspiring record of rapport and reconciliation.

His secret seems to be his amiable nature. He saw the best in human nature and in life's blessings in a time of terrible ordeals. He could see the humanity in the Calvinists followed by his father and in the court of King Charles V and the Catholic Kingdom of Spain—which attained the loyalty of his mother. He knew the wisdom found in Amsterdam and Louvain, Rome and The Hague. The best of insight, beauty and knowledge were celebrated in his hometown of Antwerp. As Vincent riveted his mind and heart on the great Rubens works which filled the city and continued to reach levels of glory in Paris, he was transfigured by the sublime spirit of the man. An apprentice in the Artistic Order of St Luke, he also had his own students. In what would become the brilliance of the Antwerp Academy and the Flemish School, there was no more formidable presence than Rubens.

C.V. Wedgwood, an eminent historian of the period, claims that Rubens "was a happy man . . . who delighted in the physical world—in its color, texture, form and movement. Most of all he delighted in the plastic and supple beauty of the human body. He . . . was (also) deeply imbued with the intense and exaulted religious faith of his time."[4]

The first and most important input and inspiration into Vincent's soul, given over to ministry and art, is that impulse so unmistakable when one looks on the work of Rembrandt and Vermeer, Rubens and Van Dyck—which can only be called visible piety—a love of God in and through humanity—a solemn theology of beauty.

Cliff Edwards summarizes: "In the heart of our study of Van Gogh we struggle to see the world through a pair of humanity's most creative and intense eyes. We seek to learn from the gaze that engaged the life around him with such compassion and depth, and left such awesome traces of his own journey of discovery" (see Appendix A).

4. C.V. Wedgwood, *The World of Rubens,* 1577–1640 (Alexandria, Va.: Time- Life, Co.,1967), 7.

Ministry Reconceived

I conclude this chapter with reference to an excellent theological study of the life and work of Vincent and Paul Gauguin by Debora Silverman (2000, Farrar, Straus and Giroux). In a similar journey to the Protestant seminarian, Van Gogh, Gauguin, a Catholic seminarian at Orleans, believed and acted out a well thought-through Catholic aesthetic theology. Serene transcendence radiates through his work. We remember the exhibition on the two roommates in Arles at the Art Institute in Chicago—Studio of the South. Even the work of each on the other's chair expresses subtle tones of difference—cathedra and plain old chair. Paul was Michelangelo—Vincent—Rembrandt.

Van Gogh—the Protestant, according to Silverman, worked more as a craftsman and artisan—who worked on the model of craft labor—agonizing on the terrible antinomies of Dutch Reformed culture—faith and works, nature and divinity and immanence and transcendence. He was a "weaver-painter," one who sought to concretize and materialize the ineffable.

My thesis which arises with the immense benefit of having used Cliff Edwards' wonderful set of volumes on Vincent's theology and the new six-volume set of the *Complete Letters*, finds a theology at once traditional—Catholic and Protestant—neo-evangelical and futuristic. This complex of theological identities will be developed in the coming chapters of this book.

Later, then, Vincent's sister-in-law Johanna offers revealing reflections on his last days in Antwerp. Before departing to Antwerp, Vincent left all his drawings, paintings and his other belongings in his garage studio at the Etten parsonage, which his mother eventually left in the dust bin and cases for a carpenter—who eventually sold everything to a junk dealer (wish you were there for that garage sale?). Here we can be thankful to Johanna Van Gogh-Bonger—who despite her rage at her brother-in- law, Vincent, for contributing to her husband Theo's premature death after only months of marriage—meticulously kept some 200 works left in her care, refusing to sell any even when she and her son Vincent were destitute. (See Vol. 1, p. xxxix, *Complete Letters*, Bullfinch edition).

At that time, Theo wrote: "Vincent is one of those who has gone through all the experiences of life and has retired from the world; now we must wait and see if he has genius . . . I think he has . . ." (p. xxxix).

By February of 1886, Vincent was worn-out and exhausted—according to his doctor, it was complete prostration. The Academy course of study was nearly over and he had alienated most of his teachers. Johanna failed to see the constructive aspects of his ordeals as she misunderstood the spiritual and ethical aspects of his travail in vocation. Only long hindsight could know. Vincent was ready to depart to new climes and chances.

A Study in Mortality

I believe that Vincent confronted his vitality and mortality in Antwerp for the first time. He now knew that the door to church ministry was closed and that he was receiving another post of service in the world. His doctor in Amsterdam said as he was going that "he wouldn't live that long" (L550 [12/19/'85, Antwerp]). He was on the verge of starvation from destitution. He smoked and drank and sought sex in dangerous ways—having failed in other overtures—Cos, Sien, and the like.

He shaped up a bit in Antwerp, shored up his rotting teeth and mouth. He hoped to live to be 50 or 60, to have enough time to create a body of work which took so much preparation and experience (L 550, Ibid.). Yet Hobbes had said that life was "brutish and short" and with the 20th century's Dr. Martin Luther King, Jr., his wish for a long and successful life might not be "in the cards" or in the Yom Kippur Book of Life that Vincent could have celebrated with the Orthodox community just adjacent to the Antwerp Academe. Such realism was appropriate—especially with the milieu of suffering and deprivation which was so prevalent at century's end—and accentuated in his case.

In Letter 550, he laments his "lot in life" and his complicity in that degradation. Yet he believes that something of great beauty and value to people is happening in his own allotment of gifts and opportunities—his own life-span. In this overarching perspective, he can believe that work, success, frustration and failure, sickness and health, vitalities and morbidities, flow into the making of a life and a gift to the world—regardless of whether he himself (or Theo) will live to see it come about.

Eventually, we will have to revisit his final days in Auvers and see what pattern of circumstances and vicissitudes are at play—his failure to be successful at making a living—though his productive contribution to human betterment may be close to being unmatched in human

history; the "lifeboat ethic"—where someone has to go and where he has become a burden to Theo, Theo's baby Vincent and Jo's future and the only "way out" would be to "lay down his life." The inauguration of this consciousness of mortality first occurs in Antwerp, and in the next four years it will race toward inevitable consummation. Perhaps it is always the case that such morose awareness dawns in a house of such sublime beauty—Antwerp.

In a "Letter to Artists" (1999), Pope John Paul II reflects on the Genesis passage—"God saw all that he had made, and it was very good." I close this chapter with excerpts and interpretations:

> 'As ingenious creators of beauty' you fathom the pathos of the Creation with which 'God at the dawn of creation looked upon the work of his hands.'

> All of us are commissioned to the 'crafting of our own lives'—we are meant to make it a masterpiece.

> Beyond this universal aspect the artist has a special relationship (ministry) with beauty:

> ... touching on the ultimate mystery that is God

> ... The history of art—medieval, renaissance and modern has a unique revelatory power to make faith and Gospel come to life.'[5]

In Antwerp, Vincent embodies and deepens this theological vision and mandate in his own ministry in religion and art. With the impulse of "exuberant brushwork" and the impediment of "literary melancholy" (Walther and Metzger, Ibid.), both gained in Antwerp, he sets off for Paris.

5. Rome, 1999.

5

Asnières-sur-Siene

A NATURAL THEOLOGY OF THE BODY

As SPRING BROKE IN Antwerp, Vincent took his leave and departed for Paris. Beginning in March, 1886 and concluding in February, 1888, Vincent is back in Paris. He had been there before for short stints—the last in '75–76 involved intense Bible study. Now he is living in the city with Theo but working mostly in the Northwest suburb—Asnières-sur-Siene, which lies along the famous water-way 7.9 miles from the city center. Though full of challenges, these two years will also afford profound development in the artistry and pedagogy that was his ministry.

Paris had earlier provided a retreat into biblical and theological reflection. This time in town, he is taking his ministry and witness into the heart of the art world. That he is still reflecting on ministry in life and on the theological underpinnings of such is betrayed in one of the first letters from Paris in '87. Writing to sister Wil in (L 574 [late October, '87, Paris]), he affirms that as the grain of wheat must fall and die, so germination in the human world is about love. Vincent has already assented to the misleading old saw that "loving art makes such human love impossible." In kindly, big-brother advice to the tender-hearted kid sister, he warns against the corrosive effects of melancholy. "Why do you seek the living among the dead? He is risen" . . . then again "the spoken or written word (Calvin) remains the light of the world."

His early work back in Paris is reconnoitering the new surroundings. A moving sketchbook in Rijksmuseum Van Gogh—done in black

and colored chalk and violet ink shows a street with people walking, The Garden of the Tuileries, people in the cemetery on a rainy afternoon. He sketches on the borders of menus in the restaurants—half a franc for *poulet* or picture—slim pickings.

He worked in the studio of Fernard Corman and befriended the likes of Toulouse-Lautrec and Émile Bernard. He found himself in the very center of the revolution in art called Impressionism and Post-impressionism. Theo's gallery was on the Boulevard Montmartre. It was the exclusive show place of Degas and a regular venue for Seurat, Monet, Pissarro and others. Our detailed knowledge of Vincent's unfolding spiritual pilgrimage lapses here because he is living with Theo and is obviously not writing but is engaged in face to face and heart to heart dialogue, into the wee hours of every morning. Long after Theo had retired each night, Vincent was sitting at his bedside struggling through today's cares which were always sufficient bread for the morrow—even though he now occasionally had the warm supper which he had largely missed from the day of expulsion from the parsonage, during the long vagrancy in Drenthe—until now, a duration of 5 years.

Perhaps only brothers close in age can know the mingled frustration and die-hard attachment of the relationship. Here in Paris, it was the odd-couple in extremis with tidy and meticulous Theo and slovenly Vincent. "Throw him out," everyone advised, but Theo could only say, like Sancho to Don Quixote de La Mancha—"I like him, no matter how crazy he gets, I simply like him." Theo said on February 24, 1888—"I miss him. How much he knows. He has such a sane view of the world" (L 579). Theo had been given a glimpse of the extraordinary clarity of perception so often granted to misfits.

He soon leaves Corman's studio to "set out on his own." He flirts with pointillism with an amazing picture of a "chestnut in blossom." It must be April in Paris.

Decades after the tandem deaths of Vincent and Theo, Johanna reflects on this new home for such an odd couple of Siamese twins:

> The new apartment on the third floor of 54 Rue Lepic in Montmartre had three rather large rooms, a small room, and a kitchen. The living room was comfortable and cozy with Theo's beautiful old cabinet, a sofa, and a big stove, for both the brothers were very sensitive to the cold. [My aside: here in just a decade—another shivering Bohemian pair and their dying friend would languish over Mimi's "*Che Gelid Manina*"/ Puccini—*La*

Boheme). Next to the living room was Theo's bedroom. Vincent slept in the other room and behind that was the studio, an ordinary- sized room with one not very large window.

Here he first painted his immediate surroundings—the view from the studio window, the *Moulin de la Galette* viewed from every side, the window of Madame Bataille's small restaurant where he had his meals, little landscapes of Montmartre, which was at that time still countrified—all painted in a soft, tender tone like that of Mauve. Later he painted flowers and still life and tried to renew his palette under the influence of the French plein-air painters such as Monet, Sisley, Pissarro, etc., for whom Theo had long since opened the way to the public.(*The Complete Letters*, Bullfinch ed.,Vol.1, p.xiii, ff).

The change of surroundings and the easier and more comfortable life, without any material cares, at first greatly improved Vincent's health. In the summer of '86, Theo wrote to his mother:

We like the new apartment very much; you would not recognize Vincent, he has changed so much and it strikes other people more than it does me. He has undergone an important operation in his mouth, for he had lost almost all his teeth through the bad condition of his stomach. The doctor says that he has now quite recovered his health; he makes great progress in his work and has begun to have some success. He is in much better spirits than before and many people here like him . . . he has friends who send him every week a lot of beautiful flowers which he uses for still life. He paints chiefly flowers, especially to make the colors of his next pictures brighter and clearer. If we can continue to live together like this, I think the most difficult period is past, and he will find his way (p. xl, xli).

Vincent was a popular fellow, always invited to the studios of other artists with many coming to see him. Theo exclaimed, "I got to know many painters who regarded him highly." He had begun to gain status as a painter with red apples and various flowers—a pot of chives—mackerel and meat. He knew the markets in Les Halles and at St. Placide—where I now work near Institut Catholique de Paris. The live animals for sale— hare and geese—coleus plant in pots. He would draw stuffed animals—an owl, a kingfisher, a Kalong bat and green parrot, and every sort of flower.

His presence was remarkable. A British colleague (Hartricks) remembers a 'robust appearance, a weedy (wiry) little man

with pinched features, light-blue eye, red-hair and beard—
poured out sentences in Dutch, English and French—he will
leave you, 'glance back over his shoulder and hiss at you'—just
like the parrot."[1]

He told Theo that he was working in the spirit of the great Provence
painter—Monticelli—in the South—then Paris. "M. was sad and crazy
and very poor. He dreamed of sun and love and gaity and went through
'Gethsemane' to get there" (misunderstanding and rejection). Vincent
followed M's *empâtements*—small brushstrokes.

He was mentor to the teenager—Èmile Bernard—whom he often
visited in the wooden studio of his parent's gardens in Asnières. The
scenery became the subject of intriguing work: boats, islands with blue
swings, fashionable restaurants (exteriors and interiors), multi-colored
sun-shades with pink sweetbriar, deserted little corners of a park or
country houses for sale.

Johanna also gives us another hint of the two brother's inner life.
They went together to hear several Wagner concerts. One can imagine
that the themes of *Gotterdammerung* (death of the gods), *Valhallah*—
salvation and damnation—suffering, death and transfiguration, were on
their minds and in the public *Zeitgeist*, especially as it weighed issues of
meaning, beauty, good and truth.

That autumn, Vincent organized an exhibition, "*Impressionistes du
Petit Bouvelard*," which had entries from Seurat, Gauguin, Pissarro, and
Vincent himself. His work, *The Voyager de Argenson Park in Asnières*
(where Vincent worked with Signac) was there in the Théâtre Libre
d'Antoine.

Still lives with fruits, flowers, and books especially caught his fancy.
But the furious activity began to break him down and by the late winter of
1888, he was preparing to head south. Again he had in mind a colony for
this new phalanx of artists of the truth, beauty and the common people of
the world. He wanted to be his own man within this array of prodigious
painter-poets, and, in his case—painter-pastors.

He placed himself firmly in the community of the new painters—
whose heirs would be Picasso, Rothko, Pollack and whose legacy would
be a new epistemology and aesthetic—one more abstract and sugges-
tive—but certain in its departure from modernity with all its confidence
and serenity. Though the movement rejected Vincent's "peasant" style,

1. Jan Hulsker, *The Complete Van Gogh* (New York: Harry Adams Inc., 1980), 230.

and though various primitive styles flourished—even among the abstract Impressionists—Vincent sustained his passion for the renovation. Daily in the Louvre and Musée d'Orsay, he admired Degas' supple figures and the landscapes of Claude Monet. He wrote Levens, his English friend:

> I do color studies in flowers . . . red poppies, blue corn-flowers, white and rose roses, yellow chrysanthemums—seeking oppositions, blue with orange, red and green, yellow and violet—seeking *les tons rompus et neutres*. Looking for intense color not grey harmony. In Spring I will be going to the south—blue tones and gay colors (L 459a, Paris).

In 40 years, Vincent would be the darling of Paris—but not now and Theo is already emaciated with consumption. Still Theo sustained his support—he couldn't live with him or without him.

Works During the Paris Period

- *Still Life with Hollyhocks; Still Life with Zinnias*
- *Still Life with Fritillarias*; multiple still lifes with sunflowers
- Two Studies of Paris Restaurant Du Tanbourin—Boulevard de Clichy
- Allotments on Montmartre (2)
- *Voyer d'Argenson Park* / Asnières; (VVG's) answer to Seurat's *La Grande Jatte*
- *Man with a Spade in Suburb of Paris*
- *Portrait of Alexander Reid; Self Portrait with Felt Hat; Self portrait of a Painter*
- *Still Life with Fruit; Books* (Romans Parisiens); *Chestnut in Blossom*
- *Agostina Segatori in Du Tandourin; The Italian Woman*
- *Japonaiserie: Oiran* (After Kesai Eisen)
- *Portrait of Père Tanguy* (Paint man/socialist leader)

Theological Reflections

Beginning in 1880, the literary and philosophical movement that took hold in France was one of naturalism and realism. Vincent was deeply shaped by this consciousness. He was reading Zola, de Maupassant, Flaubert, and his own correspondence and art meditates on the movement's themes. Though the etiology of his concerns for social conditions, the harshness of life, poverty, disease, prostitution, children and endless, unrelieved toil and filth may have been prophetic and religious, he was influenced by, and in turn, influenced, the realist and naturalist school of thought. One can easily imagine that Vincent would get along well with Marx, Wilberforce, Gilbert and Sullivan, Dostoevsky and Dickens.

This mood of realism seemed to instill in him a more accepting and less harsh view toward himself and others. *"Tout comprendre, c'est tout pardoner."* In his letters to his younger sister Wilhelmina, he is offering a more accepting and accommodating theology. Wil cannot comprehend the ways of providence where so much good is lost in the real world of strife, conflicts, and limitations. "Why is it that not all grains of wheat reach their potential of flourishing?" She seems to be questioning the goodness of creation and asking—with her big brother—why evil and suffering—disappointment, frustration and failure endure in God's good world.

I find it fascinating that Vincent is not only seen as one who has experienced these vicissitudes of life but he has become to her a wisdom figure—fathoming the questions in a more thoughtful way. His answer is to live while we are given life and breath and to seek meaning in the natural impulses of love—one to another (LW 1, Vol.3, Bullfinch, p.427). He has moved into the wisdom Christology/theology of Ecclesiastes (*Qoholeth*) and the Gilgamesh Epic where the primal paradigm wanderer in search of meaning is counseled to "cling to the one who lies on his breast and the tiny hand placed in his." "All is vanity," he might agree—but it is for naught to grouse in self-pity but to be thankful in each moment and celebrate those good gifts of grace all around.

If my arguments to this point hold, you may agree that he has actually discovered, through his art, through his study of the human subject—especially in adversity—and through his study of the Faith—a new Humanity, Christology and Creation Theology and that this anthropology enfolded in this divinity constitutes his comingled ministry. Perhaps he has assimilated Victor Hugo's words in *Les Misérables*—as reference is

made to the Christ figure—Jean Valjean—"who loves another has seen the face of God." He reflects in this letter from Asnières that his finest work is the one he crafted in Neunen—just before these months in Antwerp and Paris, of the peasant farmers eating potatoes (*Erdappeleaters*)—which he called his sacred painting of the Eucharist (The Last Supper, L W-1).

The eucharistic theology he seems to have embraced was my subject in a sermon preached in my home church, First Presbyterian Church of Evanston (Illinois), in the summer of 2010. There I was on assignment as a Parish Associate, a role I now play at The American Church in Paris while on sabbatical (2011).

Excursus: Life Together

Sermon for July 25, 2010, First Presbyterian Church, Evanston, Illinois

Text: 1 Cor 11:17–26

He was a Congo insurgent—call him Emmanuel—a common name in this land of colonialism and church missions. Our congregation has deep commitments to this torn land.

Emmanuel was in a gang called Mai-Mai—they raped many, including one lovely young woman named Mimi from the village of Gomer. Dirt poor himself, this was Emmanuel's payoff—the spoils of war. Watching women raped and men killed before your eyes is the age-old tactic of making a community lose heart.

That would be the end of the story except that when all seemed lost, a miracle of love and communion, of grace and forgiveness, entered the anguish and pain. A cross was again to be planted in *Peccata Mundi*—the sin of the world. The Church and NGO's–our world's best hope for forgiveness and togetherness—got people together in what we call truth and reconciliation ministries.

Emmanuel walked up to Mimi's tiny hut; she spoke quietly and forcefully: "you disgraced me and ruined my life in this community— now you are my life and you have to take care of me." Emmanuel fell to his knees and begged her forgiveness—he had wronged her with unspeakable violence. She touched his weeping head and forgave him. He then drew a tiny piglet from beneath his wrap—worth $15, perhaps half

a year's wage—she could raise it into a 100-dollar asset. His gift at the communion altar—you remember—if you are out of peace with your neighbor, first reconcile with your neighbor, then return with your offering to the altar. Emmanuel gave his eucharistic gift to her and to Christ—the captain of souls—the head of the table—the face in the eucharistic altar, the Lord who guides the behavior of both and gives them each to the other in communion. The documentary ends with her walking back home to a new life—leading the piglet with a rope.

The essence of the message of our text today is best expressed by a Lutheran, Dietrich Bonhoeffer, in his work which I often teach—*Life Together/gemeinsames lebens*. You will recognize the words—*Gemeinde*—congregation—this was Luther's translation of Paul's word *koinonia*—communion. Perhaps you prefer the phrasing of a good Presbyterian—here's Joe Harotunian—our Chicago neighbor at Mc-Cormick—then UC, when he writes in his book, *God with Us*. He says this: "The problem of humanity today is that we have lost sight of a 'life together.'" "God," writes Harotunian, "communes with us by our communion with one another. Our communion with one another is a sign for God's communion with us."

These are pretty heady statements—if this is so, then Communion—like baptism—is a matter of life and death. Perhaps this is why, when he was being led to the gallows at Floosenberg and was asked by a friend, "Pastor Bonhoeffer, why are you not afraid?" he answered, "I am not afraid. I have been baptized." Communion is of that import and that is why it was called in the early church, the *pharmakon ton thanaton*—"the medicine against death."

There's another etymology to *koinonia*—life together-communion. A sociologist named Toinnes said from earliest human beginnings, there have been two kinds of human associations—*Gesellschaft und Gemeinschaft*—technical cash transactions—the Lebron James deal—market-place transactions of business and commerce—you scratch my back and I'll scratch yours—*Gesellschaft*. Then there are loving, intimate relations—church/family/friendships with God and the other. Human community in God is meant to be communion—*Gemeinde*. Toinnes, of course, got this from the Bible. One of Toinnes' students, Martin Buber, put it simply—"We either live as I/It or I/Thou."

But enough academic theology—let's stick to the text and walk together through this passage. Let's exegete and exposit this text in some

depth. Then we will summarize our findings briefly by noting three insights into Communion.

The natural scriptural unit here is composed of ten verses—17–26 of 1 Corinthians11. But since Paul is a Hellenistic as well as Hebraic writer—and one part can be a roadmap to the next—there is a context in chapter 10 that is essential to understanding chapter 11.

First, note that this is a reality show—it's a real church supper—which at that time was a kind of love feast. In the house churches of Corinth, which like Romans was right on the tracks, bringing both sides, rich and poor, together, it was a jungle out there. It was like a picnic or church pot-luck for which Aunt Bee made her famous chicken pot pie that everyone wanted to get to first—like hot dogs on the church lawn. Why is it that from the time, we are kids and we seem to want to get the best for ourselves, jostling for the best toy, the good seats up front and the choice cuts? This parenesis is the first part of our text and that behavior seems to get worse as we get older.

Sara and I know such churches (we served Second Presbyterian in Chicago) and two groups—exquisitely blended in communion—gay white males and single black moms. Then we served the Church of Christ Presbyterian—pan-Asian and classicist Issi—refined in faith in the American concentration camps of 60 years ago, with someone who couldn't even speak Japanese or Korean. Yet they blended into a communion song of love. We are thankful that First Presbyterian is becoming such a diverse and inclusive communion.

Then, in verse 23, our pericope begins a very solemn didache—a sacred, authoritative teaching–an instruction. Patterned on Torah, it is a Jesus rabbinic midrash on Torah—transmitted by Paul, apostle, theologian/church planter—one who, as much as anyone, is the responsible architect of the theology of the Christian church.

Some observations on text and context:

Again, it is life and death business—you can die from pandemonium or you can find life. There is some confusion about what is meal and what is sacred meal. Paul is exasperated when he cries out "eat at home and don't be hogs or inconsiderate boors—here at church." The two meals do belong together—but—the bottom line is that this is no fast food stop on the way to the beach. Even though these Sunday evening love feasts may occur at someone's back yard barbecue—a house church, this is worship and sacrament. This is the bread/ body life and blood of God—given for sustenance, salvation, and life of the world. This Creator

God–now clarified for the world in the Son and gifted to the world in the Spirit, is the spirit/life of the world and every living creature—which is everything in creation. Chapter 10—the cup of blessing which we bless, is it not the *koinonia* of the blood and body of Christ? It is communion with the Holy Spirit of God. Without this bread and wine, the world and each of us will die. What a mysterious creator and strange creature we have here, said Kazantzakis in *Zorba the Greek*—you put in wine, bread and radishes and out come laughter, sighs and dreams.

A scan of chapter 10 shows what is really happening in life together, *koinonia* or communion. We are dealing with the double-barreled sin, the maladies and misdirections of heresy and injustice. These are the twin breaches of the vertical Unity or Oneness of God and the horizontal Way of God—space and time. This, of course, is the substance of Torah which is also the Law of Christ or Paul's interesting phrase—the Gospel of God (Rom 1:1). You can feel the Decalogue distillation of the biblical way pulsing through chapters 10 and 11.

Chapter 10, verse 7 says don't be idolaters or blasphemers—you sit down to eat and drink, then get up to play games.

Breach of Torah is the breaking of our own life lines with God and with each other—again at 10:17, for we, being many, are one bread and one body, for we are all recipients of the one bread.

Union or communion is the gift of the union of God—who is One, with the one world—God's family.

So let's bring it home: What is communion, Eucharist, mass, the Lord's supper, love feast, dinner with Jesus at the roadside inn near Emmaus? Or in that balcony restaurant—an upper room—for Passover Seder? What's going on here and what does it mean?

Note three movements in this sermon. Communion is 1) ethereal; 2) earthly and; 3) eschatological. It is beyond us and here and now. It is down to earth and it is leading us somewhere new.

Let's lock these in our minds through three of the world's great paintings of the Last Supper, Rembrandt, Van Gogh, and Dali.

The early models of communion present what might be called an ethereal understanding. Jewish Passover, Jesus' awesome enactment of that paschal feast—the celebration of the sacrifice of the lambs—all converge into that primal liturgy and moving words—"this is my body"—this sublime admixture of heaven and earth is captured in many of the depictions of the Last Supper—especially that of Rembrandt. Something is going on in earth and in eternity. What opens our eyes is what Vincent

calls–"white light"—*Shekinah*—radiance of the divine presence. Even stronger transcending *koinonia* is found in Rembrandt's gathering at "Emmaus."

Jewish Passover is a theophany—God has made a worldly appearance with a message: angels of death and deliverance—recognizable world antagonists—Pharoah or later, Herod—but always that unseen and uncanny deliverer—from the oppression or distress that torments us. In Scripture, this is *Yahweh* and *Ben Adam*, the Son of Man. This is the God who comes across to Moses as *Ehe yireh Ehe*—"I will be who I am." One who walks silently among us, bringing us together, taking us onward.

Or take another great communion text in the Gospels, the historic travelers from Jerusalem who descend down toward Emmaus—dejected, wondering—who then are joined by that ethereal companion—like the crucified one—now at the seaside—now in the upper room; here they are trodding along the way—like a rabbi opening the scriptural midrash— the parade of texts—explaining why this all happened. Then, the stop at the roadside inn and the bread and wine and the breakthrough—he was known to them in the breaking of the bread. Then the blind eyes opened and the confused hearts were convinced—and he disappeared into the dark sky—and the remembrance: "Did not our hearts burn within us as he taught us along the way?" "Do this in remembrance of me."

There may be something ethereal in these comings and goings but one thing is certain—we are there and He is there—communion and life—together. Wherever two or three are there—One is in the midst at table's apex—leading out and on—and bread and fish and drink—and bitter herbs and sweet honey.

Communion is also earthy. Van Gogh himself—and the world has come to think of *Potato Eaters* as his last supper. The poor farmers dug their sustaining breads from the ground—the dirt—the *adama*—is still on their hands. A young woman serves a dish of steaming new potatoes—a life sacrament with some peoples as rice is with others. An elder matron pours out the soothing libation of the barley-malt coffee. Several generations are drawn together around one table. It recalls the scene shared by Eric Erickson as he was researching *Young Man Luther*—as he paused in the simple hut of primitive rural German peasants—with the rough-hewn hard-wood table and the illiterate *Pater Familias*—uttering the *Vater Unser*—the Lord's Prayer—*par coeur*. Vincent has followed this admonition of Delacroix and that of Hegel to portray "the ugly" as indispensible to the comprehensive beauty of life in the world. In Letter

418, he claims to have created the work with "willpower, feeling, passion and love."

One scholar of *Potato Eaters* writes: "The sharing of their meager repast alludes to the Eucharist"—remember the bread and fishes in the Gospels—"the ritualistic distribution of the meal acknowledges a holy presence among the humble peasants gathered around the table" (Erickson). Chardin called communion—"the Mass upon the earth." For Harotunian, the communion is rooted in creation and incarnation—in the physical and natural world. These days we feel the call of our stewardship—our solidarity with earth, sea and sky—with brother sea-turtle and sister pelican. Our communion is with flesh and blood—all flesh—say Scripture—all flesh shall see that glory together (Isaiah 40:5). In 10:26, Paul finds the ultimate meaning of communion in Psalm 24 "the earth is the Lord's and the fullness thereof."

That Vincent is preparing a eucharistic and sacramental tableau in the *Potato Eaters*—his self-appraised "best work"—is evidenced by the context and texture of the accompanying work on "spuds." In the works at Neunen, he draws the planters, diggers and lifters. He exhibits the baskets, the still-lifes, the loading and carrying. For Vincent, this series on work was his prayer for "the hands who have prepared this food"—the sweat of his brow—the gift of authentic life—"outside paradise."

We must therefore eat to thanksgiving and cease eating to our own condemnation. Scripture shows us that we wrest our bread from the earth by the sweat of our brow—and in the bearing of life and life together, here in the common life, the drama of communication and excommunication plays out.

Van Gogh was asked what really was a religious painting—was it the Garden of Gethsemane with the serene olive groves and the saintly Jesus with a halo? No. He said it was "a simple gnarled olive tree standing there for hundreds of years. People's eyes are the real cathedrals—a human soul, a poor beggar, a street walker." From earth herself, God extends His way-going and onward going in a great circle dance with—bonded and banded—devout and needy people—extended out through all time into all eternity—throughout the whole creation.

Finally, Communion is, as Dali suggests, a journey out into God's new time and place in God's imparted new being and new horizon. It is an eschatological feast . . . Here together we "show forth the Lord's death till he comes." Ultimately, communion verges from earth into eternity, where God abides.

In Communion, we hold out hands of *koinonia* fellowship to the other, the stranger, the least of these, the enemy. Think of the immigrants or international workers today in our midst. How urgent now that we offer God's communion to these brothers and sisters who are not only fellow humans but our brothers and sisters in Christ. We must not be tempted aside by those who call for excommunication and extradition.

By now Mimi has raised her piglet and perhaps started a new cottage enterprise. Emmanuel has reentered life as a new reconciled being in Christ—their communion hands out in Congo are joined with ours right now of the people of our own congregation extended across the continents. All who follow Jesus—all around the world—yes—we're the church together. All present company—and by the countless thousands in the communion of Saints past and out into Dali's future horizon—who have been drawn into communion only to be sent out to the ends of the earth are Church. We invite you today to come—to come in, come together and to move out in this great procession of life together.

In the Name of the Father who seeds and gathers; the Son who finds and saves; and the Spirit who enlivens and grows—the One God who forever fashions human communion—be glory forever. Amen.

Theological Analysis: Love for the Least of These

In the letter to Wil, Vincent asks after the prostitute Christine—Sien. "Did her child live?" He asked this, invoking a context of one of the most theologically and ministerially evocative experiences in Vincent's life. Cliff Edwards calls it the "Birth of God," the story of the "Cradle" (*The Shoes of Van Gogh*). His important work on the theological disclosure of the "'meaning' of the cradle" belies the theory that Vincent is becoming more cynical and secular, showing that in actuality a new and profound theological framework and correlative imperative to ministry is arising in his chastened and chastised mind. This natality/nativity conviction began with his haunting dark depiction of a new-born calf being carried into the barn from birth out in the chilly field. We are in the Bethlehem stable.

The cognate set of works seems to have occurred in the months before and after Paris sojourn II. These include the Letters reflecting on the birth of the baby to Sien—and the cradle at her bedside—(1882); *Child in the Cradle with Kneeling Girl* (1883); *Madame Roulin Tending a Cradle* (1888) and *First Steps* (1890/after Millet). Significant cross-reference here

is Millet's *Bringing Home A Calf Left in the Field* (1864/in the Art Institute, Chicago) and in the contemporary hermeneutic on the same theme, Picasso's *Guernica* and Robert Bresson's film, *Au Hazard Balthazar* (1966).

What I have called a *Theology of Natality or Nativity in Birth Ethics* (1989, Crossroads) and in *Jew, Christian, Muslim* (2003, Wipf and Stock) and analyzed as *Akedah* theology—after the Abraham/Isaac narrative in many studies (see my treatment of Jon Levenson's *Death and Resurrection of the Beloved Son* in *Jew, Christian, Muslim*, 2003 and in the autobiography, *Ministry on the Edge*, 2010, both from Wipf and Stock) is the subject of Vincent's ponderings and broodings and indeed, the whole body of "Natural" and "Providential" theology all through the 19th century. His tormented yet prophetic apperception (theologically and ethically infused perception) along with the *Zeitgeist* of the age was not yet capable of a fulsome "Interfaith Theology" where a cross-Abrahamic reflection in a global context was possible.

When Vincent came back to Paris (Auvers) for the final phase of his earthly ministry, we confront a moving scene–one which will mean much in making sense of his biography. Here he and Theo are reunited with the new mother, Jo, whose marriage Vincent had resisted—his gravy-train threatened. Together, they look down on the new Vincent III (after the stillborn one, who came out of season, and our Vincent II). Now at the sight of Johanna's child—the brothers collapse in tears—they are at the manger in Bethlehem. The mystery of this birth and all births is portentious and promising, for it is linked to the mystery of life and death, of themselves, of the world and of God. God was willing to "die at the hands of the world—in order to be born into the world—that the world might live." Not only generationally as the multitudes of mothers who have died across the millennia giving birth attest—but the process of birth itself is a kind of death into life. As a universal proverb has it (including this genre of art), "For each of us who must pass on, a new child is born to carry on"—". . . and when I die and when I'm gone, there'll be one child born in this world to carry on" (Laura Nyro, 1964).

The theological theme is voiced in the anthem, "All in the April Evening":

All in the April evening, April airs were abroad.

The sheep with their lambs passed me by on the road.

All in the April evening—I thought on the Lamb of God
(Hugh S. Robinson)

117

When Vincent painted *La Berceuse* (Madame Roulin, the postman's wife in Arles), he told Gauguin that he painted this scene of a mama rocking five times as he thought of sailors—"who are at once children and martyrs, able to see this study in the cabin of their Icelandic fishing boat"—from Pierre Loti's popular novel *Pecher d'Islande*—"and would feel the old sense of being rocked and be overcome by remembering the lullabies." (L 574, [Late October'87, Paris]).

Our daughters had a wonderful preschool teacher when we moved from Texas to Chicago who explained and conquered anxiety when she sat in her rocking chair and said to the kids "the rug you sit on is my lap—I'm rocking each one of you." In this painting, *Berceuse*, there is no cradle apparent because the viewer is in the cradle. Reflecting on this moment, Cliff Edwards notes Vincent's words: "I will not live for many years."

The case of Vincent and Sien deserves similar attention. Edwards tells it best in the chapter, "The Birth of God" in *The Shoes of Van Gogh*.

> 'The child in the cradle' for Vincent was 'the eternal poetry of the Christmas night baby in the stable' (L 245 [7/6-7/82,The Hague]). This 'light in the darkness' would not be put out. This caring for a child—one abjectly helpless who, when abandoned, will surely die unless adopted by wolves—teaches us that we are to sacrifice our comfort and self-absorption into total availability to another—'to get a life is to get out of yourself'—as my ever-intruding children admonish their easily-perturbed father. For Vincent, this was a parable of 'the divine presence in a difficult world.'[2]

As I write this passage, waiting for one of the three toddlers now under our grandparental care to wake from her nap, I meditate on Reinhold Niebuhr's so-Augustinian words when he dedicates the *Nature and Destiny of Man* to his dear wife and the ever-disturbing "kids who keep interrupting him as he tries to complete these" Gifford Lectures (1939). I concur with Vincent's insight.

When Vincent was thrown out of the parental parsonage in Etten for good on Christmas Day 1881 (for not attending church—a 28-year-old should know better)—he left for The Hague where he developed a liaison with a 30-year-old prostitute—whose 45-year-old mother and her 12-year-old child he had taken in as models and was prepared to marry the now-pregnant Sien to spare her disgrace. The mystery of the

2. Cliff Edwards, *Shoes of Van Gogh* (New York: Crossroad, 2004), 28.

conception of Jesus—and the attending scandal—comes to mind. Now Sien was about to deliver. Vincent took her to the free "lying-in" hospital and marveled there at the miracle of this scandalous, though sublime, nativity—much like that of Jesus and his mother that night in Bethlehem.

After the distressed birth—dangerous to both child and mother— furiously greeted by his family and the upr[t]ight church folk—Vincent is disowned as an implacable sinner and the parents begin the process of having him declared insane and incompetent. The entire package of sexuality, poverty, prostitution, impropriety and degradation is rejected in disgust. Vincent—the beloved son—is despised and rejected—a derelict like all the sick, poor and dejected. How quickly they have forgotten Luther and Calvin and their theology of dereliction—that only the despised and rejected see the Kingdom of God. Only Vincent sees through into the grace and miracle. He looks upon the cradle in the poor ward of the hospital:

> I look at this last piece of furniture without emotion, for it is a strong and powerful emotion which grips a man when he sits beside the woman he loves with a baby in a cradle near them. And though it was only a hospital where she was lying and where I sat near her, it is always the eternal poetry of the Christmas night with the baby in the stable—as the old Dutch painters saw it—Millet and Breton—a light in the darkness, a star in the dark sky. (L 245)

Edwards continues:

> Vincent had already placed 'a small iron cradle with a green cover' in his studio and hung over it Rembrandt's etching of two women by a cradle, one reading the Bible by candlelight. The presence of the cradle, for Vincent, marked his studio as the one truly rooted in life. It is that 'small iron cradle' that Vincent sketched in black chalk and pencil in the autumn of 1883. It is in a corner of Vincent's studio in The Hague. Christine's daughter kneels at its foot, her left hand on the cradle, her face hidden from us as she views her tiny brother. The baby's face is drawn with sensitivity and delicacy not often seen in Vincent's portraits. The child sleeps peacefully, one hand holding the blanket to his chest.[3]

We remember that just as sailboats on the sea at St Remy are Jesus on the stormy sea of Galilee, Sien rocking the cradle and the calf being

3. Edwards, *Shoes*, 31.

carried into the barn after birth in the field are nativity scenes and the *Potato Eaters* is Eucharist. Like Millet, his mentor as a peasant painter, Vincent's work is profuse with biblical imagery.

Vincent writes:

> But if one feels the need for something grand, something infinite, something that makes one feel aware of God, one need not go far to find it. I think I see something deeper, more infinite, more eternal than the ocean in the expression of the eyes of a little baby . . . if there is a 'ray from on high,' perhaps one can find it there (L 242 [7/2/82, The Hague]).

Jesus Van Gogh, as he was called, is cast into the wilderness—now the barren stretches of heath in Drenthe—to be severely tempted. I wonder if the life of the one generation earlier near-neighbor, Søren Kierkegaard, is known to Vincent—out on the Jutland heath of Denmark—his father, a shepherd, curses God by reason of his poverty and suffering and Søren—a philosopher—evangelical—like the great artist—wonders whether the "son's teeth are set on edge by reason of the sins of the fathers" (Jer 31:29).

But even Theo agrees—he must go into exile from the first sojourn in Paris.

> 'Brokenhearted Vincent agreed with Theo . . . here in the desolate regions of the barren stretches where peasants gather peat—without funds and without paints—he draws the scenes around him. . . .when I meet on the heath such a poor woman with a child on her arm or breast, my eyes get moist . . . it cuts right through me—this little boy—Sien's child—lay on my lap— I think we parted with inexpressible sadness. I understand Jesus' words, when he said to the superficially civilized, the respectable people of his time, 'The harlots will go into the Kingdom of God before you' (L386 [9/14/83, Hoogeveen]).

Ministry involves "hands-on" care to the vulnerable, needy, and poor because God has made Godself known in condescension to the weak of the world. "Who loves another has seen the face of God"—Hugo reflects in *Les Misérables*. So theology brings about ministry as ministry invokes theology. Art and Ministry are inextricably intertwined and codependent experiences. The "Light from above"—another word for Torah, Wisdom, Messiah, Christos, Word—"God with us" is what Bonhoeffer called "the man for others." This is the messianic secret. Vincent is discovering this

in his own flesh and blood—his own faltering being and it is reluctantly received—even among his own family, being so inimical to the age.

In 1888, when Vincent was in Arles, Gabriel Fauré introduced his *Missa Requiem* in the Church of the Madeleine, Paris, where he had succeeded Camille Saint-Sëans as music director. Here a master of another art form comingles the *Pie Jesu, Agnus Dei* and the *Libere me*:

> Merciful Jesus—Lord—Lamb of God who takes away the sin of the world—*dona eis requiem in sempiternam*—give us everlasting rest. *Libera me Domine de morte aeterna*—Deliver me Lord, from eternal death.

For Vincent, his morbidity and impending mortality was the signal of his altruistic ministry in response to the undergirding redemptive drama of faith tradition. Johanna and her son Vincent wisely dedicate the *Complete Letters* to ". . . the memory of Vincent and Theo . . . And in their death they were not divided" (2 Sam 1:23). When Jon Levenson wrote his masterwork, *Death and Resurrection of the Beloved Son* (Yale, 1994), he pondered the enigmatic theological-biblical history of fathers and sons, sons and brothers, throughout Scripture. We think of Cain and Abel, Joseph and his brothers, David and Jonathan.

Siamese twins often live and die in vicarious coexistence. I've written on such cases in many essays and books on neonatal ethics. Vincent and Theo seem to be growing old and sick together—though only in their 30's. In *Asnières and Montmartre,* Theo looks haggard. As Vincent completes two self-portraits—*with a felt hat* and *a painter*—we see the evolving joint emaciation of this fraternal symbiosis that was such a great gift to the world. Fritz Erpel has analyzed these and additional (e.g. Neuneñ) self-portraits and sketches, and observes:

> . . . lonely, haggard, emaciated even sickly . . . shows face of an elderly workman . . . a strong willed conqueror, an ascetic and hermit . . . frequently he looks weary, gloomy, even blank . . . a man testing himself.

And on the self-portrait with a straw hat:

> . . . he was a strong man, a little cracked—or rather very much so . . . dreaming of the sun, and of love, and gaity . . . but always harassed by poverty . . . an extremely refined colorist.[4]

4. F. Erpel, *Self Portraits* (Amsterdam: Deutsch, 1963), in Nouwen's notes in Toronto Unpublished Papers.

Henri Nouwen comments in his notes on Erpel's book: "He (Vincent) wants to be a friend of mankind" (Unpublished notes, University of Toronto archives).

Finally, Vincent has had enough of Paris—the second sojourn. There are strong hints that Toulouse-Lautrec convinces him to head south. The influence of Monticello and Cézanne also weighed on his mind. To Gauguin, he wrote, "I'm going south to the land of blue tones and gay colors" (L 569 [Sept or Oct, 1886, Paris]). "I was very miserable, quite ill almost addicted to drink. I crawled back into myself, without daring to hope." He arrived in Arles in the state of complete mental collapse (*"presqu' evanouni cerebralement"*). He asked Bernard to come with him—"the Midi is the place for the studio of the future."

He wanted to leave the impression with Theo that he was still there. Solidarity—even sibling solidarity—as we will see, involves "laying down one's life for a friend"—"a greater love" (John 15:13).

6

Arles

A THEOLOGY OF COLOR, TEXTURE, AND VULNERABILITY

THE TRAIN PULLED SLOWLY out of Arles. It was a local locomotive heading north—major stops in Lyon, Dijon, and Orleans. *El hombre loco* was not on board. He was being cared for in an asylum after the razor incident and the profusely bleeding ear. We remember the self portrait with the bandage—often cynically—though perhaps prophetically, called—Jesus Van Gogh. His seizures were also getting serious and he needed peaceful care. On that starry night, the lunatic lay beneath the star-lit moon as the light dipped in the sky over the Rhone River. On board the Paris train were the two consoling and concerned visitors—Theo van Gogh and Paul Gauguin.

Arles represents the epitome of Vincent's pilgrimage into radiance and color—the splendor and haunting dark presence of God in the night and day of human existence, in earth, sea and sky, and—for Vincent—in the mystery of vocation and ministry. Rich blue and emerald green patches of water illuminated the verdant landscapes. The resplendent pastures and food celestial of the Good Shepherd were still the yearning of his soul in the "valley of the shadow." The bright sky illumined his impressionist–tinged fascination with Japan—the land of the rising sun and the many Japanese prints he and Theo had collected.

Our best entrance into this eventful *kairos* (divine-time) year spent in Provence is to scan some representative work which displays his awakening soul:

- *Landscape with Snow*
- *View of Arles with Irises in the Foreground*; *View of Saintes-Maries de la Mer*
- *Boats on the Beach* (After Delacroix)
- *Le Pont Levis*; *Night Café*; *Café du Forum*; *Yellow House*
- *Courtyard of Hospital in Arles*
- *Provençal Orchard* (works now with Reed Quill); *The Red Vineyard*
- *Cypresses, Olive trees—Montmejour*; *Blossoming Peach Trees*
- *The Langlois Bridge*
- *Harvest in Provence*; *The Sower*
- *Portrait of Josef Roulin*; *La Berceuse: Madame Roulin*
- *Window in Van Gogh's Studio in Asylum at St. Remy*
- *Wheat Field with sun and cloud*; *The Starry Night*
- *Self Portrait with Palate*; *Irises*

Though it was still cold and snow lay on the ground when the train pulled into Arles, and for days to come, he greeted the oriental dawn—the Japanese sun—somewhere abroad in his imagination in the Pacific islands, where many of his Parisien artist-colleagues were already in person. Scarcely aware of the sunrise awakening around them, they saw Old Mother Europe growing dark, cold and oppressive and longed for the natural warmth—the unrestricted gaiety—the color, beauty and austere dignity of the Orient.

In the decadent West, Spengler saw *Der Untergang des Abendlandes*, not *Morgenlandes*—even the twilight of the gods. But Japan was not the cat's meow. In Letter 585 from Arles, Vincent writes Theo that he "is in Japan." Vincent spoke of aesthetics, rather than the politics, of a people who were just then becoming a dangerous "world empire" and who would bomb to destruction at Pearl Harbor that next empire which, in turn, would then genocidally destroy Hiroshima and Nagasaki and begin the nuclear age. Vincent's eye saw, rather, horizons of peace and reconciliation, through the posters papering his room in the Yellow House. His heart and mind were attuned to the exotic birds and flowers, rocks and

roots, even as a strangely hopeful and horrific world history was closing around him.

Vincent romanticized Japan—which has always been a nation and people with an enigmatic spirituality. Vincent actually thought of himself as a Zen Buddhist Monk (Self Portrait #61, Sept., 1889) and dressed as such in one self-portrait. In Antwerp, he began his study of the Japanese woodcuts—especially their bright colors. "It's like a whole religion (taught to us by the Japanese who are so simple and who live in nature as though they themselves were flowers" (until Tsunamis tear them apart, that is.) Vincent continues . . . "it seems to me that people cannot study Japanese art without becoming much more alive and happier, this brings them back to nature . . ."[1]

Reading Zola and Hugo, Stowe and Dickens assure us that, despite his idealizing flourish, these global and political matters were in his mind and on his brush. With the lapse of more than a century—when his inspired works often sell for 100 million dollars—and often to Gilbert and Sullivan's "Gentlemen of Japan"—we can only wonder at the enigmas of that history.

Vincent's health soon improved and his frenetic painting soon took on some dramatic vividness. Still poor as an Etten-church mouse, he reduced his budget for brushes by clipping off a quill, creating startling texture-effect that has long amazed and engaged the world. An early work—*The Langlois Bridge*—probably painted in those first weeks, possesses a "bright blue sky" against the busy commerce below. Reveling in the lower rental costs, he secured four rooms in the Yellow House with studio in situ and restaurant at hand. By May, he had sent a cache of 24 works to Theo in Paris. Thirty-five would follow in autumn.

Fruit trees in bud and bloom then captivated his mind and heart—renewal of light and life out of the frigid and dark European winter—gentle peach, soft apricot, pale pink apples and white almonds and pears—all against verdant foliage of the myriad mutations of green-yellow standing out from the vivid brown earth, golden fields and the grey and blue sky and cloud-scapes. Here was the domestic grace of *Dame Nature Europienne* such as the world had never seen. This was not the haunting dark beauty of Nordic Grieg and *Finlandia* or ostentatious Amsterdam or Paris elegance, nor is it even an imagined mythic, Asian *Morgenland*. Here was Provence—*Al Andalus*—ancient Graeco-Roman glory, Moorish

1. Wessels, *A Kind of Bible,* 151.

Islamica—with brilliant sun, baked and stolid stucco construction—poor peasants and a faint *Havalero.*

As honed in Antwerp when he first joined movement to line, form and figure, now he began to convey mood—sunset and moonrise. He now intuits the fact that we have only begun to fathom after Einstein: that light and life, movement and mass, sound and speech, wisdom and word are covariants on one spectrum of disclosure/insight—of gift/task. This is not only the phenomena and epiphenomena of the electromagnetic spectrum which verges into mystery on all its edges. This is the philosophical wisdom of truth, goodness and beauty and the undergirding and overarching mystery of the reality of God which touches tangentially and transcendentally everything and every moment in creation.

The cold-dry katabatic winds of afternoons in Arles would prove to be a parable of the life/death gusts that would now cross his brow and his landscapes. As he walked the beachy sands, he could not even set up his easel. His words in Letter 755 (Arles) are prophetic:

> I've been out on several hikes round about here, but the wind makes it impossible to do anything. The sky was hard blue with a great bright sun that melted all the snow—but the wind was so cold and dry it gave you goose pimples (L 755)

A whirl-wind of concrete, very down-to earth events, like the inflamed bush on a Sinai desert, the cave-stable in Bethlehem or the lonely cross on a Jerusalem hillside, provides context for this so-human theophany. Here in Arles it was like the frequent wind-storms (mistrals)—violent body-breaking or soul-shattering gales or gentle-healing breezes that would sweep across Vincent's hardened brow.

In 13 months, he would check himself out of the monastery sanitarium in St. Remy and board the night-train to Porte de Lyon in Paris. Before that last gasp of sanity and productivity—ministry, par excellence—such vicissitudes would pass his way: setting up rooms in the Yellow House; exciting preparations to lure the equally destitute Paul Gauguin—to chair the proposed Artist's colony—the Studio of the South; the unceasing argument ending in the slash that proved to be his first clear epileptic seizure; the eviction by the police of Arles on the complaint— qua lynching—of neighbors—over the protest of his friends—postman and Madame Roulin; the marriage of Theo to Johanna in April of '89 at which Vincent was obviously not the pastor—or even the best man; and the departure that would prove to be the *dénouement*—at Theo and Jo's

invitation—to see his newborn name-sake nephew—the now-editor of our prize correspondence. Through it all—400 days, approximately 300 compositions—gifts galore are received, some discarded, some trial—and—error experiments, some miracles for the ages—saved by Theo, Jo, Vincent Jr. and others for all posterity.

Vincent's production in the summer and autumn of 1888 is astounding and magnificent. In mid-August, he sent another roll to Theo, including several seascapes—one of the old fishing village of *Saintes-Marie-de-la-Mer*, invoking Debussey's composition, *La Mer* one decade later. They also simulate Delacroix's *Jesus in the Boat on Lake Galilee*. These were all in the packet along with 35 other works—orchards, fruit trees, wheat-fields and the like. These works would eventually constitute a core of his *oeuvre*—a treasure-trove of insightful and inspiring sketches and paintings. These works are accomplished even while he continued to struggle to believe that his work would ever be praise-worthy and appreciated. Yet his hope was strong—in a subliminal way carrying him along.

Throughout the correspondence of the period, to Theo, Willemina, and Paul Gauguin, one feels that he now senses that even in the face of his morbidities and mortalities—his work will one day thrill the human heart because it has touched the gates of heaven. Not that he is sentimentally pious. In St. Remy, he rejects and loathes the officious religiosity of the sisters—especially in the dark and dank winter months. In his own experience, as well as in all vital prophetic faith, formal and empty worship is rejected. With his close soul-brother—Søren Kierkegaard—we are not to transform the great and good God of Abraham, Isaac and Jacob into "ludicrous twaddle." In his forays outside of the monastery-hospital in St. Remy, he walked and talked with the subsistent-peasant-workers on the land—persons whom he always felt to be his superiors in the eyes of God. That he shared their poverty and pain was his only claim to justification before God and in the *Dignitas Natural* of Luther and Calvin. In *Dignitas Alien,* we all receive the indiscriminate Grace of God—but God's preferential option is with the poor.

He has seen the starry night, albeit from behind bars, like the reed of Isaiah's prophesy and his new quills he has bent but not broken, the dimly burning wick of flaming red hair He is not quenched . To the contrary—as Rembrandt's *Abraham's Meal* and *Pilgrims at Emmaus* were inspiring works for the travail at Arles—the divine companion drew near in meal and text, color and canvas. McLean's song now rings across the heavens:

> Starry night, paint your palette blue and gray, look out on a summer's day, with eyes that know the darkness in my soul. Shadows on the hills, sketch the trees and daffodils, catch the breeze and winter chills, in colors on the snowy linen land. Starry, starry night, flaming flowers that brightly blaze, swirling clouds in violet haze, reflect in Vincent's eyes of china blue. Colors changing hue, morning fields of amber grain, weathered faces lined in pain, are soothed beneath the artist's loving hand.[2]

He offers his *Benedictus* of ministry from St. Remy-de-Provence in Letter 720 to Theo and Jo:

> I wanted to tell you that I think I've done well to come here, first in seeing the reality of the life of diverse mad or cracked people in this *ménagerie*. I'm losing the vague dread, the fear of the thing. And little by little I can come to consider madness as being an illness like others (L 720)

In pain without self-pity and sympathy free of self-service, he sees stars in the night to which the diverse peoples on earth will have recourse through countless endless nights.

The significance of this body of work is perfectly and poignantly clear now with a century's hindsight. Vincent was the pioneer—one among a phalanx of others—of a new age of artistic brilliance, a populist, colorist extraordinaire—a cult figure of popular culture—everyone in the world has one of his paintings on a magnetic miniature on the fridge or a small transparency in the window. Vincent is unique in human history— as significant in import and impact as, say Dickens, Mozart, Caruso, and Kierkegaard—an inspiration to the wise and simple—as both communities find fellowship with him—comingled in selection and service—mastery and ministry.

Only today—with the benefit of perfect 20/20 hindsight—can we be certain that Vincent's day is a true moment of artistic renaissance. We now know that the painters of the Grand Boulevard: Pissarro, Monet, Sisley, Renoir, Degas, et al. (exhibitors in Theo's Gallery) and the painters of the Petit Boulevard: Van Gogh, Bernard, Angretin, Lautrec, etc. (exhibitors in the restaurant on Boulevard Clichy) have effected an aesthetic revolution whose reach is global and lasting.

It is a unique idea of Western tradition that in amplification of the more universal "great men" theory, that certain events are periods of

2. Mclean, Ibid.

world-historical significance. The convictions that such peaks are scattered among the routine hills of the mountain ranges of ordinary history is found in such thinkers such as Milton, Hegel, Mozart, Marx, Toynbee and others, following earlier minds like Aquinas, Maimonides, Avicenna as they re-echo the Jewish, Christian and Muslim historical visionaries beginning with the Deuteronomist, Isaiah, Paul, Augustine, Mohammad, Boethius and others.

The broad Abrahamic, Mosaic, Prophetic, and Jesus tradition perceives—or better, apperceives—*kairos* moments of particular fulfillments within the routine *kronos* flow of historical time. The West—to follow Whitehead's etiological theory of this phenomenon—fashions a new view of time and space in its scientific, theological world-view—where now an Alpha and Omega—a directionality and purpose—even progress and process—construe time as linear—"going somewhere." Yahweh is God who will be—who goes where He will (Exodus). This view will clash with Parmidean metaphysics and all Jungian cyclicities in the West as well as the dominant Oriental cosmologies and temporalities of Yin/Yang, cyclic, illusionary and eternal-recurrence theories.

Western thought, in Whitehead's view, blending Hebraic Jehovah consciousness where God superintends cosmic direction and Hellenic consciousness of correspondence of empirical thinking and rational mind (Logos)—gives rise to the secular world views and ethics which today dominate East and West—North and South.

What is the bearing of this theology of history on interpretations of art history which are at work in the interpretation of Vincent's work?

The underlying convictions and conceptions of sacred history (*Heilesgeschicte*) underlie the secular notions which arise within the materialistic milieu of modernity. With these convictions, the West has infected the world—until very recently. These views proceed from Judaic, Greek, Christian, Latin and Islamic cultural beliefs and values. The cardinal tenants of sacred history concern the mystery of power and destiny of individuals and nations. Here weakness and wisdom trump force and expediency—at least in theory—as these correlate with the actions of justice, peace, love, war, freedom, life and health, suffering and death.

This analysis which I offer, bearing only on theology and ministry, focuses on a theology of vulnerability. In biblical language—especially in its prophetic and Pauline strands—Vincent is learning that his strength is being made perfect in weakness—perhaps even in "a thorn in the flesh"—which may have been epilepsy or Hippocrates' disenchanted "Holy

disease"—perhaps the affliction of Saul/Paul himself. I hope to show in this section of our study that Vincent's life story corroborates the "vulnerability" thesis and that the thesis is enriched by Vincent's experience. My exploration follows three developments:

1. Vincent positions himself in his search for authentic vocation within the deep religious heritage—Prophetic and Pauline—where vulnerability engenders spiritual strength.

2. He also finds meaning in the Eastern theology of metamorphosis—Greek, Buddhist, Japanese and naturalistic.

3. Then—finally—he takes strength and meaning in what might be called a "Radiance-Theology" of Christian theology, both Catholic and Protestant.

In Arles, Vincent's work continued like a mistral—a paroxysm of fury—soon lapsing into exhaustion and stillness. Paul Gauguin swept in by night-train early in the summer. Theo had used the bequest of his deceased uncle's to subsidize his trip and allowed Vincent to finish furnishing a studio and bedroom for his guest in the Yellow House.

Though his production of hundreds of works in the Arles period would not be appreciated for several decades, Vincent seemed to have had a glimpse that they were beautiful—despite Gauguin's ravings. Actually, Paul's works were splendid as well—more controlled—yet stirring. The joint exhibition arranged between The Art Institute in Chicago and the Van Gogh Museum in Amsterdam (2003) reveals the complementarities of these two men of genius—both theological masters–seminarians who could never acknowledge any affinity. They both painted and wrote about what they were doing in the "Studio of the South." Their compositions depicted peasants, town's people, landscapes and houses—even furnishings like beds and chairs. In their correspondence, they reflected on the concepts and motivations behind these works. In the end, it all blew up in an outrage with an attack with a razor that sent Paul away to lock himself in a hotel room with Vincent eventually slashing his own throat—at least the ear-lobe—a cruel gift to his prostitute friend and her Salome-like request: "If you love me, daddy, give me the head of John the Baptist" (think of Caravaggio's painting of the platter). This was a strange kind of gesture to have the last word to "show" Paul. Sexuality, as Vincent hinted, was an unspoken issue in this drama, as elsewhere in his life.

Studio of the South

At his invitation, Paul Gauguin joined Vincent in Arles and by May, 1888, they were living together in the Yellow House. This "Studio" was the first embodiment of his vision to assemble the artists of the day—something like the painters guild of Antwerp in the 17th century—in this case, in pursuit of a common humanistic/theistic endeavor that would recognize "art as a source of hope amid the challenges of modern life; of the artist as a missionary-Prophet; and of a brotherhood of painters joined in the pursuit of shared beliefs."[3]

In this fragile experiment—the two young seminarians—both persistently spiritual and ethical—both deeply frustrated with the acculturated and indoctrinated church—especially for its disdain for the poor and the sick—found common ground—and dissent, in long disputations every night. Both were no longer at home—Vincent at the Presbytery in Zundert, Gauguin in Tahiti and Peru. It was a stylistic school they sought—not exactly a school of Impressionism in the style of Monet and Renoir and not a new school like Picasso would start in one decade—this on Cubism. Perhaps it was like the missionary school started by the Jesuits as priests went out to cultivate and harvest the new evangelical fields now white and ripe in China and Japan.

The Vulnerability of God

This moment of crisis—history proves—deepened the spirit of each man. Here Vincent produces *Starry Night* and *Café de Nuit, Bedroom, Empty Chair* and *Yellow House* and Paul matches him—not only with the chair and café but with portraits, sunflowers and his masterpiece—*The Vision of the Sermon*. The quintessence of the experience for each—Studio of the South confirms it is a fresh experiential understanding of God. Not Nietzsche's dead God but a similarly obsolete and irrelevant deity is cast aside for a more human, warm-hearted, living and vulnerable God. In the glory days of Protestant and Catholic orthodoxy nouveau—stern and confident even as her currency depreciated like the 1929 crash—this diversion from the straight and narrow—and its new gospel of conveyance—was unspeakable.

3. Douglas Druick and Peter Zegers, *Van Gogh and Gauguin: The Studio of the South* (London: Thames and Hudson, 2001–2002), 7.

> "... at home (in Holland) a beggar is a spectre, here (at Arles), a caricature" (L 767 [5/2/89, Arles]).

> "Vincent's Letters express a haunting passionate expression of longing for a God who is tangible and alive, who truly comforts and consoles, and who truly cares for the poor and suffering ... a God so real, so direct, so visible in nature and people, so intensely compassionate, so weak and vulnerable, and so radically loving ... a God we all wanted to come close to." [4]

Cliff Edwards provides me with a starting point and structure for this interpretive section and indeed—this chapter. In his *Van Gogh and God*, in his chapter entitled "The Vulnerability of God," he lays out his notion of underlying belief and activation of ministry that we are tracing. The phrase "the vulnerability of God" does some violence to the goodness and providence of God. It is unlikely that Vincent would have taken to the notion—indeed, he probably would have rejected it as he did the label "socialist" for his own politics. But in actuality, it affirms something very important about the love of God—the persistence of *hesed* in Hosea despite rejection and the *agape* of Jesus—even in the face of our indifference. It is also a phrase which captures well the actual point of the designation—a parable about human responsibility.

The phrase has found its way into the theological nomenclature of the day. It started in Vincent's day in the Enlightenment convictions about the affinity of divine and human qualities of being. Nietzsche, for example, affirmed the "Death of God" as the town crier fearfully proclaimed in *Also Sprach Zarathustra*.

For Nietzsche—as with Wagner, Schubert, Goethe, and others—the diminution of the gods allowed the empowerment of humankind. This idea—or manic desire—goes back into the Nordic and Icelandic sagas and the *Gotterdammerung*—the twilight of the gods. In Schubert's *Die Winterreise*—into which Vincent is surely entering (winter, aging, dying)—we have a plaintive assertion—"if gods are no more in the earth then we ourselves are God." The "humanity of God" is a theme in Feuerbach, Marx, Freud and Nietzsche—reaching a certain culmination in the later work of Karl Barth.

At the outset of the sojourn in Arles, Vincent has already entered the period which all humans face—terminal anxiety—fear of death, mingled

4. Henri Nouwen, "Foreword" to Cliff Edwards, *The Shoes of Van Gogh* (New York: Crossroad, 2004), viii.

with *Todessucht*—yearning for death. Such anxiety rises from anticipation of heaven through faith and from sheer exhaustion and hope for release and rest. Vincent had long endured the perennial anguish of most persons in the world—suffering (bodily, mental, social and spiritual) and poverty (hunger, humiliation [begging and contempt] and gnawing doubt). As we have shown to this point, he also experienced—almost continually along with the premonition and then impending presence of mortality—the confrontation with immortality—the question of destiny and God.

In Letter 626, from Arles to sister Wil, we catch a wonderful and poignant glimpse into Vincent's struggle with vulnerability and suffering which sharpens our vision into his emerging and soon culminating ministry. His little sister—who so loves and respects her big brother—perhaps the only one in the household, church and community who discerned his gifts (besides Theo), she wears her own tender heart all over her sleeve. In Cliff Edwards' most recent book on this filial correspondence, we see how this special relationship layers back this fragile, though immensely potent life, which is already profusely exposed and transparent through his art and correspondence.

Vincent first questions that pouring out "melancholy" to each other may help but it may also keep us from serious love and work, as it causes us to wallow in self-pity. "The best treatment for all ills," he declares, "is to treat them with profound contempt." He seems to be saying—"Work it through to some creative end, find accomplishment through adversity— for it is God who works–even in your adversity accomplishing his own good ends" (Phil 2). Vulnerability arising from patience and solidarity with those who share the "fellowship of pain" (Albert Schweitzer) is creative as it changes the world toward truth, goodness and beauty. Here he recalls again the Apostle and his own charter of selfhood—" . . . that I may know Him and the power of his resurrection, the fellowship of his sufferings, being made like him in his death—that if possible I might attain the resurrection of the dead" (Phil 3:10).

In Willemina's *sehnsucht* and *schadenfreude*, her personal drama and that of her brother is linked with national (the Dutch State), natural and cosmic processes. In the end, Vincent can only look in the mirror, send her a sketch self-portrait—and get back to work. Perhaps he recalls other memorized words of the apostle: "Now we see in a glass darkly, then face to face" (1 Cor 13:12).

We learn this from Vincent in his reconstitution of Dutch Reformed theology into one fully humanistic and universal—one fully integrated at the level of faith and works. He has managed to blend the valid truths of Calvinist and Armenian doctrines of the satiety and suffering of God into a realistic theology of Vulnerability—of salvation and ministry. Consider this set of notes from the early correspondence to Theo from Arles:

> As for my work, I brought back a size 15 canvas today. It is a drawbridge with a little cart going over it, outlined against a blue sky—the river blue as well, the banks orange colored with green grass and a group of women washing linen in smocks and multicolored caps. (L 469, Bullfinch, 585 VG Museum [3/16/'88, Arles]).

> I am in the middle of *Pierre et Jean* by Guy de Maupassant . . . where he explains the artist's liberty to exaggerate, to create in his novel a world more beautiful, more simple, more consoling than ours, . . . like Flaubert he may be saying that 'talent is long patience' (L 470 Bullfinch, 588 VG [3/21/'88, Arles).

> I want to paint a *provençal* orchard of astounding gaity . . . (Ibid., 473/592).

> I don't see the whole future black, but I do see it bristling with difficulties and sometimes I ask myself if they won't be too much for me [suicide?]. But this is mostly in moments of physical weakness—last week I had such a fierce toothache . . . (480/602).

> I should be afraid of nothing if it wasn't for my cursed health— it's patience I need . . . and perseverance (480/602).

> I do not know who it was who called this condition—being struck by death and immortality—we do not feel we are dying, but we do feel the truth that we are of small account . . . those skies all pink, yellow and green of the impressionists . . . they are in truth coming (489/611).

A very revealing picture of the artistic manifestations of his own spiritual tragic-comic, multicolored pilgrimage is found at Arles in a side trip to Sainte-Marie.

Reflecting on the sequence of letters from Arles, we see a classic formulation of an understanding of the drama of human destiny within the enfolding purposes of the One who is the Giver of Life and Death, Health and Suffering, and the Author of temptation and patience/ perseverance through the opportunity/ordeal of this small speck/moment of life that

is our watch. Our vocation or ministry is to see within and beyond this obscure veil of tribulation the "astounding gaity" of the commonplace (Pont Levi bridge with cart and the commerce of life beneath this "bridge over troubled waters" with clear blue overarching and undergirding in sky and water). With the gift and allotment of time and skill we are given here and now, we are to illumine the meaning—Truth, Goodness and Beauty—out of earth's origination and beyond into its destination in the mystery of Creation—discerning and making what is and what it is about. Our ministry is to ply that virtuosity and to offer to the world the God - Given Gift—the form, color and light that we have been given to see, comprehend and share with the world. Every human offering is a Gift of Word, picture, delight, task, insight, admonition, or consolation. Every human gesture of the "Grace of life"—from the hand of that Giver of the Grace of Life, from the new baby to the dying old man—from the poorest to the richest—is part of the panoply of ministry where every particle/ moment is indispensible. We have here—through Vincent's such gift to the world—a new ministry of Religion and art.

Another strand in the history of the doctrine of God and the theme of vulnerability is Jewish theology and philosophy in the 17th through 19th century—an era of corrosive persecution and religiously induced genocide. Spinoza, Buber, Rosenstock—Hussey and Ernst Bloch—and a host of others—fashioned a brilliant religious philosophy in which many resort to the brilliant political-ethical and behavioral-emancipatory insight of the young Hebraic-prophetic Marx and then the similarly liberationist Freud. Dietrich Bonhoeffer continues this heritage by asserting that humanity is "come of age" and cannot refuse to take responsibility and push it onto God. John Fitzgerald Kennedy sounded it in the memorable words—"in this world God's work must truly be our own."

Yet another thread in the complex movement of "Vulnerability" thought about God is a contemporary set of theologians—especially biblical scholars—Walter Wink, Jack Miles, Paul Van Buren—the other so-called "Death of God" theologians—Thomas Altizer, Gabriel Vahanian, Bishop John Robinson (honest to God), and others. The most salient work in this movement—one which resonates with the career of Vincent and helps explicate the theological side of his experience—comes from ancient Near East scholar and Pulitzer prize winner—Jack Miles, referred to above. In his contemporary trilogy—*God: A Biography*; *Christ: A Crisis in the Life of God* and his coming work, *A Norton Anthology of World Religions*, he offers a fresh appraisal of Mohammed and Islam, Jesus the

Christ and God the Father of Christianity and the founding and grounding of the God of Israel.

Miles wants to address the same issue threat Vincent surfaced 100 years earlier. *God: A Biography* considers simply, and at surface meaning, the character of God as Scripture unfolds it—the actor, the drawing, the picture, that our sources present. Is this cosmic power and presence really impotent or doesn't he care? Here one called Yahweh walks silently in the paradise garden—observing—concerned but not bossing around and smashing things.

Then this One appears to Moses in the Sinai desert—a haunting presence—"I'm moving on—come along—but keep your distance—don't touch me and don't try to see my face." This Yahweh, we learn, is much like the Son of Man. We think of Walter Wink's study of "the son of man"—*ben adam*—The Human Being. Now one appears in Ezekiel on the "sapphire throne" with a face "like a human being" (think of Yahweh in Exodus 3—also "One" who appears on a "sapphire throne" and looks human. Is this the vulnerable—at least, the enigmatic One we find in Ezekiel, Daniel, Jesus in Mark 13 or Matthew 25—even the Book of Revelation?)

This God has ceased to be a warrior, a *deus ex machina,* who writes the script and pulls the strings and sometimes brings the whole thing crashing down, to start over. This One seems to be non-coercive—one who sticks with the risk of freedom—maybe red and green can go together or one can gaze into the sun and paint it. Here we find a companion with those who are his friends—gently wooing us and leading us into a project-*cooperatio Dei*—a joint venture—*Tikkun,* divine and human—repairing, healing and mending the aching, suffering earth.

Dietrich Bonhoeffer's read is most salient—taken from his own imprisonment in *Letters and Papers from Prison.* Like Vincent, he is bound toward death in a creative mission which means transcending something old to allow the presentation of something new. One church is falling into disrepair as something fresh struggles to be born. To Bonhoeffer, this perplexity is what is addressed directly by the Gospel: "God lets himself be pushed out of the world on to the cross. God is weak and powerless in the world, and that is precisely the way, the only way in which he is with us and helps us. Christ helps us, not by virtue of his omnipotence, but by virtue of his weakness and suffering."

This theocentric view of the incarnation seems to be ingrained in Vincent—not only through all of the life phases we have reviewed

from Aldersgate to Auvers—but from his fundamental formation in the Schleiermacher stream of theology of culture in the broader Reformed tradition. Schleiermacher—and his cultural sensitivity—we recall—is celebrated by Bonhoeffer, acquainted as he is with the English and even American religious heritage.

In another sense, the "vulnerability of God" is simply a parable about human responsibility. Rather than an assertion about the character and strategy of the creator and finisher of the world, this image is about our human struggle to be part of the answer rather than the problem. Vincent's rumination about a master painter who has "messed up," committed a "blunder," a piece of work in this particular composition—while intriguing and certainly honest about where we are—is overdrawn. One can only think of the plaintive quip of Robert Frost: "God—if you'll forgive all my little jokes on you—I'll forgive your great big one on me."

The best this author can make of this passage is not that this is a "limited" Process God—which would be incompatible with Vincent's Calvinism but that—as with his ruined "sand-blown over" canvases on the Moors of Drenthe—the winds of disarray (the risk God took to grant freedom and love in creation) needed to be allowed to bring ultimate decorum.

While the audacity of wretched Job gives us an ironic moment in the sun as he calls God into the dock—we are set in a place more right and good in chapter 38 of Job's famous book: "Where were you when I called forth the starry night of Orion?"—"can you blow the mistral onto the earth? . . . and bring *visio Dei* right down into this flesh that worm's surely destroy?"

In monotheism generally, and in the Abrahamic faiths in particular, even in desperate ages of human misery and degradation—God-almighty is posited as strenuously impassible (unchanging)—One who doesn't slumber or sleep—though he right well rests from his labors in the delight that creation—on sight—"is good." God is sovereign, knows what he is doing and what he is getting into. Omnipotence, omniscience and omnipresence may be borrowings from Greek metaphysics—especially neoplatonism—but that way of comprehending God and the world itself is the gift of Scripture and the God of Abraham, Isaac and Israel—the God and Father of the Lord Jesus Christ.

Scholasticism also resists the notion of the vulnerability of God. It seeks philosophical, political, even mathematical coherence, logic and consistency. Scholasticism tends to subject God to the categories of

human rationality. A vulnerable God is an oxymoron. All the same—Augustine, Aquinas, Luther, Calvin and most classical, Renaissance and modern theologians and Church Fathers, indeed all biblical theology, gives some credence to a suffering or vulnerable God.

Holy Vulnerability according to Sarah Coakley

Sarah Coakley, now a Regis Professor of theology at Cambridge, for example, seeks a theological understanding of vulnerability which resonates with the interpretation we have offered on Vincent Van Gogh. In *Kenosis and Subversion: On the Repression of Vulnerability in Christian Feminist Writing*,[5] she seeks the delicate equipoise among three forces which arise as persons face oppression and adversity—submission to God, human vulnerability and the power of being.

Writing as a feminist theologian, Coakley seeks to avoid dehumanizing passivity while recovering the value of kenotic vulnerability which, christologically construed, is divine power wrapped in the gift of helpless human flesh. Just as Vincent wields thought and will, word and color in his unique–though idiosyncratic—assertion of the virtuosity of one's being in the service of fellow-humanity—a peasant painter, living poor for the poor, Coakley lays down a philosophical-theological background for such "being for others."

Finding wisdom in paradoxical reasoning—e.g. strength in weakness as justice is being sought—Coakley argues that the Christological doctrine of self-emptying (Phil 2)—wherein the divine/human son honors God by not grasping at supremacy or even equality—but in "self-emptying" in order to embrace helpless humanity through identification and incorporation—in suffering, death and resurrection—exists so that agony (and oppression) is transfigured into the very power and wisdom of God in life.

Coakley's construal of vulnerability supports the line of thought this study has taken from Cliff Edwards. She argues that "kenosis" actually subverts the pretensions of power by exhibiting a "great reversal"—found in "the Magnificat" and "topsy turvy" awareness—where the mighty and haughty are cast down in the very act where the lowly and poor are being raised up.

5. (Edinburgh, 2008).

In Christian feminism, Coakley shows that not only is our life saved as we lose it, but submission—even abject suffering—can be redemptive and transformative—because of the "arc of justice" by which God orders history. Because God takes down the oppressor and the powers of domination and subservience is subverted into power. Vincent wanted to see great works of beautiful art bringing beauty and joy—the wonder of God's creation—in the simplest hut and hovel where work, love and faith transformed adversity into solidarity.

When we turn to Vincent, we see that he is always pondering these mysteries—in the down to earth victories and vicissitudes of his existence. In Letter 604/800—September, '88 from St. Remy—we find his penchant for vibrant description of color—as if nature was the very substance of the tragicomedy of existence amid the tortured-triumphant Dance of the triune God through God's world.

> My Dear Theo,
>
> I'm writing you from Saintes-Maries on the Mediterranean— which has a color like, in other words changing—you don't always know if it's green or purple—you don't always know if it's blue—because a second later, it's changing reflection has taken on a pink or grey hue. You eat better fried fish here than beside the Seine—I board and eat for 4 francs a day . . . (L 619/831).
>
> What do I hope for? Is it that a family will be for you what nature, the clods of earth, the grass, the yellow wheat, the peasant are for me . . . you will find in your love for people, something not only to work for, but to comfort and restore you when there is need . . .

In his important book—*Luther and the Family*—William Lazareth (Muhlenberg, 1960) shows how Luther saw the family as a bastion against the storms of life. Family was "the little church"—here were the sick, the hungry, the naked—here all the commandments are put to the test—here is the arena of love of the neighbor.

Vincent, by contrast, was a vagrant on the earth. A Pilgrim wanderer, he "had nowhere to lay his head." His family were the peasants—the poor of the earth—mother earth herself. "Blessed are the poor—theirs is the Kingdom of God" (Luke 4:20). He did sense an urgent task before him (ministry) and life's finality loomed before him in the near future. He hoped that his work (Light) might find vindication should he live or should he die. In a Letter written during 1883, he had said that "he did

not intend to spare himself—I don't care much whether I have longer or shorter time . . ." "In a few years I must finish a certain work."

Writing from Arles—Vincent echoes this complex sense of vocation (ministry) involving accomplishment and termination. It also involves grave doubts about the beauty and perfection of the divine composition of this creation—and the artist. If mighty God would let his fellow-artists die destitute, perhaps he also is weak and vulnerable. "This good old God took a terrible lot of trouble over this world study of his . . . it is only a master who can make such a blunder. And this life of ours . . . we must not take it for anything but what it is, and go on hoping that in some other life we'll see something better than this." (L 613 (490), Bullfinch, [5/26 /88, Arles]).

When Jesus of Nazareth, called the Christ, identified his ministry/ mission with the figure of "the Son of Man," looked over the city of Jerusalem and somehow in his mind's eye saw that she was to be reduced to rubble—"not one stone left standing on another," he weeps for the city, aware of a peace that was concealed from its fear and violence. The earthly city—even in these *kairos* times when a heavenly city is touching close to terra firma—moments, when eternity is tangentially touching earth—still those who have eyes cannot see and those who have ears cannot hear.

Augustine builds his monumental theology of earthly and heavenly history on this notion of the fragility of this time and place and the blessed grace and peace of the realm of God come down among us in the God/ Man and in intimation and even real presence in sacrament and church. The mystery of the biblical city—come down from heaven (Revelation) which interpenetrates our city is the enigma and energy which is embodied in the flesh and blood of Vincent. *Civitas Dei* amid *Civitas Terrena* is the impulse and spirit invoking all knowledge, art, moral striving—all human work in the world. Vincent therefore is a pioneer and harbinger of the sacramental family of humanity—he has achieved the ministry.

Vincent's journey to the East—the "rising sun"—"the day-star"—is also crucial in the experience in Arles. He has been deeply moved and influenced by Zen Buddhist art. He paints himself as a Buddhist Monk much like the Jesuits who bedecked themselves as Confucionist monks in China. His walls were lined with Japanese prints. He loved and emulated the delicacy, symbiosis with nature and sense of effortless movement.

Spirituality originates in the East and arrives late in the retrograde West. India is the crucible of both Hinduism and Buddhism—archaic

faiths. Indo-European cultures sweep from the steppes of Asia north and west into the pagan and primitive forests of the north. The Mediterranean genius of Greece and Rome have some sources in the Orient—at least the Western Orient. Plato may have sojourned in Egypt. At heart, Judaism, Christianity and Islam rise from the ancient near-east with influential source material coming from Syria and Egypt, Babylonia and Persia and far deeper oriental seats of wisdom. Paul, the Apostle, yeasted his faith— *en Christou*—in Arabia for three years (perhaps symbolic years).

In Arles, Vincent first puts the disc of the sun into the picture. Here, Vincent believes, God looks at us in the eye and we return the gaze. In Provence, life is blossoming within the radiance of the sun. This is not deluge and Tsunami or harsh desert—Drenthe's chill or the sun-drenched heat of Arles. This is blissful symbiosis.

We witness here what could be called the mythology and morphology of Japanese nature philosophy and mystic theology—symbolized by rock gardens and gentle prints of common folks embedded in nature. The reverence for trees—trained Bonzai and verdant forests with waterfalls— makes the present calamity of the Tsunami in Asia in the 21st century so poignant. In Tsukasa Kodero's brilliant summary of the *Mythology of Vincent Van Gogh,* including the correlated notion of body and blood,[6] is where the doctrine of *shirnkaba* is explicated.

". . . Blood, blood, blood—not ideas. Anything but blood is a lie. Vincent Van Gogh's paintings are great because they are neither ideas nor art—they are his own blood."[7] Arles—in this light—what Vincent thought of as his own Japanese sojourn, is the beginning of Vincent's passion, crucifixion, and forever-after being. In the "Yellow House," he faces the lynch mob and in St. Remy he has a Joseph of Arimathea reprieve and rest—for the temptation moment until Satan returns in Golgotha fury—and his *requiescat in pace.*

Much of Eastern wisdom has to do with suffering and death, reality and illusion, truth and ethics—the themes of Vincent's existence. Wendy Doniger—the Mircea Eliade Professor at the University of Chicago— summarized the conclusions of a lecture on "the faiths of India" by saying that Indian philosophy taught us to be suspicious of our senses, and her religion taught us to trust what we perceive. If the same holds for the Western epistemologies, Vincent is at once credulous and dubious about

6. Tsukasa Kodero, *Mystery of Vincent Van Gogh,* 153.

7. Ibid., 153.

what he sees and feels. He sees color and light, illumination and shadow, and they vibrate vividly—they bend like Dali's drooping watch or his own church at Auvers, against which his tombstone rests. At the same time, he is aware that reality is refracted to and through our sensorium and that impressions, abstractions and intimations are the more true eyes and the more accurate, mimetic work of our hands. He also knows that eternity touches and passes on, although it lies under and above everything here, now and forever.

Finally, Vincent's view of God, human destiny and ministry, remains that of the classical Christian tradition: "God so loved the world that He gave his only-beloved Son"; He (the Son) did not consider equality with God something to be grasped—but emptied himself (*kenosis*), taking on the form of a slave and became obedient unto death. Therefore, God has highly exalted Him; Whoever would follow my way must take up his cross and follow me; That I may know Him and the power of His resurrection, being made like him in his death. . . that if possible—I might attain the resurrection of the dead" (Phil 3)

God's great condescending love searches out the lost creation. That creation is ingratiated and filled with glory through the biblical chronicle of God's search for Man and Man's search for God—through the journey of the Son—the Logos/Light of creation/incarnation—and through the ongoing history of the Spirit—who brings the Light, Life and Love of God ceaselessly into the world as God's action and human need meet and intertwine. Radiance is God's gift via the creation for those who have "eyes to see." Vincent, in Arles, helps us see this Emmaus gift and understand.

In an ancient hymnbook entitled the *Salisbury Diurnal,* we find a tribute to the persecuted martyrs that make it a perennial choice on All Saints and All Souls days. "Holy is the True Light" is a hymn that also takes my mind and heart to Vincent as the dusk descends—even amid the whirling radiances and torrid heats of his sojourn in Arles.

> Holy is the True Light, and passing wonderful, lending radiance
> to them that endured in the heat of the conflict, from Christ
> they inherit a home of unfading splendor, wherein they rejoice
> with gladness evermore, Alleluia (Hymn #3).[8]

Arles is—in Vincent's life—a point of unspeakable divine glory— of resplendent color—all amid the harsh travail and mistral of broken

8. *Salisbury Diurnal,* Translated G.H. Palmer, orchestrated, R. Vaughn-Williams, 1950.

life—poverty, sickness, animosity—and irrepressible hope. It is the story of Vincent. It is the history of God.

7

Auvers-sur-Oise

THE THEOLOGY OF *DÉNOUEMENT* AND THE "GREATER LOVE"

Seventy days, seventy priceless works. A walk in the field, a borrowed revolver, then silence. A ghastly suicidal crime against humanity—or an act of greater love? Suicide or accidental homicide? Of one thing we can be certain: Vincent was 'tir'd o' livin' (not paintin') but scared o' dyin' (Jerome Kern's and Oscar Hammerstein's "Old Man River" in the American musical, *Showboat*).

The works of the period are well known. His drawings include:

Auvers cottages with thatched roofs, *Peasant woman in an old vineyard*

The house of Père Pilon; the church at Auvers

A field with wheat stack; The Farm of Père Eloi

Harvesting; House with Peasant Woman Walking

Landscape with bridge across the Oise; Farmhouse in a field

Haystacks; Sheaves of wheat

Paintings from his time at Auvers-sur-Oise are:

Portrait of Dr. Gachet; Dr. Gachet's Garden; Auvers Town Hall

Landscape with the Chateau of Auvers at Sunset; At eternity's Gate (reprise)

Blossoming chestnut branches; Village Street in Auvers with Figure; View of Auvers

Daubigny's Garden; Wheatfield with Crows

Landscape with carriage and train in background

Marguerita Gachet at Piano; Portrait of Adeline Ravoux

Glass with carnations; Japanese vase with roses and anemones

Rose roses; Young man with cornflower; Hay stacks under rainy skies

The works reflect the biography. Vincent arrived in Paris at 10 a.m. on Saturday, May 17, 1890, after a night on the train from Arles. Theo was there to meet him at Gare de Lyon and drove him by carriage to his apartment at 8 Cité Pigalle. Johanna remembered his arrival, after anxiously awaiting the cab into the Close where their apartment stood: ". . . here was a sturdy, broad-shouldered man, with healthy color and a smile on his face."

We can imagine and actually witness the anxiety melting away—the ear, the fight with Gauguin, the confinement—he seemed whole and well. She described how this so-special uncle stood over the cradle and, with Theo at his side, smiled through tears at the tiny face. "He was cheerful and lively during his three-day stay"—remembered Jo.[1] (C. Edwards, *Mystery of the Night Café*, p.100). But Paris proved to be too busy and shocking. He needed some country with trees and streams—field and trees. He found sustenance in the simple peasants of the land. In a short time, he adjourned to a northwestern suburb for some peace and quiet. He was frightened and shaken in the noisy city. He was a rural painter. He was not Lautrec at the Folies-Bergère or Degas in the ballerina studio.

But another dark-lined cloud is looming and will become starkly vivid in the course of 70 days. His initial works back north are of clouds and impending storms. My favorite work of this culminating Paris period is *Champs Sous un Ciel D'orage* (1890), warm, pleasant cultivated fields with a stormy sky in the background—reminiscent of El Greco's *View of Toledo*. I have copied this Paris scene onto translucent plexi-glass—creating a phenomenon that makes me wonder if Vincent tried his hand in stained glass.

Early in the correspondence from Auvers, he writes—now to Theo and Jo—"I have a study of old thatched roofs with a field of peas in flower in the foreground—and some wheat background of hills." I imagine

1. Cliff Edwards, *Mystery of the Night Café* (Albany, N.Y.: SUNY, 2009), 100.

this flowering pea-field to be pink and purple. One thinks of the monk, Gregor Mendel, in his monastery pea garden shucking out the unraveling mysteries of genetics. "As I thought, I see more violet hues wherever they are—Auvers is very beautiful." Purple, violet and lilac has cooled his soul from the scorching, searing sun and the dramatic—so dramatic yellows. Ubiquitous gentle rain has replaced the howling mistrals. But oh, those balmy, starry, starry nights—he can't forget. In the northern climes, such as in my gardens in Evanston, Illinois, and the neighboring brilliant gardens and undulating Japanese bridges of the nearby Chicago Botanic Garden—the springs splash with blues and violets—the mid-summers and autumns cast their blazing glory with goldenrod, bronze and gold. And it is like his art, a parable, for Vincent's life is burning itself out in the anguish of another glory.

At Auvers, he is standing by open fields with storm clouds. The vivid mountains here are softer than those we see the storm rising over that El Greco saw in the *View of Toledo. Wheatfields with Crows* has been much mulled over with autobiographical and Freudian graphics. I side with Cliff Edwards that this is a joyous song of nature as much as a film of impending *dénouement.* Crows often do fill an ominous cloud-filled sky, as we know from Hitchcock's films. Hawks and vultures soar with stately poise, ready to nose dive when vulnerable prey is ripe for the taking. But here is still the glorious field—ripe unto harvest—with the evangelical metaphor that Vincent invokes elsewhere. "Look on the fields—they are already ripe unto harvest"—Luke 6:1; John 4:35, words of a physician of body and soul who may also have been an artist, and the beloved John, the apostle-poet.

Edwards describes the mood of this inception of work in Auvers: "a field of wheat ready for the harvest bends with the heavy grain and moves in harmony with the invisible winds from a deep, rich, stormy sky. Three paths of brown earth and green grass open directly before us and lead off the canvas to right and left."

These busy paths were often traversed by the funeral cortege—perhaps the white horses and carriage of a child's funeral. Vincent may have thought of another great artist of his era—Fyodor Dostoevsky—whose Grand Inquisitor in *The Brothers Karamazov* just started circulating late in Vincent's life. In this scene in the city square in Seville, the child's bier passes the crowd on the street—the aroma of orange blossoms fill the air and the haunting visitor tells Tabitha to arise. Later that night, the healer lies in prison and the old Inquisitor tells him to go away—"You left

the church to us—the miracle and bread, the color and glory of life, the mystery and resurrection—we don't need you or want you back." Vincent understood this parable—he was living through it.

"In the painting the central path curves into the golden wheatfield itself. Forty or more black crows"—perhaps they cawed painfully as they did here in Northern Illinois some few years ago when they died out. Two children came to their end which was their beginning in these ensuing months after the Arles train pulled into Gare de Lyon that stormy Saturday morning. The brothers were 37 and 34 and their lives are unimaginable victories in the face of excruciating suffering—*Kindertotenlieder*. Today we appreciatively remember this work through the rendition of the late Dietrich Fischer-Dieskau.

The Auvers story begins with Vincent's arrival, the homecoming scene at the cradle, of settling into the Auvers studio with Dr. Gachet as a dubious attending physician; the infant Vincent whose destiny will intertwine with that of his now obscure—soon famous—uncle; the flurry and flourishing of work—ending in the tragic, inevitable, yet promising dénouement; Death for and into a greater life through the "greater love." The Auvers drama ends on the hillside churchyard with the two inconspicuous tombstones—Vincent and Theo Van Gogh.

The fascination and concentration of Vincent's art that last summer might be called genre *"in musse."* He is looking at the kernel and seed, the husk and cast-off shell. He is seeing, considering and experiencing the conception and inception—the birth, decay, life and death of all living things. It is the grain of wheat which must fall into the ground, crack and die—to come to life. It is the ripe, golden fields—plenteous to harvest. It is the pink and white chestnut branches in bud and bloom—then nut. It is the peas in subtlety colored blossom, then sturdily encased fruit. It is the coffin-like cradle of the smiling, precarious infant nephew which becomes the cradle-like coffins of two brothers.

Nature obviously is a parable of human life, growth, stress, suffering, death and new life. In Arles, he spoke of the "orange apricot blossoms in the fresh field of green" (L 589 [3/25/88, Arles])—a symphony of inspiration to his own flourishing, yet failing existence. Here is the *"Provençal* orchard of astounding gaity." Like the "vine and branches" or "fig trees" of biblical metaphor, these are parables about our own nascence and growth, ripening and colorful senescence—life, death and new life. Vincent is an old man at 35, and he is about to be born into new being. He now writes in Letter 597 ". . . the little pear tree is vertical, the

ground violet—with straight poplars and a very blue sky . . . with a big yellow butterfly in one of the clusters"—the parable of encasement, death, sloughing off the burden and *resuscitation*. In Letter 7 to Wil, he writes in June of 1890—weeks before his death—"the more ugly, old, vicious, sick and poor I get, the more I want to take my revenge by producing brilliant colors, well-arranged—resplendent." His last words: "*La tristesse durera toujours.*"[2]

Vincent had tried to preach, teach, write, evangelize and console— he failed to find the necessary nurture and advocacy. He found another ministry of word and image which is now known and loved (through digital proclamation) in every corner of the world.

His fallback was pictures—unforgettable scenes. He always felt that these still-life scenes (*Nature Morte*) were of much less value than real life scenarios. Love and family, children, friends and people were a much higher value. Yet he lived out the complex wisdom of his contemporary, Karl Marx and his side-kick, Friedrich Engels—also a failed pastor: "philosophers seek to understand the world—I seek to change it." Vincent opened our eyes and perhaps changed our outlook as had no other in the history of sensory artists: writers, musicians, painters.

In Auvers, he starts in late May with simple, unassuming modesty and attention to the mundane:

> There is a great deal of color (here in Auvers) . . . could you send me 10 meters of canvas and 20 sheets of Ingres paper. There is a lot to draw here. I do not say that my work is good . . . there is less bad stuff. My relations with people are secondary because I haven't the gift for that . . . serenity will come as my work gets on a bit."

I use the word *dénouement*. It conveys the sense of fate, inevitability, necessity: it possesses a kind of Greek, Stoic, Catholic or Calvinist predestination. In Auvers, we see the overriding fear of the next seizure attack looming over Vincent's every thought, every written note and every brush stroke. At that time of history, there was absolutely no prevention or treatment—pharmocologic or shock—for epilepsy—ironically called, across the ages, the "holy disease"—or for most other seizure or acute brain-pain disorders. The fear haunts patients, even today, of that next attack—the seizure—the migraine—the bipolar break.

2. Hulsker, *The Complete Van Gogh*, 585.

With this backdrop of apprehension, Vincent slowly becomes a complete recluse, a mad eccentric genius, a martyr fool-figure. Beneath that malaise and malady, we see a deeply human being—in an attenuated sense, a Christ figure, at least in terms of his being in all measures, like all of us. In light of my affirmative thesis of his being and destiny, I see this *dénouement* as the vehicle of a heightened appraisal of destiny and task— a new accent on the centrality of one's work and ministry as the meaning and legacy of one's life. It is a spiritual and ethical phenomenon as well as one physical and historical. This chapter seeks to unfold that thesis.

I will unfold what we may call the mystery of this particular "*Sein zum Tod*"—this personal trajectory of being toward death (Heidegger, et al.)—in three stages: 1) The Moron; 2) The Martyr; and then, 3) The Minister.

Vincent is first designated a fool—a holy fool. This is a process which seeks to marginalize in order to stigmatize—"despise and reject," in biblical metaphor—to rid the world of an embarrassment in order to confirm the world in its convention of injustice and keep its misdeeds in the dark. It demands the darkness in rejection of the light (John 3:16 ff). It doesn't succeed. A redemptive impulse subverts our malevolence and malfeasance—tears down the dividing walls of our construction (Ephesians and Robert Frost), turning them "topsy-turvy" into a martyrdom where "what we meant for evil, God will use for good" (Gen 50:20/ Joseph cycle—precursor of the Jesus cycle). Finally there will be vindication of Vincent for "pouring out his soul unto death" (Isa 53) as his ministry is fulfilled and humanity and divinity is "satisfied."

1. He was hounded out of the "Yellow House" at Arles by the lynch mob as they shouted "Fou-Fou-Fou-Fou." This week, as I write, at Garrett-Evangelical Theological Seminary where I teach and Cliff Edwards studied, another Ph.D. graduate, James Cone, will give the opening convocation address. He will speak on his thesis—continuing his work on Black Liberation Theology—that an incessant mania for lynching blacks permeates the white psyche long after the bodies have ceased to appear in the trees—pickings for the crows and vultures in the golden wheatfields of our contentment and affluence.

2. Bob Herbert recently wrote in *The New York Times* of "the increasingly grave crisis facing black men"—"more than 70 percent of black children are born to unwed mothers"—and even those moms are absent in large numbers so that kids end in the street or cared for

by a grandparent or other street-waifs. By young adulthood, "a solid majority of black men without a high school diploma have spent some time in prison." "Homicide is the leading cause of death in young black men"–and in some areas "virtually no one has a legitimate job." He describes a virtual genocide of prejudicial violence of the dominant white society mingled with the severe self-destructiveness of the blighted community. Cone's indictment of a lingering "lynching syndrome" is universally acknowledged in Chicago, Detroit, Paris, London and Juarez, Nairobi and Kinshasa.

3. Vincent experienced the same marginalization and a persecution— and the wish that he be removed from the human community. The dominant community felt that there was no room in the world for him and them. "They never understood—perhaps they never will" ("Starry, Starry Night").

In Vincent's case, the nature of the disdain verging on death-wish, sympathetically and symbiotically involving both persecutor and victim, is very complicated to discern and decipher. In Vincent's Auvers consummation of his life, we get certain hints from his relationship with another sick man much in need of a physician—Dr. Gachet. Vincent always portrayed him as a "man of sorrows," much in the visage of Georges Rouault's clown/ Jesus. Vincent himself dwells on Gachet's compulsion about his own portrait and about his desire that Vincent make him a copy of Delacroix's *Pieta*—which we are not sure if he ever finished.

What could this mean? In the history of art, the Madonna holding the deposed body of the crucified, and now deceased, son is profound in meaning, as Michelangelo would show. Sometimes the body is enfolded, not by some *Mater Dolorosa,* as in *la Berceuse*—where the observer of the picture sees it from her tender, embracing lap—but by the Father God-self, who consented to the execution but now is absorbed by the grief and sorrow. Often the composition becomes the Holy Trinity, the Triune God, as the dove of the "Spirit"—that ubiquitous companion/observer of the Passion–hovers over as in the Gospel of John.

In Letter 643 to Paul Gauguin, Vincent says: "I have a portrait of Dr. Gachet with the heart-broken expression of our time." His wife had died and he was far from a well man. But what of this phrase ". . . the heart-broken expression of our time?" Was this the *schadenfreude* of this age, when a sense of Enlightenment and optimism—hope and mutual support, was breaking down and the dark clouds of an ominous future

were hovering near in the dark clouds—global economic crisis and world war—the seeming disdain spreading against the poor, sick and destitute of the world, and the accompanying disillusionment and materialistic greed of modernity. At the same time, remorse is growing over the evils of colonialism and exploitation of the poor, abroad and at home, even though the worst abuses of that age such as the rubber trade in Congo—necessary for modern transportation, industry and war-making—was still alive and well.

Scapegoating thrived in such an age. Artists and poets were found guilty of their counsels of despair and disorder, their inability to instill hope as Shakespeare and even Hugo had—and their indictment of the insensitivity and injustice of the dawning age. The secular departure from the church and the transposition of the tithe—education, health care, pensions for the elders—hospitals and hospices—child care and unemployment insurance, from church to state, brought great blessing. Entrepreneurial capitalism became a savage capitalism. The age also increased blame on the needy for their plight and the accusation of being laggard, sexually deviant or morally deficient. We think of Charles Dicken's and Leo Tolstoy's indictments of the callousness and judgmentalism of the early modern elymosenary state.

Vincent's malaise was biological and sociological. Yes, he reflected the spiritual temper of the age and the cost of being an ethical pioneer in such a time. He also was caught in the vise of living a visionary existence—of being an aesthetic pioneer in an age of great professional anxiety, conventional conformity—an age when cultural appreciation was restricted to the patronage of a tiny elite. "Get to work, man"—" down to the assembly line"—"migrate to the city and make it on your own"—"kids, we need all hands on deck, get down in those factories—we need those tiny fingers and we can only pay coolie wages"—all this has displaced the structure of ecclesial philanthropy, tithe and parish care. The few saw what was happening, and what was coming—most went blithely on their merry way, earning, saving and investing, " looking out for #1," while the new ethical challenge and imperative passed them by.

Shakespeare's and Verdi's fool has become the holy fool of Dickens and Dostoevsky—a religious and righteous sentinel—a martyr.

My clue here is the correspondence around the well-being of nephew Vincent. First, there was the genealogical connection. Our Vincent's grandfather was the progenitor—a minister-theologian trained in Leiden. His uncle Vincent (Cent) was an art dealer. Vincent's earlier

brother Vincent was stillborn. Vincent now bore the name, the legacy, the expectation—the very flesh and blood of the lost, beloved son.

Now, as life waned in his so long awaited being, along came another Vincent and the child's life was threatened from the beginning. In (L 896 [7/2/'90, Auvers]), we find the child sickly and near death. "I have just received your letter in which you say that the child is ill . . . I feel how dreadful it must be and I wish I could help you . . . I will not conceal from you that I hardly dare count on always being in good health. If my disease returns you will forgive me. I still love life and art very much . . . I rather fear that toward say forty . . . "and his thought tails off. The chosen one—one born out of season is blessed in the birth of another (replacement?) and his survival is threatened as is Vincent's own life—and he can do nothing to help—or can he?

In Daniel Boyarin's *Dying for God*—a study of religious martyrdom in the ancient biblical—Jewish and Christian—world, he recounts the agonizing report in Maccabees where the mother of five sons watches each of them threatened with ghastly death—by the official religion—Greek paganism, unless they disown the God and faith of Israel.

One by one, she calls on each to bravely lay down his life—for the sake of the confession. Like the suicide-martyrs at Masada, their lives are a sacrificial oblation to the holiness of the divine Name. Righteousness in destiny is only sealed as "a greater love" prompts one to sacrifice all—to literally "love the Lord with body and soul (Life), mind and strength"—the pivotal requirement of Torah, Prophet and Gospel of which the Martyr, Dietrich Bonhoeffer spoke—"when Christ calls one He bids him come and die" (*The Cost of Discipleship*). There are several distinct meanings of suicide—existentially or socially driven—in our languages—*selbstmord*, "laying down one's life"—these need to be sorted out in Vincent's case.

Reading between the lines, Vincent may have found himself confronted with such a sacred, faith-lineal challenge—where either he or the child must die. With Theo's imminent demise mounting in the background and with the acute scarcity of funds to support these three lives—to which is added Jo's nursing, nurturing expenditure—a question of martyrdom—at least perceived martyrdom, may be arising. In a larger sense, we may ask whether Vincent "lays down his life," not only in fear of another seizure that will put him out of business for months—not out of triage judgment where one or the other Vincent must die—but for some holy cause. Edwards opens this issue in each of his books by framing

Vincent's witness—as I do—in the context of Isaiah and the "suffering servant."

C. I propose a more modest interpretation, which again I have learned from Cliff Edwards, that Vincent senses an impending mortality throughout his all too short two-decade working life as a minister, then artist. He interprets this allotment as a divine gift and destiny but, more importantly, as the life which justice and love requires of him. One's vocation or ministry—a bestowal received by every being in creation—is a radiation of light, a canvas of color, a many-colored dreamcoat which each of us displays in our brief watch in the world. Each quest and destiny is unique—no one else can or could do it—each of the hairs of our head—golden blonde or flaming orange, is known to God—as is the place and span of our ministry. When we die, we lay down that gift with thanksgiving—and our works follow us. Again, Vincent's signature Scripture speaks for everyone: "Let your light so shine before humanity (*anthropon*) that they seeing your Good Works—may offer their (particular) glory to our father in heaven" (Matthew). This is a new universal piety, which Jesus builds on the foundations of world faiths, Judaism, and all derivative spirituality and morality in this world—and is the groundwork of human love.

The Psalms—a universal residue of Abrahamic scriptures—speak of the works of our hands and lives as a divine establishment—a sculpture or building—in this world. These works of glorification and virtuosity—the gestures of love can never fail and cannot be lost—for God is Love. Their works follow them and when we celebrate the season in *Rosh Hashanah/Yom Kippur* and the *Ramadan/Id-al-fikr*—they are registered in the "Book of Life." One Christian variant on these deep liturgies is the Apostle Paul's yearning in the midst of his anguish "to depart and be with Christ." What he receives is rather "my grace is sufficient for the day—work for the day is coming when our work is done."

As I write, the new conductor of the Chicago Symphony Orchestra—Ricardo Muti—conducts the *Requiem Mass* of Luigi Cherubini. The text is always the same ". . . may the One God, the Father Eternal and Light over all—grant them rest eternal—and their works do follow them"—our ministry.

8

Accession

A THEOLOGY OF RESURRECTION AND RECEIPT OF ETERNAL SPIRIT INTO THE WORLD

LIKE MOZART AND MOSES, the burial plot is obscure—if known at all. Two inconspicuous markers in the Auvers' churchyard: "*Ici repose Vincent Van Gogh*"; "*Ici repose Theo Van Gogh.*"

The body was still warm in the grave when the sparks of interest in Vincent's work started to simmer. The Phoenix was stirring in the ashes. Again the cruel irony is borne out that the "blood of the martyrs is the seed of the church." On the eve of Vincent's death, Theo held a memorial exhibition in early January, 1891 and by the end of the month—he too was laid to rest in Auvers. Other memorial exhibitions occurred in Brussels, Paris, The Hague and Antwerp.

In the next decade, Retrospectives were held in Paris and Amsterdam. The first event in America—which eventually embraced the work warmly—occurred in New York City in 1913. Within a century, he had become one of the most celebrated and recognized painters in history—the "inventor of modern art," a colorist as innovative as the glass maker at Chartres Cathedral. His influence is self-evident in Picasso, Willem de Kooning, Mark Rothko, and Jackson Pollack. Explaining Henri Matisse, the German Impressionists—De Brucke and certain Asian schools—begins with Vincent.

In recent years several of the multitude of observers, on-lookers—who must now number in the millions—have sought to trace the

phenomenon, the influence, the mythology of Vincent Van Gogh. What can explain, they ask, the meteoric rise in attention after such an obscure and unimpressive beginning? Today, it is very difficult to find anyone in the world who has not heard of him. In his own day—Brother Theo knew that something extraordinary was happening and he passed this intrigue on to Jo and his son Vincent (through Jo)—even though their lives were all threatened by the fragile and hyper-dependent existence of Uncle Vincent. Perhaps Barnard, Pissarro, Toulouse-Lautrec and Gauguin, among others, had "eyes to see" what was happening.

This work does not weigh in on this search for explanation but rather seeks only to set the record straight in one small way–influenced by the pioneering probes of a fellow-theologian—Henri Nouwen. The author of *The Wounded Healer*—perhaps alone of his generation and by virtue of his extraordinary cross-cultural sensitivity (Biblical and Euro-American, like Cliff Edwards, who understands both the Japanese and French as well as the Anglo-American context)—peered deeply into those same eyes as Edwards, seeing one who looked on the world with a penetrating gaze to its understanding and enrichment. The new vision—to become universal—is seen in history perhaps once in a century. Cliff Edwards begins his annex to this book with the startling assertion: "We struggle to see the world through a pair of humanity's most creative and intense eyes. We seek to learn from the gaze (Derrida) that engaged the world around him with such compassion and depth." (Appendix, p.1)

My overriding purpose for spending these considerable hours late in my own career is to say thank you to God for Vincent and to Vincent for the human family. His most crucial contribution to humanity may be his vision into the pathetic soul—the soul of the simple and the ordinary, the suffering and the derelict, the poor and laboring—those perennially over-burdened, over-accused and over-looked—the oppressed of the earth who are the "preferential option" of the Lord of Israel/Son of Man/*Ellah/Abba*—the One the world has come to recognize as the One God—Father Almighty—Creator of all. As Henri Nouwen wrote, it was a divine gift that "He wanted to see the misery of all things." In doing so, I would add, he caused us to see the sheer joy of life, in the world—*Quelque chose la Haut*—within the purview from above by the One "Who is over all and in all" (Eph).

Today the news carries a rare instance of good-tidings. Hunger in the world has dropped beneath the one billion number—thanks in part to falling food prices—secondary to global economic weakness (*New*

York Times, Sept 15, 2010, A4). For this we can, in part, thank Vincent. His lasting legacy is the heritage of a better world—where the plight of the vulnerable is made visible, colorful and unforgettable. We still eat potatoes at his simple Neunen table—under that "White Light"—Vincent's "Strength from Above."

Vincent is recognized in every continent and among every people on earth. His legacy is rich, deep, and complex. I hope to have shown, in this essay, that his impact is at least a three-fold *Munus Triplex*: now not Orthodoxy's Father, Son and Spirit or Calvin's Prophet, Priest and King, but Artist, Correspondent and Minister.

By now the reader is aware that I am offering an even more radical appraisal. Can we find here a glimpse into revealed theology—the very character and activity of God, as much as a fresh view into the man, into the resplendent world around us and a portrait of the inestimable, indomitable and unconquerable spirit of human persons?

My thesis requires the very recent discoveries of this three-fold genius–finding in him a complex virtuosity involving writing, drawing and preaching—a most unusual triumvirate—bearing a universal cache: in short—a ministry of art and religion. Events such as the publication, through the Van Gogh Foundation, of the complete *Correspondence* in six volumes in 2009 (Nienke Bakker); the 2009–2010 exhibition in the Van Gogh Museum in Amsterdam of the *Correspondence*; and the pioneering research of the Henri Nouwen Foundation in Toronto into "The Ministry of Vincent Van Gogh"—of which this project is a part, all these developments, in part, constitute the new evidence.

The essence of what I wish to argue in this section called "Accession" is what theology takes up under the subject of God; the Resurrection of the God-in-our-midst (Emmanuel) and the Spirit in the world. Assessing his ministry against the underlying theology of his life and witness is therefore a task of a theology of the One God: Father, Son and Spirit—the latter theme of which systematicians like Paul Tillich, Jürgen Moltmann, Kathryn Tanner and others identify with the creative activity of culture—including the arts. This is also explored in theological discourse under the theme of contention with the adversarial powers in the world and the victory of the Divine Way over the persecuting powers of adversity, violence, poverty, sickness, defeat and death. Here we allude to work like that of Daniel Migliori and Walter Wink.

I have mentioned the work of Liberation theology. One variant of this school of thought is Black Theology (James Cone) and the close

cognate field of Womanist Theology (Katie Cannon, Bell Hooks, Toinette Eugene, Emily Townes, Andrea White, et al.,) which embraces not only the concerns of Black Theology but of the other Liberation theologies— Feminist, Hispanic, Asian, etc. Most important in the case of Vincent— Gay, Lesbian and Bisexual and Transgender Liberation (LGBT) theologies and the extension of these concerns into the realms of sex-trafficking, sex-slavery, prostitution, unwed mothers, etc. finds pertinence (See Appendix, Vaux and Glaser).

Though persecution of persons of African descent in light of the "Great Passage" is the signature "lynching" in human history, we must add to this burden the atrocities visited upon the Jews, Muslims, Koreans (by the Japanese), the Armenians (by the Ottoman Turks), women, children and LGBT—by the whole world—especially by the good folk of the three monotheisms who have been known to resort to stoning and lynching—especially against gays and unwed mothers.

Vincent was involved in the art, gay and sex scene. He consorted with women of the street and was treated for gonorrhea and syphilis— which may have been related to his mental conditions. With Sien, Kee Vos and Margo Begemann, he wished to take them to wife and family, shelter them in his arms and home (hovel) and he was refused, as he was at other times in his short adult life—and his censorial family decried the relationships.

On the sexual matter, he mentions several times that something is "unmentionable" both in reference to home life in the parsonage, in the candidacy process both for ordination and as evangelist, in the domestic hassle with Gauguin, and elsewhere. This opens the conjecture that he may himself have been homosexual, bisexual or that he had certain issues with gender identity and sexual promiscuity.

This Dionysian/Apollonian issue has particular bearing on our theme of ecstasy and eschatology—of sin, judgment, death and resurrection and new life as well as biblical sexual ethics as it arises in Puritanism and conservative Christianity.

Jesus associated with sinners and prostitutes, adulterers and homophiles (don't make me prove that—but I know it is true to Jesus' character). He was executed in the terrible, disgraceful manner of a criminal—and one contemptible. He was hung on the tree—reserved for the cursed by God and men—"outside the city" on the garbage dump named Golgotha—the place of skulls—here was the sordid place of the despised and rejected. We remember Vincent's laconic piece of a skull—smoking

a cigarette—posing a certain defiance on his part toward decorum and decency. His God is friend to the derelicts (Luther). This reminds us of a certain sacrilegious art work in a recent Chicago exhibition depicting a crucifixion robed in lingerie. It also calls to mind the execution of castrated blacks on the lynching tree or Matthew Shepherd, the gay man, hanging crucified on a barbed-wire fence in Wyoming.

Serving inner city Second Presbyterian Church as pastor at a time when its main constituency was gay men and unwed black mothers, and seeing the exquisite care that came about for them, makes me wonder whether Vincent's sin was against Victorian prudery in his simple care for those same unwed.

This *scandalon* of the cross—where God has chosen the despised of this world to confound the wise—remains an interpretive motif as we think about Vincent. In the language of the beginning of Paul's first letter to Corinth—a city of degradation—"the preaching of the cross is foolish to those that are perishing"; "We preach Christ crucified, a stumbling block to the self-proclaimed righteous and foolishness to those who claim to be wise (my paraphrase)"; God has chosen the foolish of the world to confound the wise—the weak to confound the mighty" (1 Cor 1). Yet from the death-heaps of Golgotha, one—the Sublime One—walks back into this world. And as Henri Nouwen, a gay priest, author of *A Wounded Healer,* a saint after Vincent's heart, writes—this man never died—he walked back into this world—"to become the friend of all."

The words of Albert Schweitzer—written just 16 years after Vincent's death—on the same turf where both pastors lived out their lives, strike home—perhaps because both of their art works—Bach on the organ and La Berceuse on the easel—exhibit similar theological notions of life-everlasting—which is what we're after in this chapter:

> There is silence all around. The Baptist appears, and cries 're-pent, for the Kingdom of Heaven is at hand.' Soon after that comes Jesus and in the knowledge that He is the coming Son of Man lays hold of the wheel of the world to set it moving on that last revolution which is to bring all ordinary history to a close. It refuses to turn, and He throws Himself upon it. Then it does turn; and crushes Him. The wheel rolls onward, and the mangled body of the one immeasurably great Man, who was strong enough to think of Himself as the spiritual ruler of mankind and to bend history to His purpose, is hanging upon it still. That is His victory and His reign.

The truth is it is not of Jesus as He is historically known, but Jesus as spiritually arisen within men who is significant for our time and can help it. Not the historical Jesus, but the Spirit which goes forth from Him–(*through us today: my summary*)— is that which overcomes the world.

He comes to us as One unknown without a name as of old by the lakeside he came to those men who knew him not. He speaks to us the same word—'Follow thou Me' and sets us to the tasks which He has to fulfill for our time; He commands, and to those who obey Him, whether they be wise or simple, He will reveal Himself in the toils, the conflicts, the sufferings which they shall pass through in His fellowship, and, as an ineffable mystery, they shall learn in their own experience who He is.[1]

The question which must be asked about Vincent and his problematic sexual proclivities and his commendable compassion for those driven to sexual promiscuity or trapped in the oppression of prostitution, sex slavery, homosexuality, unwed motherhood and other experiences on the "lynching trees" of contemporary prudishness and self-righteousness is this—"What is the liberation effected by the God of the Oppressed (Cone) in our individual and common life in the flesh—in this world?" Two biblical parables come to mind—both expositions of the commandment—cognate to "No other gods"—"No sexual infidelity." Consider the story of the Woman at the well in John 4 and the story of the Stoning of the Woman caught in adultery in John 8. Both incidents amazingly appear in the Gospel of the "Beloved Disciple." The groundwork teaching in both narratives is the same: 1) condemnation of religious, vindictive violence; 2) forgiveness; and 3) the proffering of new life. Here is the unfolding ethical midrash:

"Woman, where is your husband?"	"Master, this woman was caught in the very act."
"You are right, you have no husband."	"The one of you without sin cast the first stone."

1. Albert Schweitzer, *The Quest for the Historical Jesus* (New York: Macmillan, 1906), 370.

"The one you're with now is no husband."	The line in the sand . . . C6 + C7 (adultery/killing?) "Woman, where are your accusers?"
"The hour has come to worship the father in spirit and truth."	"Go and sin no more." (John 4)

Observations:

- "There is now therefore no condemnation . . ." (Psa 51:1; John 3:16, 17; Qur'an: 3:103,105).

- We are liberated to mercy, commitment and new life in the resurrection Spirit—"Liberty."

- "If the Son/Messiah, Logos, Torah, *Taurut* sets you free—you shall be free indeed." (John 8:36).

- Go out into the world offering forgiveness and reconciliation such as you have received.

- The best way to know God is to love many things—love a friend, a wife, something.

Augustine—another playboy—confessed, "Late I have loved Thee, O ancient Beauty, ever new." As I ponder the accession of Vincent's gift into the world, I take him at his word that his sole and enduring purpose is to love another. "The best way to know God is to love many things, love a friend, a wife, something" (L 121).

He obviously is starved for love—though his heart is full-bursting of this desire—so vivid in Augustine's exposition. His shot in the field of Auvers that golden afternoon was meant to break and silence his aching, loving heart. Reflecting on the declension of Love as I find it in the so-caring yet so-conflicted existence of Vincent, I go back to the typology of love in Augustine and his protégée—C.S. Lewis. Here is my matrix:

- Unrequited love, love for the "least of these"

- Love of those considered unlovable—the loathsome, troublesome, contemptible (see Martha Nussbaum)

- Love of the stranger, alien (migrant), enemy

- Sacrificial love—agape—"He who must die"(Vincent and tiny Vincent)

- Love which sees beauty in the common, sordid, (Sien, the prostitutes, Jesus and Magdalene)
- Love of the creation, nature, love as light and word
- Works of Love—Kierkegaard
- The Art (artistry) of love—Erich Fromm
- *Eros, phileia, agape*—the canopy of love

Vincent was once asked about his life's creed:

> I want to be silent—and yet, because I must speak—well then—
> as it seems to me: to love and to be lovable—to live—to give life,
> to renew it, to restore it (nursing the dying Sien or the burned
> miner in the Borinage for months)—to preserve it—and to work
> (think of Freud's love and work), giving a spark for a spark, and
> above all to be good, to be useful, to be helpful in something,
> for instance lighting a fire, giving a slice of bread and butter to a
> child, a glass of water to a sufferer (L R4).

Harriet Beecher Stowe's *Uncle Tom's Cabin* was one of Vincent's favorite books, a treatise on justice in life and the desperate poverty and prejudice he had to experience. Vincent also found here a treatise on the transitoriness of life and hope for the world to come. In the Yom Kippur liturgy, this is the liturgy of the Messiah found at the end of days while the gates are still open for us to repent and come in with Messiah. Jewish legend asks where the Messiah will be found. He is among the lepers, lame, sick and poor at the gates of the city—here is the bosom of Abraham. The Liturgy concludes with the *Neilah* (closing of the gates).

The sun is low, the hour is late; let us enter the gates at last. When a man begins life, countless gates stand waiting to be opened. But as he walks through the years, gates close behind him one by one . . . At the end, they are all closed, except the one final gate, which we must enter. Today I shall come, says Messiah, if only all of you would listen to my voice.

Uncle Tom's Cabin, or Life Among the Lowly is the story of a long-suffering slave who is sold to Simon Legree—a brutal owner. Though the book supports abolition, it commends compassion and gentleness—silently absorbing disgrace and suffering. Rather than the letter of Karl Marx to Abraham Lincoln at the same period commending careful resistance and rebellion in its good time, Stowe commends a kind of non-resistance to evil based upon a spiritual model of trust in God and

unwillingness to employ evil to combat evil. Both postures can convey a love toward both perpetrators and victims in human strife.

Human morbidity and mortality—injury, defect, sickness and inevitable death—is a thin screen between the "is" and the "will be" of our existence. This fragility prompts our contingency—total dependency on God and the ability to care and love others. It is also the vehicle of divine care for the world. Vincent frames the theological ground of this fragility-interdependence with an interesting metaphor—the developing masterpiece that is the "ever-being created" world.

> The study is ruined in so many ways. It is only a master who can make such a blunder, and perhaps that is the best consolation we can have out of it, since in that case we have a right to hope that we'll see the same creative hand get even with itself (L 490).

The notion here is much like one of the major concepts of creation in the Hebraic-biblical tradition where the pristine creation was spoiled by mutiny in the divine entourage itself—the fallen angels (Gen 9)—so God does a rework of the canvas creating humans as cooperators in repairing the earth—*Tikkun Olam*. This is the reality in the Abrahamic theologies of mending (saving or salving/healing the wound) of resurrection and reconstitution—giving a new start through eternal spirit processing and accessing into the ever being-renewed creation.

In Edward's words, "the mystery of our flimsiness . . . is the hope of the eternal."[2] "If we are as flimsy as that, so much the better for us, for then there is nothing to be said against the unlimited possibility of future existence."

Vincent's words here resonate with many of the theological (Augustine), ethical (Rauschenbush) and secular (Emerson) arguments for resurrection, everlasting life, the world to come and new being. Transitoriness is the motivation and proof of the lasting meaning of Vincent's and our frail and fallible ministry and art. Reformed liturgy prays:

> On Rosh Hashanah we reflect, On Yom Kippur we consider:
>
> Who shall live for the sake of others, who, dying, shall leave a heritage of life.
>
> Who will burn with the fires of greed, who shall drown in the waters of despair.

2. Edwards, *Van Gogh and God*, 142.

Whose hunger shall be for the good, who shall thirst for justice and right.

Who shall be plagued by fear of the world, who shall strangle for lack of friends.

Who shall rest at the end of day, who lie sleepless on a bed of pain.

Who shall go forth in the quest for truth, who shall be locked in the prison of self.

Who shall be serene in every storm, who shall be troubled by the passing breeze.

Who shall be poor in the midst of possessions, who shall be rich, content with their lot.

Forgiven the past, renewed for tomorrow, we go forth with rejoicing.

Conclusion

WE HAVE PROPOSED AND developed the thesis that Vincent Van Gogh conducted a brilliant ministry in Religion and Art. As Methodist Curate in England, a song of beauty and grace was planted in his heart. In Amsterdam, he struggled with official ministry and discovered he was meant for something greater. In the Borinage, he discovered a heart, pen and brush for the poor and vulnerable. In Antwerp, he learned to draw with life-like depth. Asnières taught him biblical meditation and to translate this to a vibrant screen. In Arles, his palate turned to the crimson tone of desperation and the bright Lapis/Sapphire/Gold of peace and glory. In Auvers, his ministry turns introspective and furiously beautiful. The Accession to victory and everlasting delight finally vindicates his witness to the world.

The evolving theology which unfolds during these short years of service involves the Blessed assurance of an atoning God, the Convincing Word of Logos theology and biblical learning, the descent of Emmanuel God and the Crucified One into the hovels of desperation, biblical grounding, natural revelation and anguish in order to accomplishment as The God of the oppressed , the God of the Living, provides ultimate vindication and victory. We are introduced to this Ministry of Religion and Art by an animating God, ancient and avant–garde—One for all time and for ours. We have been offered the gift of Love—the Love of Light and color—of Form and Movement—we resolve to pass it on—for Love is Light and Life—and God.

Appendix A

Six Surprises/ Illuminations on the Journey

MUSING ON FOUR DECADES STUDYING VAN GOGH'S LIFE AND WORK

CLIFF EDWARDS
Author of *Van Gogh and God* (1989), *The Shoes of Van Gogh* (2004), and *Mystery of the Night Café* (2009)

KEN VAUX HAS KINDLY invited me to play some part in this wonderful work on Van Gogh, and has allowed me the enjoyable privilege of musing over the four decades of my Van Gogh research in an informal manner. What follows is a rather "free-association" flow of remembrances, surprises, illuminations, mysteries yet to be solved, fleeting insights, and tangled puzzles that I hope someone will unravel one day regarding the artist Vincent Van Gogh and his contribution to creative art and creative spirituality. I follow my own memory and associations here, without any regard for the order in which the surprises or illuminations occurred.

I will use throughout this essay the letter numbers in the new six-volume *Vincent van Gogh—the Letters: the Complete Illustrated and Annotated Edition* published in English by the Van Gogh Museum in Amsterdam and the Huygens Institute in The Hague in 2009. The text of the six volumes is available on the Internet at www.vangoghletters.org

and contains in the final volume a table that indicates the relation of older numbering systems to their own numbering of the letters.

I begin with my own paraphrase of a passage I once discovered in Proust's great work whose title we sometimes translate as *Remembrance of Things Past*. Proust tells us there that "the only true voyage is not visiting strange lands, but rather seeing the universe through the eyes of another." That, it seems to me, is at the heart of our study of Van Gogh. We struggle to see the world through a pair of humanity's most creative and intense eyes. We seek to learn from the gaze that engaged the life around him with such compassion and depth, and left such awesome traces of his own journey of discovery in lines and colors on canvas and in scribbled words on stationary.

Surprise/Illumination One

I came to the study of Vincent Van Gogh in a strange, round-about way. I was living in Japan at the time, at a Zen monastery named Daitokuji at the edge of the city of Kyoto. As a Western professor of world religions, I wanted to understand Zen Buddhism and Eastern thought and art from the inside. I was rather fearful of my first eyebrow to eyebrow meeting with the Abbot, famous Zen master Kobori Sohaku. Would he seek to shatter me with some incomprehensible koan-question, and then dismiss me from the monastery? We sat together on a tatami mat and shared tea. I was both puzzled and relieved when he spoke. His two questions to me were not easy, but they were comprehensible: "Tell me what you think the Book of Exodus meant when it had God answer Moses' request for the Divine Name with the words, "I am that I am"? His second question, even more surprising, was, "What can you tell me about that Dutch artist Van Gogh, and why do you think the Japanese people love his work so much?" I won't tell you my answers to either question, but I will tell you that the abbot's surprise question about Van Gogh got me started on learning all I could about the artist, who was only a hazy image or two in my mind at that time. Ever since that day in Kyoto, I have sought to understand how it is that a Western artist came to be a favorite of so many people across Asia. My best attempt to answer that puzzle is the chapter titled "The Oriental Connection" in my book, *Van Gogh and God*. It notes how Vincent and Theo collected Japanese prints, how Vincent copied Japanese works, and how he painted himself as a Buddhist

monk in a self-portrait he sent to Gauguin. A Van Gogh scholar I have always revered, Jan Hulsker, kindly wrote me to say that he thought that chapter made an important contribution to Van Gogh studies. But I view "The Oriental Connection" as a slim beginning to answering the Abbot's question. I believe that Vincent experienced nature in a way we might call "natural Zen." I have always intended to write a book on Van Gogh and Zen, but my guess is that such a work must be taken up by someone better qualified, and certainly younger, than I am.

Surprise/Illumination Two

In the great Indian classic, *The Bhagavad Gita*, the Deity comes to earth as Krishna and finally reveals his cosmic nature in chapter eleven. At the heart of that revelation, Krishna says, "I am become kala, the shatterer of worlds." Kala can have two meanings—"time" and "death." "I am become "time" that shatters the world you knew, and hides the past in death." That verse came to my mind just two years ago when I revisited the places where Van Gogh had lived and hiked and painted in Provence, and the place he died in the vicinity of Paris, in the village of Auvers-sur-Oise. The places where I felt Van Gogh's presence so powerfully forty years ago are being rapidly devoured by time. I shouldn't have been surprised, but I was.

First, let me remember the Ravoux Inn on the one main street of Auvers-sur-Oise. Forty years ago I walked past the village farmer's market and came to the Inn where Vincent lived out his last 70 days. The tables outside the front of the inn were filled with local students, joking, teasing, flirting with each other. Inside, there was only the woman who managed the café and waited on tables. I ate a meal there and then asked her if this wasn't the very place where the artist Vincent Van Gogh had died, and could I possibly see his room. She slid a key across the bar to me. "It's a dusty hole up at the top of the stairs. You're welcome to go find it," she said. I had that attic room to myself for the afternoon. It was barely a closet, with a bed, a chest of drawers, and one glass hatch in the ceiling that allowed in the only light and air. I could sit quietly and imagine how stifling the little space was during that last summer of the artist's life. I could imagine the energy it took to paint 70 masterpieces during those 70 days. I could picture Vincent and his brother Theo talking quietly in that room in the hours before Vincent died in that bed. But what was the

Ravoux Inn like on my recent visit? A parking lot with tour buses now dominated the location. The outdoor tables and students were gone. A menu in the window made it clear that expensive meals for tourists were the order of the day, including a monitored peek at Van Gogh's room and a film on his life. Time was destroying the space where I once so easily imagined the artist's presence in the silence of an attic space.

But Arles, in southern Provence, was an even greater surprise. My recent visit revealed that the two blocks outside the northern portal of the city where Vincent's beloved "Night Café" and the "Yellow House" had once stood, had recently been converted into a circular roadway for cars entering Arles. Near the location where the café stood before being bombed out in World War II, a new school was being built, and a department store stood close to the old location of the Yellow House. Vincent's old neighborhood in the "seedy" part of town was being swallowed up by modern structures and a steady stream of cars. I had carried copies of my book on Vincent's painting of the "Night Café" to give to the director of the Van Gogh Foundation, so I walked into town to the Foundation office. As I entered, a guide was explaining to a group of tourists that the famous "Night Café" was just a few blocks away, in a restaurant and hotel section built over the old Roman Forum in the heart of the city. I interrupted to show them a map in my book that makes clear the actual location of the one-time "Night Café" outside the city where their traffic circle now exists. The guide waved me off. It was obvious that the city of Arles was creating its own Van Gogh tour, and wanted tourists to spend their money at the Forum. They had now baptized the site of Vincent's painting, "Café Terrace at Night", in the town center as the site of his "Night Café", and re-located his neighborhood, including a replica of his room in the Yellow House, to the Forum and Coliseum area with its tourist shops and hotels. "Kala," time, does devour the old world. I hiked to the ruin of the monastery outside town where Vincent loved to paint and draw the wheat-fields that stretched below the monastery ruin. It was a wonderful hike and the ruined monastery is still magical, but there are no longer wheat-fields stretching to the horizon. Irrigation has now converted those fields to rice paddies.

You might simply quote Yeats to me: "That is no country for old men." Perhaps there is no longer room for meditating on the clods of earth and the views that once inspired the artist. If so, we must all the more celebrate the fact that Vincent Van Gogh left us over two-thousand paintings and drawings that can provide such meditative locations for

those with imagination, and some six hundred letters that describe what that world revealed to him. Perhaps the lesson I should take from all this is the lesson Vincent learned: find meaning in what is closest to you, in your own time and place. But perhaps we can still learn to see our own time through Vincent's imaginative eyes.

Surprise/Illumination Three

But of course paintings and drawings can also be destroyed by time. Just weeks ago, I was surprised by two wonderful books that helped me appreciate an artist I had generally dismissed, and through that artist, I have come to value a Van Gogh painting I had generally ignored, a painting that was in fact destroyed in Germany during the Second World War. The artist I dismissed for years, and whose painting I once found distasteful and meaningless, is that strange artist born in Dublin in 1909, known largely for his paintings of persons seen as masses of raw flesh and trickling blood enclosed in nearly bare rooms. The artist's name is Francis Bacon, and you may know him for his series of dark, phantom-like images of Vincent Van Gogh. Those images were drawn from Vincent's own painting of himself on a country road, hiking from Arles toward the village of Tarascon ("The Painter on the Road to Tarascon"). To enter the world of Francis Bacon, I recommend a book by the French philosopher, Gilles Deleuze, *Francis Bacon: The Logic of Sensation* (Univ. of Minnesota Press, 2004), and the art critic John Russell's *Francis Bacon* (Thames and Hudson, 1971). Their understanding of Bacon's painting opened his work for me, and through his work, opened new paths to understanding Van Gogh.

Deleuze and Russell helped me to see that Francis Bacon dared to see humans from the inside out, to feel the strange sense of mouth and teeth, limbs and nerves, we know as the self when we are not simply viewing our mirror image from the outside. Bacon, in fact, could describe painting as "the pattern of one's nervous system being projected on canvas." When I looked again at Van Gogh's painting of himself, bristling like a porcupine with his easel and canvases poking in all directions as he hiked in the heat of the day on a dirt road, I think I began to see what Bacon saw in that now destroyed Van Gogh painting. Van Gogh was painting his own determined journey to paint; he was depicting the animal force needed to make the long hike. Vincent saw the strange angles of his canvases

and easel as part of his very body, as his very nervous system displayed for the viewer. Is this part of the power of Van Gogh's many portraits of himself, of the postman and his family, of patients and attendants at the asylum, of Dr. Gachet? Certainly, they display something other than mirror images. Vincent would say he was "doing paintings with heart." Is there already the hint of Bacon's seeing from the inside through his own nervous system? Again, my new appreciation of Francis Bacon, who viewed a destroyed Van Gogh painting with seriousness, came as a surprise and an illumination that lit up a destroyed Van Gogh painting I had largely ignored.

Surprise/Illumination Four

While on the subject of destroyed paintings, I should say a word about two Van Gogh paintings that surprised me a year ago and have stayed in my imagination ever since. Perhaps they are the beginning of a book. I call those two paintings Van Gogh's "Ghost Paintings." During 1888, his most creative year as an artist, Vincent composed two large paintings unlike anything he had ever attempted before, and unlike anything he would ever attempt again. The "ghost paintings" are, in fact, much like Edgar Allen Poe's "purloined letter," hidden in such plain sight that they have become invisible to us. You may never have heard of those paintings, and certainly you have never seen them. Yet I am more and more convinced that those two paintings determined the course of Vincent's art for the remaining two years of his life. You might guess that there is a strange twist to the mystery of those paintings. Let me take you to their hiding place and allow the artist himself to tell you their surprising secret. In the summer of 1888, he wrote to Theo in a deceptively off-hand manner:

> I've scraped off one of the large painted studies. A Garden of Olives—with a blue and orange Christ figure, a yellow angel—a piece of red earth, green and blue hills. Olive trees with purple and crimson trunks, with grey green and blue foliage. Sky lemon yellow (L 637).

That composition of a painting from the life of Christ is strange enough for an artist who avoided painting traditional religious themes, but far more mysterious is the fact that 75 days later, on September 21, 1888, he made a second confession to Theo:

> For the second time I've scraped off a study of a Christ with the
> angel in the Garden of Olives. Because here I see real olive trees
> (L 685)

I will leave you with this mystery: a twice painted, twice destroyed painting of Christ by an artist who never again (and never before) attempted his own painting of Christ. The fact that he would later, in the asylum, copy Delacroix's *Pieta* because his print of the work was destroyed by accident, only deepens the surprise and mystery for me. Did Vincent need an image of Christ in his asylum cell, as he seems always to have needed such an image on the walls of his rented rooms? Was Vincent haunted by the life and death of Jesus? Do we hear little about that haunting because Vincent was reticent about embarrassing brother Theo with such discussions, as Theo had become a gentleman agnostic Parisian, and preferred to avoid "religious" talk? Was Vincent driven to paint Christ's agony in the Garden, but conflicted about doing such a painting and having it displayed among his own works? I've recently invited artists to attempt reconstructing what the painting might have looked like, based on Vincent's descriptions and the paintings of "Christ in the Garden" by other artists whose work Vincent knew. My own candidate for the image Vincent may have had in mind as he painted is a moving etching of Christ and the angel by his favorite artist, Rembrandt. Feel free to pass along that invitation to reconstruct the "ghost painting" to artists you may know. I hope to have a gallery display those attempts next year.

Surprise/Illumination Five

The wonderful new resource provided by the Van Gogh Museum in Amsterdam, and Huygens Institute in The Hague, edited by Leo Jansen, Hans Luijten, and Nienke Bakker, deserves its own place among these surprises and illuminations. *Vincent van Gogh-The Letters: The Complete Illustrated and Annotated Edition,* published in English in 2009, sets a new standard for Van Gogh research. From here on, all of us working on Van Gogh topics will owe it much. Imagine, all the letters by and to Vincent placed in chronological order with brief but revealing notes, and the images of all available works of art mentioned, displayed along with the letters mentioning them. And there is more: all those letters are available to us free on the internet, along with a wide variety of research options. I worked through it all this past spring, and found it filled with valuable surprises.

Seeing paintings, drawings, and prints as Vincent and his correspondents mention them is an unbelievably useful, and often a moving experience. Further, being able to follow the correspondence in the order it occurred brings both new puzzles and new insights.

I will choose here simply one instance of a letter that was illuminated for me through its new context at the appropriate moment within the correspondence. It is barely a note, but its simplicity yet poignancy make it fairly jump from the page. One is invited to sit at a table in the still of a cold Paris night with Theo's recent bride and read her words to that strange brother-in-law, Vincent, in his asylum at St.-Remy. She is expecting the birth of her child at any hour. It is after midnight on Wednesday, January 29, 1890. Vincent's favorite sister Willemina, Jo's mother, and Theo have been sitting at the table with her. Gradually, those around the table leave her so they might get a few hours of sleep. She is writing something for Vincent alone, something she doesn't intend the others to see. Her doctor means to spend the night, and he too is sleeping in another room. As readers, we must remind ourselves how common death in childbirth for mother or child was in the 1880's. She entrusts these words about Theo to Vincent, whom she has never met except through the letters he has been sending her husband, Theo:

> He's been so good to me; so good—if things don't go well—if I have to leave him—you tell him—for there is no one in the world he loves as much—that he must never regret that we were married, because he's made me so happy. It sounds sentimental—a message like this—but I can't tell him now—half of my company has gone to bed, him too because he was so tired. Oh if only I can just give him a dear, healthy little boy, wouldn't that make him happy? I'll just close, because I keep having waves of pain which mean that I can't think or write properly. When you get this it will all be over.
>
> Believe me, your loving Jo

Our knowing the outcome, the birth of Vincent's namesake, and our realizing that she did not then know the outcome, are bound to increase the drama of that moment and the burden of her request to Vincent. That letter, 845, is followed by letter 846, a response from Vincent. A note reminds us that the artist himself had a serious attack on January 19, and was barely recovering. His response to Jo notes how touched he has been by her writing him on such a night. He continues:

How I long to hear that you've come through safely and that your child lives. How happy Theo will be, and a new sun will rise in him when he sees you recovering . . . And, in Leiden, Ma will rejoice in it more than anyone else, because she's longed for so long, I believe, that things were rather happier for him.

He signs himself "your brother, Vincent," adding that he is not able to write more, "because I'm still not entirely calm." The context is further enriched by an earlier melancholy letter from Vincent to his mother (Letter 831) in which Vincent tells her of his "terrible self-reproach about things in the past," and his realization of how much Theo had given up over the years to help her and "Pa."

Perhaps this one illustration will serve to indicate the many rich surprises the six volumes of letters and notes and images promise the reader. Often it is simply the new arrangement of the letters and the fresh translations that allow us to read with new eyes.

Surprise/Illumination Six

A few years ago I took part in a conference on Mediterranean Studies. That conference led me to look more seriously at Vincent's journey from the edge of the North Sea, with its cold winds, fog, and dark storms, to the edge of the Mediterranean with its brilliant sun, warmth, and clarity of vision. The contrast of Vincent's early Dutch works and his later canvases in Provence provided its own surprise and illumination. Take, for example, one of Vincent's very first oil paintings, *View of the Sea at Scheveningen* painted in August of 1882 and described in a letter of August 26. Compare this fishing boat on the dark and dangerous waters of the North Sea under heavy gray clouds with the fishing boats at Saintes-Maries on the bright Mediterranean under a brilliant sky during his stay in Provence. Vincent had moved from a world of mists, muted light, and earth colors to the golden sunshine and bright colors of the Mediterranean world, a world he knew through the work of two of his favorite modern artists, Delacroix and Monticelli. Similarly, one might compare the earth-tones of his portraits of Dutch peasants painted in Nuenen, Holland, with the "furnace" of heat and light reflected in the face of the Provence peasant, Patience Escalier, done at Arles in August of 1888.

The Dutch artist who spent most of his life close to the mists and storms of the North Sea seems purposely to have moved south to the

Mediterranean, with a way-stop at Paris, to transform his life as artist. He sought to discover the full sun and limpid air, the clarity and brilliance of the color it liberated, and the rich flowering of nature it nurtured in one corner of the Mediterranean world. For Vincent, it appears, a "utopian vision" of the southern land of sun and sea transformed Provence into a personal "gateway to the East," and gathered up his love of Japanese art, the African canvases of his great colorist, Delacroix, and a taste he developed in Paris for the painter who had lived in Marseille and discovered the power of the sun, Monticelli. Certain passages in Vincent's letters from Provence now jump from the page for me as I experience with him the power of the southern sun:

> Under the blue sky, the orange, yellow, red splashes of the flowers take on an amazing brilliance, and in the limpid air there is something or other happier, more lovely than in the North. It vibrates like the bouquet by Monticelli which you have (L 657).

> There is a sun, a light that for want of a better word I can only call yellow, pale sulphur yellow, pale golden citron. How lovely yellow is! (L 659)

> Why did the greatest colorist of all, Eugene Delacroix, think it essential to go South and right to Africa? Obviously, because not only in Africa, but from Arles onward you are bound to find beautiful contrasts of red and green, of blue and orange, or sulphur and lilac (L 682).

I believe that part of the complexity of the life and work of Van Gogh is his response to the contrasting sense of the dark North and the bright South. The northern mists and storms resonated with the suffering and sacrifice he felt called for in life, while the southern sun and colors brought a celebrative liberation to at least some of his days during his last three years. The contrasts of North and South, I believe, deepened and broadened his perspective on the pursuit of meaning and the life of the spirit. I hope others will pursue the influence on Vincent of his move from the North Sea to the Mediterranean, completed through a brief stay in the northern village of Auvers-sur-Oise, not far from Paris. Perhaps in Auvers, he began to discover some way of integrating these forces, an integration cut short by his death. But in Vincent's imagination, his trip to the south was also a journey to the Orient, an opportunity to discover the secrets of the Japanese prints he and Theo had been collecting. The

brilliant colors and clarity of those prints certainly opened a way of seeing he sought to share through his canvases, a way he felt Delacroix and Monticello had experienced before him.

As I began this essay with the story of my discovering Vincent Van Gogh through a question a Japanese Zen Master asked concerning the Japanese love for the artist, ending these few surprises/illuminations with a return to Van Gogh's imaginative discovery of Japanese color and clarity on his journey from Holland to Provence in southern France may complete the circle for now. Proust encouraged us to embark on the "only true voyage," the attempt to see the world through another's eyes. Our choice of the creative eyes of a singular artist makes that journey a lifetime challenge. But I have found it to be a challenge as colorful as the artist's canvases, and as profound as his deepest musings, and I believe that might be true for you as well.

Appendix B

Vincent van Gogh and the Notion of Creativity and Madness

JAN VAN EYS, MD, PH.D.
Clinical Professor of Pediatrics, Emeritus
Senior Scholar in the Center for Biomedical Ethics and Social Policy
Vanderbilt University School of Medicine, Nashville, Tennessee

VINCENT VAN GOGH WAS undoubtedly a great artist. Through his God-given talent, he was able to convey both the dark burden of the everyday struggles that humans endure and the light that makes the world shine in a burst of color that gives a glimpse of the beauty of creation, visible even when human hands helped to sculpt the landscape. Over his creative lifetime, the paintings progress from depicting the compassion with the human burden in the dark-lit rural Netherlands, through the human-distorted urban landscape of Paris, to the exuberant light of Southern France that revealed God's illumination.

Few people have the ability to create such a revealing, thought-provoking, and joy- producing oeuvre. We call it a God-given talent. But how does God give humans this grace and burden, and how do we use such a gift to express our vision of God?

Most humans, even when expressing a deep and abiding faith, wish that God would leave them be unless they feel the need for God's loving intervention. But when they receive a unique gift from God, it also becomes a burden. This was once expressed clearly by my friend Joseph

Fletcher, the Episcopal priest, who crafted *Situation Ethics*.[1] Fletcher suffered much derision and accusations of heretical thinking for his notions.[2] He tried to swear off God and left the priesthood to become primarily a medical ethicist.

At a small private dinner at my house, he said to me, "Jan, I tried to leave God alone, but he won't leave me alone." One's talent becomes perforce an assignment to become God's messenger. All creative persons become prophets and all prophets protest at some time or another like Jonah did when he was sent by God to Nineveh.[3]

There is a stock character and real life stereotype, called the tortured artist. Vincent van Gogh fits that character exactly. He seemed overwhelmed by his internal conflicts, some of which seemed to be generated by his God-given mandate to preach in paint. It has become fashionable to explain those conflicts by linking creativity and madness. This notion has been popularized through book and film. As a specific example, one could cite the film about John Forbes Nash, Jr., who was a mathematical genius. Nash earned the Nobel Prize in Economic Sciences for his work on the importance of game theory for economic systems. Nash suffered from schizophrenia.[4]

Many forms of mental illness are implicated, but the most frequently impugned is bipolar disorder (manic depression). The psychiatrist Kay Redfield Jamison has written beautifully about the association of creativity and bipolar disorder.[5] A prominent exemplar often used is the poet

1. Fletcher, J. *Situation Ethics: The new morality* (14th ed.; Philadelphia: Westminster Press, 1973).

2. Cf. Cunningham, R.L., ed. *Situationism and the New Morality* (New York: Appleton, Century and Croft, 1970).

3. Jonah rebelled against God's call. Finding that God was everywhere, he gave in and preached to the citizens of Nineveh that God would destroy them unless they repented. When they did repent, Jonah was disappointed. God showed Jonah that he actually still was fighting God, even when seemingly obedient.

4. The film is the Academy-Award winning movie, *A Beautiful Mind,* issued in 2001, by Universal Studios. It starred Russell Crowe and was directed by Ron Howard. It was based on a book by Sylvia Nasar with the same title.

5. Jamison, K. R. *Touched with fire; manic depressive illness and the artistic temperament* (New York: Free Press Paperbacks, 1993). Jamison suffered from bipolar disorder herself, beautifully described in her book, *An unquiet mind; memoirs of moods and madness* (New York: Vantage Books, 1995). Dr. Jamison, professor of psychiatry at the Johns Hopkins University School of Medicine, is considered the world's expert on the disorder.

Sylvia Plath, who clearly suffered from bipolar disorder. She is cited to say, "If I rest, if I think inward, I go mad."

But while the association seems real, it begs the questions: Is the association one of cause and effect, and which is the cause and which is the effect? Or is it a true correlation but the association is coincidental and creativity and madness are not related?

In the 1960's, Thomas Szasz published his book, *The Myth of Mental Illness*. The main thesis was that there should be a distinction between an illness, i.e. a measurable and demonstrable abnormality in the function of a patient's body, and a mental abnormality, which is, in his view, only a deviation of expected behavior.

In his summary statement and manifesto, Szasz states, "Individuals with . . . kidney disease (bad kidneys) are literally sick. Individuals with mental diseases (bad behaviors), like societies with economic diseases (bad fiscal policies), are metaphorically sick. The classification of (mis) behavior provides an ideological justification of social control as medical treatment."[6]

His major concern was that while physical illness is reported to a physician by the patient and verified by the physician, mental "illness" is often assigned by the physician (psychiatrist) without the patient's discernment of an abnormality. Szasz was especially critical of the use of the insanity defense in criminal cases, because, if successful, this could land the defendant in a psychiatric hospital for the criminally insane without the ability to get a fair trial. The madness of the defendant was assumed to explain the criminal behavior.[7]

There is no doubt that expressing new ideas and displaying unique talents can at times be identified as socially undesirable behavior. We see

6. To give an interesting historical example, relative to the theme of this essay: William Chester Minor was an American physician who served in the Union army during the civil war. He was given a medical discharge because he was diagnosed with paranoid schizophrenia. After discharge, he moved to London, England. One early morning while he was walking in a heavy fog, he heard footsteps behind him and he shot at, and killed, an Irish laborer because to him, the footsteps seemed threatening. He was convicted of manslaughter but was sent to prison as a criminally insane person "until her majesty's wishes became known." While in prison, Minor became the most prolific contributor to the first edition of the Oxford English Dictionary. This history is documented in: Winchester, S: *The Professor and the Madman; A tale of murder: Insanity, and the making of the Oxford English Dictionary*, 1998, New York, NY, Harper Collins.

7. The manifesto can be found on the web site of Thomas Szasz, MD, *Cyber Center for Liberty and Responsibility* (http://www.szasz.com/manifesto.html).

that judgment rendered most often when the gifted have an irresistible urge and desire to follow, above all else, the dictates of their gifts. Gifted persons are indeed often antisocial by conventional standards. They can be rightfully called tortured artists. They are misfits and exhibit bad behavior. Thomas Szasz would have decried calling them mentally ill and thereby diminishing their accomplishments.

Thomas Szasz was correct that we often use illness as a metaphor describing behavioral and social adjustment. Specifically, we still use mental illness as a metaphor for misbehavior, but we substitute the term "Madness." Susan Sontag eloquently described how certain diseases (historically, in sequence, tuberculosis, cancer, and now AIDS) became associated with personal traits. The common denominator of those seemingly lethal diseases was their mysteriousness. People did not understand their etiology and thus feared them. They attributed psychological traits to the sufferer, which then translated into the notion that the psychological qualities caused the illness. But she also said emphatically that illness is *not* a metaphor; ". . . the most truthful way of regarding illness—and the healthiest way of being ill—is one purified of metaphorical thinking."[8] She is absolutely correct, and yet we persist in metaphorical thinking, especially about mental illness.

Sontag's train of thought is important, because Thomas Szasz was wrong that mental illness is a label for bad thoughts and undesirable behavior and, therefore, not equivalent to physical illness. A variety of mental illnesses have as etiology an identifiable biological abnormality or derangement.

We know a lot more about the function of our brain. We are beginning to understand the use our nervous system makes of an assortment of neurotransmitters. Each neurotransmitter seems to have a specific function. A derangement in the balance between synthesis and destruction, or a variation in the sensitivity of response to the neurotransmitter, can translate into very specific mental illnesses. The bipolar disorder has a strong genetic component, signifying structural abnormalities, resulting in a biochemically specific disease. That insight puts bipolar disorder on par with diseases of other organs wherein genetic variations create a specific disease. It is suspected and sometimes evident that this holds for other mental illnesses as well.

8. Sontag, S. *Illness as a metaphor* (New York: Vintage Books, 1979), 3. She discusses tuberculosis and cancer. A later book adds AIDS: Sontag, S. *Aids and its metaphors* (New York: Farrar, Strauss & Giroux 1989).

What is more, such understandings have resulted in the development of disease modifying drugs, which are widely used, often with significant therapeutic impact.

Nevertheless, we persist in linking creativity and madness. The American Institute of Medicine sponsors yearly conferences under that title, repeated at various sites around the globe. These conferences are very popular and are attended by physicians, psychologists, social workers and various lay persons. All conferences are structured by discussing artists and their art, using biographies and illustrations to create insight in the nature of their works. When the artist is a composer, live recitals of his or her music are often given to illustrate the works. In all cases the creativity is evident and the madness is often impugned as a causative factor, but the data for that association are at best vague.

The relationship between creativity and madness becomes even more complicated when we realize that madness can take many forms in this context. Thus, the mathematician John Forbes Nash suffered from schizophrenia; the poet Sylvia Plath was bipolar; the composer Frederick Delius had tertiary neuro-syphilis; the abstract painter Willem de Kooning was afflicted with Alzheimer's disease. Each had a different field in which his or her creativity was expressed, so that one might posit that each mental illness might correlate with a specific form of creativity. However, examples of other pairings of specific creativity and madness are readily found. Thus, the composer Robert Schumann was bipolar while the painter Henri de Toulouse-Lautrec had syphilis. Of course he also suffered from pycno-dysostosis, a genetic bone disorder, not affecting the brain, and alcoholism, which does.

Yet, even if the association between creativity and mental illness is real and non-random (and many psychiatrists believe that it is), nothing I have said so far would allow a conclusion as to which one is cause and which is effect, or even whether the association has any etiological relation at all.

However, even if mental illness and genius just coincide, they would undoubtedly feed on each other. A happy, well adjusted, and self-satisfied genius may exist, but that description sounds oxymoronic. That may be only our prejudicial judgment. But it is likely that such a genius would not be recognized as such.[9]

9. There is one caveat: there are child prodigies who could be without discernable madness. One classical example comes from the, perhaps apocryphal, story of Carl Friedrich Gauss when he was a first grader in a one room school house. The teacher

How does this all relate to Vincent van Gogh's life? To approach that question, we have to reflect what a visual artist, such as a painter, tries to accomplish.

Painters, who use their God-given skills to convey their perceptions of the light of God, are great evangelists, each in their own way. Yet, to tell us about their experience, and of the truth of their vision, they must perceive the light of God themselves first, and let that light permeate their own consciousness—their own souls. It is the creature's lot that humans must use their body and its senses to perceive the light.

When the artist's body functions abnormally, because of an illness that affects the mind, or because of habits that distort perception, we see a transformation of the creativity-driven intake into a transformed output. It is that singular and personal imprint that makes the artist unique and potentially great. In fact, if that imprint is missing and the artist faithfully reproduces what we see ourselves, we do not call that artist great nor do we call him or her creative. We say that he or she just paints pretty pictures. Starving artist sales events are full of those.

The care artists give their body will always color and potentially distort their vision. Vincent was not necessarily a good steward of his body. He was fond of absinthe, the once banned beverage that was, in his lifetime, a popular drink in café society.[10] The drink has a seductive visual appeal, undoubtedly attractive to a painter. When poured from a bottle it is a clear, brilliantly green liqueur. However, because of its bitterness, the drink was traditionally diluted with a specified amount of water, poured through a slotted absinthe spoon wherein a sugar cube was placed. This dilution changed the appearance of the glass from clear green to a beautiful yellow opalescence. The ritual of presentation of absinthe would be

assigned his pupils to add all the numbers from 1 to 100. Little Gauss handed in his slate immediately while all other students were still laboriously adding. He had discovered a generalization for calculation of the sum of the elements of an arithmetic series. The teacher recognized Gauss's ability and helped him further his education. Gauss became arguably one of the greatest mathematicians of all times. For a discussion about this story, see Hayes, B. *Gauss's day of reckoning*. American Scientist, 2006, 94: 200–205. The story of Isaac Asimov about child dreamers (note 17) is relevant here. The way we handle child prodigies (e.g., as a child with a special gift or as an asset to the adults in charge) will determine the ultimate fate of the yet unformed genius.

10. For the past three years, it has been legal, once again, to sell absinthe in America. See Julia Reed, "Absinthe makes the heart grow fonder," *Newsweek*, April 1, 2010

very attractive to Vincent as it was to many artists. Toulouse Lautrec was a habitual absinthe drinker also.[11]

However, the chemicals in absinthe, especially the terpenoid *thujone*, wracked the brain, exacted a price, and shortened one's life. The mental distortions and convulsions from the terpenes can be alleviated with bromides and aggravated with nicotine use. Vincent was treated with bromides and forced to cut down on smoking during his institutionalization at Arles.

Vincent van Gogh also suffered from *Pica*, the compulsive eating of non nutritive substances. He ate camphor, drank turpentine, and munched on paint. Paint and turpentine contain terpenes (and camphor is one itself) like thujone.

There also may have been an underlying, possibly hereditary disease from which Vincent suffered. Because of his creativity, the most often postulated mental illness is bipolar disorder. However, that may be more because many think it ought to be manic depressive illness rather than that the evidence is strong for it. Actually, the disease that best fits all symptoms, including intermittent mental illness, is *Acute Intermittent Porphyria*. Wilfred Arnold was one of the authors who made that suggestion.[12] Acute Intermittent Porphyria and a similar disease, *Porphyria Variegata*, were found in the Netherlands.[13]

There are fundamental realities at play in creativity. When we preach our faith, we preach our revelation. We ought to prepare ourselves to make our vision as pure and unobstructed as we can. Unfortunately, so often our behavior clouds our perceptions. We preach what we heard and not necessarily what was said. We paint what we saw and not always what was created for us to see. Thus, even the greatest saints are also likely to be the greatest sinners, because they claim clarity while they may have fogged their vision by their actions. But precisely that realization makes their works the more powerful because we do not just recognize the light of God, but also realize our humanness by the brilliant imperfections in the artist's sermon. The creative genius interprets what is seen as the light

11. See the painting: Vincent van Gogh: *Still Life: Drawing Board with Onions, Raspail's Book, Absinthe Bottle*, etc. St. Rèmy. Oil on Canvas, 50x64 cm (19.7x11.2), Collection Rijksmuseum Kröller-Müller Museum, Otterloo, the Netherlands.

12. A detailed discussion of Vincent van Gogh's afflictions, habits, and postulated underlying illnesses can be found in: Wilfred Niels Arnold: *Vincent van Gogh: Chemicals, Crises and Creativity* (Boston: Birkhäuser, 1992).

13. Cf.: Dean, G. *The Porphyrias* (2nd ed.; Philadelphia: J.B. Lippincott, 1971).

of God and tells us about it through representation in a modified way, sometimes distorted and sometimes clarified and enhanced.

But would a sane person then not be the most creative, the most likely to convey the light and truth of God? Is the creative genius actually recognized as such because the distortions resonate with us, because we recognize what our humanness does to God's mandates? Of course, most persons with a creative talent do have the basic intellectual skills to exercise their talent. It takes a mind to use one.

But there may be much more to it. We talk about creativity as a God-given talent. That implies that God selects the creative artist from among the mass of humanity. But I would suggest that that is actually a self-serving simplification. We try to be inconspicuous to God, so God will leave us alone. We want to go about our human business to keep our lives going smoothly. We want to remain functional in our human society. We accept each other's ideas before we accept a foreign notion from outside our narrow circle in which we live and hide.

The uncomfortable truth is that God's light is there for all to see, God's word is there for all to hear. God's mandate clearly is that those who hear and see spread the word and share the vision. But we mortals are loath to break out of our comfortable cocoons to let in the light and make the word audible. We fight being disturbed. We go to great lengths to keep the status quo. We even fight rational thought and ignore data and facts to stay comfortable. We try to convince others of what we want so we can remain undisturbed in our comfortable world that we have created for ourselves. And nothing is more disturbing than recognizing God in our world. Emily Dickenson summarized it in one short quatrain:

> I dared not meet the Daffodils
>
> For fear their Yellow Gown
>
> Would pierce me with a fashion
>
> So foreign to my own.[14]

Our bodies, including our brains, work that way. Our bodies have many mechanisms to create and maintain homeostasis. Our body temperature stays in a comfortable range through widely varying ambient temperatures. Our heart rate adjusts to needs but generally stays in a safe

14. Johnson, T.H, ed., *The Complete Poems of Emily Dickinson* (Boston: Little, Brown and Company., 1960), 165.

zone. Everything in our bodies is geared toward keeping a comfortable and safe status quo.

Our brains work that way too. Our thoughts and conscious actions are dampened by the mechanisms designed to maintain chemical homeostasis. In the vernacular, we say we try to keep our cool.

But the fact is, the call of God's light and word is the same for each and everyone. All normal and sane persons fight the intrusion that will disturb our complacency, comfort and control. The disturbed mind, whether harmed by self-inflicted toxins, mental illness, or even extreme fatigue cannot succeed in that fight. For them, ideas cannot be focused, thoughts cannot be directed at will, loose associations cannot be suppressed. Those individuals become interpreters of God's light; they tell of their visions whether they like to or not.

We call persons creative when they relay what they see because they cannot block it out of consciousness. We normally do not see what we do not want to see. But if our minds cannot act on our wants for whatever reason, we become messengers. We become prophets foretelling God's light and berating those who do not see.

Different parts of the brain have different functions. It is therefore no surprise that different mental illnesses or different destructive events in the brain might have different degrees of this dis-inhibition of the flights of ideas that are the hallmark of creativity.

It is that fact that makes the madness of creativity so variable in degree and frequency. Bipolar disorder is indeed linked to creativity with evident frequency. That may only be because it is a common mental illness. Nevertheless, that association gives insight in the phenomenon. Many creative people suffering from bipolar disorder have written about their experiences.[15] A person in a manic phase has no dampening of thought and action. By the same token, persons in a deep depression have no control over their thoughts either. Such people are often in agony over their creative urges, which are at odds with all reasoning of socially adapted people. They are truly touched by fire and singed by it, even when they have visions sane people would love to have as long as they could control and guide them.

But then we have to ask: do the products of creativity we enjoy really give us only distorted pictures of reality and not reality itself? Does the madness that spurs on the creativity create false images that we can enjoy and admire, but must be regarded as unrealistic?

15. Cf. Jamison, K.R.: *Touched with fire; manic depressive illness and the artistic temperament*, 1993.

Of course, this question might have different answers, depending on what form the creativity takes. If the person, touched by fire, produced a mathematical breakthrough, eventually the validity of the new insight will show. However, the play, *Proof*, by David Auburn shows how the madness can overshadow the creativity and how prejudices can blind insights.[16]

In the visual and musical arts, the madness can be forgotten by the viewer or listener because of the direct impact of the artistic piece. But even then the notion that it is, to us, distorted reality can be a real barrier to the appreciation of what magic has really been wrought.

God's creation is a totality, albeit still evolving. A great discovery is not the creation of something new, but it makes us realize a piece of God's handiwork we had not yet known to exist. A great work of art does not give us a new insight, but it allows us to see God's creation from a new angle and a new perspective.

Thomas Szasz was correct in one observation: madness does not make a criminal. It is equally true that madness does not make a genius. Furthermore, we are all dreamers. Deep down, we all are aware that there is more to God's creation than our upbringing has taught us and that our socialization has allowed us to see. But as the science fiction writer Isaac Asimov observed, "Dreaming is a private thing."[17] We are afraid of revealing our flashes of insight. Madness may give a dreamer, and especially a talented genius, the ability to share his or her insights. Even when distorted, they are likely to be more profound and deeper insights than most of us would allow showing. By viewing and studying the artist's works, we have a chance to experience those dreams and visions.

Vincent van Gogh had a struggle with God's call. He had the talent to make that struggle visible to us. By preaching in paint, while being uninhibited in showing what he saw, he gave us a greater appreciation of God's rich handiwork. But he also gave us insight into the struggles evoked by the awareness of God. If, when we see his paintings, we allow ourselves to receive both those gifts, the beauty and the burden, we become that much richer.

16. Auburn, D. *Proof: a play* (London: Faber and Faber, 2001). The story was also made into a movie by the same name, in which Gwyneth Paltrow played the lead.

17. Asimov, I., *Dreaming is a private thing*. In: Asimov, I. *Earth is room enough* (Greenwich, CT: Fawcett Publications, 1970).

Appendix C

A Dialogue at the Night Café with Vincent and Three Protégés

CHRIS GLASER AND KEN VAUX

PICTURE IN YOUR MIND the memorable Van Gogh work—*Café de Nuit*—recently quoted in Woody Allen's film that opened Cannes this year (2011)—*Minuit a Paris*. A party of four now occupies the table where a mysterious couple sat commiserating, consoling and perhaps re-connoitering for a later *rendez-vous*.

This hauntingly mysterious painting now graces Yale University where two of the interlocutors (Glaser and Nouwen) studied and taught, and is now celebrated by a splendid book by the best English language author on Van Gogh—Cliff Edwards—*The Night Café* (ref).

At the table are Vincent and two look-alike protégés—Chris Glaser and Ken Vaux—sandy and red haired, along with Henri Nouwen—certainly a fellow Celt—more ruddy and dark, but all with blue, green eyes—writers and ministers all, par excellence.

Ken Vaux is there to interview the unlikely threesome on what all four companions on this night know to be the "unspoken issue" in Vincent's life—an issue which has involved the other three for most of the years of their adult lives. All four are bond brothers in the torments and joys of priesthood, conflicted by controversies over sexuality and the church. Eavesdrop on their conversation:

Ken to Chris: Forty years ago at Yale Divinity School, you studied with Prof. Henri Nouwen—in what, by all accounts, was a memorable course—"The Ministry of Vincent Van Gogh." What are your reflections of Vincent as explored by that class?

Chris: Well, I can't help but observe that we're sitting in Vincent's "Night Café", and, with the glaring yellows of the ascending floor and the radiating lamps, it feels a little warm and close in here—especially when compared to his *Pavement Café at Night* painted about the same time, which is open to the street and a star-scattered night. We're caught here a little after midnight, according to the clock on the wall, and there's a handful of other patrons, making the place feel somewhat empty. The strong contrasts of red and green throughout the painting—I think that you said this, Vincent—are intended to suggest human passions in conflict. And the seeming indifference of the other patrons reminds me of *The Potato Eaters*, in which family members sit at table in a cramped, dark room, making no eye contact even as they receive their sacrament of daily potatoes together.

Henri, remember the seminar room in the chapel building at Yale Divinity School was like that, too, small and cramped, around whose tables we huddled, our small band of professor and seminarians. The open doorway at the rear of *The Night Café* makes me think of the open screen on which you showed slides of Vincent's paintings that took us out of that tiny basement classroom into Vincent's world of workers, fields and skies and sunflowers. And the letters! The letters that Vincent wrote to his brother Theo—his name was not lost on us—"God"—"Theodore" meaning "lover of God." Full of soul-searching as Vincent found his desire to serve the poor, ultimately not in conventional ministry with the coal miners of the Borinage, but in the paintings—your "sermons," Vincent—visions of a new religion that you prayed would have the same "consoling effect" that the Christian religion used to have.

But back to conflicting passions, Vincent. You so very much desired to serve as a Calvinist minister, following your father's footsteps, but the church thought you took your call too literally, going down into the mines with the miners in your parish, hanging out in their kitchens, giving away your possessions to them, including your own bed to a sick woman. The church removed you from your pastorate because you identified too much with those who were outcast socially, even spiritually. You refused to keep your distance, as was considered proper for a pastor. Then painting became your passion, and you worked quickly, slathering

paint on canvases. You were distracted: first, by your pity for a woman and her child with whom you lived, then by a passion for your housemate Gauguin, delivering a piece of your ear to show your obsession.

Ken: What are your reflections on Father Nouwen as you look back across your career?

Chris: I never heard a student call him *Father* Nouwen! Just as Van Gogh simply signed his paintings "Vincent," Henri just wanted to be called Henri—isn't that right, Henri? Even then, only confirmed over the past decades, I knew that Henri's affinity for Vincent was manifold. Both came from Holland, both wanted to serve in ministry, both shared compassion for the poor and outcast, both were unconventional, both ruffled the feathers of "the powers that be" in the church and the culture. Henri told us that when he proposed a course on "The Life and Ministry of Vincent Van Gogh," other academics and church leaders dismissed it, saying, "But he was an artist." "Didn't he commit suicide?"

Both Vincent and Henri were intense—not only in their respective art forms, Vincent as spiritual artist and Henri as spiritual speaker and writer—but in their relationships as well. Henri, you could be a little overwhelming! I sometimes felt what Gauguin must have felt with you, Vincent! Thank God I was never presented with a piece of Henri's ear! But he was always willing to give you his ear, metaphorically speaking, of course! And he was similarly intense in presentations to audiences, passionately trying to get them to really hear the gospel, "You are God's beloved!" I think some people might view their intensity as unfulfilled sexual passion, and perhaps so—but I believe "the urge to merge" is ultimately what spirituality is all about. And spirituality is what true sexuality is all about as well. To be one with another is the goal of both mystic and lover. That's the way Henri described Jesus' love and God's love.

Henri may have had his own "Gauguin" in the form of a friend in the community to whom he became deeply attached, causing them both pain. As I look back, I think Henri could have benefited from "a particular friendship," as they called it and forbad it in the Roman Catholic priesthood. But it might have taken away his edge, too, his spiritual creativity as he made the personal universal and helped us all see we were living the spiritual life every day. That's what Vincent tried to capture on canvas—the iconography of everyday people, the sacrament of everyday life. And look at Vincent—I believe his least creative phases were when he was distracted by relationships. I think it could be said that your best relationship, Vincent, was with your brother, Theo. From a distance you

could pour out your heart to him in those hundreds of letters, and from a distance he supported you emotionally and financially.

Ken: As you reflect on your own career as minster and writer, how have these experiences shaped your convictions and commitments?

Chris: I, too, shared Vincent and Henri's passion to serve in ministry with the outcast, to the consternation of "the powers that be." And I wanted to do so artfully. My paper for the class was a short story about a woman in transition whose life was helped by spending time with two versions of Vincent's *Madame Roulin and Her Baby*. One she found comforting and the other disturbing. They prompted her to read books about the artist and his own "Letters to Theo" To prepare for its writing, I spent several hours with each painting, one in Philadelphia and the other in New York, much like Henri later spent time with Rembrandt's *Return of the Prodigal Son* in St. Petersburg. I listened to the comments of passersby, and contemplated the paintings as icons, given what I knew of Vincent's life and art—he once said that he'd rather paint people's eyes than cathedrals. Writing the paper was the most fulfilling academic work I ever did in school. As early as college, I had started submitting stories for my final class papers, but this brought my own sometimes conflicting passions of writing and ministry together in a most fulfilling way. Henri, you loved it!

What I got from the class was that my writing was my ministry. Though I enjoyed preaching, teaching, pastoral care, spiritual direction, and organizing—all required in parish ministry—I also needed to write as Vincent needed to paint and Henri needed to speak and write. And, just as Vincent painted this *Night Café* in which we talk to pay his rent, my writing has been precarious financially, literally having "to publish or perish"! I believe it was from me you came by the phrase, Henri, of "joining the downwardly mobile" when I decided to write full time and you decided to join the L'Arche community. But I can't be sure; we were so often on the same page when it came to spiritual ideas. We talked about it in a café similar to this on the Sunset Strip, a conversation you wrote about in *Road to Daybreak*.

Ken: How have these life-influences shaped your views on sexuality and ministry?

Chris: (Laughs.) Every time I faced a difficulty in a relationship, Henri would say, "Why don't you consider celibacy?" (Winking at Henri.) I told him what he already knew—that celibacy wasn't something one chose because of a bad relationship! It is a gift, and one not prolifically

proffered! I have found that I'm at my creative best in a relationship, not out of one. Denying that would have made me as crazed as Vincent, and as lonely as Henri. But even in relationships, one can feel lonely. Ultimately what brings Vincent and Henri and me together at this table in "The Night Café"—outside your invitation, Ken—is that we are lonely, that we want to be with one another, and that we want to be with God. Vincent, you wrote about tending the hearth of your soul in hopes that a passerby might stop in and warm himself. Loneliness may be what brings the readers of this book to this table as well. The Bible itself opens with a story of how we are not meant to be alone—but together in relationship, community, creation, with our Creator. Why anybody would want to separate us—segregate us—because of our race, religion, sexuality, gender, disabilities, age, and so on, has more to do with the serpent in the garden than with the God who comes to walk with us naked and unashamed in the cool of the day.

When I lived in the gay haven of West Hollywood, Henri asked me to take him to a few gay bars. In a video bar, with a hundred men watching music and comedy videos on television screens throughout the place, Henri said, exasperated, "How can anybody possibly enjoy this?" In other words, you come to a bar to be with people, not watch videos in isolation. Remember, Henri? This "Night Café" is more your environment, Henri— low-key and conversational. Ken, your open-ended questions have made this a meaningful conversation, the kind of conversation Henri always insisted on having with individuals and audiences and similar to the correspondence Vincent had with Theo.

Ken to Vincent: Vincent, as you gaze back across the starry nights of eternity and see this protégé–Chris—who, like you, was rebuffed in ministry, I think of your words written to Theo—that administrative hacks and self-righteous prigs who credential pastors—seem always to resort to censure those novices and neophytes whose looks and lives, and especially innovations, offend their own stogginess and conventionality. What is your everlasting response to their rejection of your felt call?

Vincent: Friends at this table, I remember a young Parisien painter, who, like his contemporary, that young Pablo Picasso, mimicked some of my moves and manners. Georges Roualt always painted Jesus as someone like the clown Pagliacci, a Harlequin, an abused yet clairvoyant and vicariously healing, ever understanding and forgiving presence. When assaulted and shamed, He pleaded "forgive them, good Father, they do not know what they are doing"

Friends, the crucified One is alive and well in this world which he so loved that He laid down his life to the force of his tormentors. He rose like the sun over Provence and is now—through our lives and works— redeeming and making new His Father's creation. That renewal comes out into the world through the embodied and ever-living ministry of the Suffering Servant whose death and resurrection brought "life and immorality to light through the Gospel" (2 Tim 2:10). We all share that ministry which prompts you and I to practice our gift and power (virtuosity) in accord with His vocation—"Let your light so shine in the world that humanity (*anthropon*) will see your good works and bring glory to our Father in Heaven."

(Chris Glaser is thought by many to be our most theologically thoughtful writer on human sexuality. His writings include *Gay and Christian* (Harper); *Coming Out as Sacrament* (Westminster); *Communion of Life* (Westminster) and *Henri's Mantle* (Pilgrim). He served with Ken Vaux on the Presbyterian Task Force appointed in 1976 to formulate a response for the church to the challenges of homosexuality and the ministry. After 45 years, that Church has at last opened its doors to marriage and ministry—something denied to Chris.)

Appendix D

Van Gogh Up Close: The Philadelphia Story

KEN VAUX LECTURE ON MAY 14, 2012

THIS LECTURE WAS GIVEN on May 14, 2012 at Bryn Mawr Presbyterian Church in concert with the Philadelphia Museum of Art on the closing day of the exhibit—"Van Gogh Up Close." The exhibit focused on the works of Vincent during the culminating four years of his painting career at Arles and Auvers-sur-Oise—a season when his full-bloomed artistic virtuosity and aesthetic theology found expression. From the beloved *Starry Night* to the ominous *Wheat Fields with Cloudy Skies*, a new iconic mood is felt, manifesting sublime Spirit as well as diabolic dissonance. From the beginning to the end, he is an evangelical artist—exorcizing Satan while evoking Spirit.

Today I wish to challenge the prevailing tradition of an evaluation of Vincent's person, vocation and accomplishment, one which has persisted for 120 years, even into recent new studies. This received opinion says that this painter-pastor was a sick and crazy man, a religious fanatic, a family rebel and sexual voyeur, suicidal and a second-rate artist.

With a closer look at the art and its interpretation in Vincent's own correspondence, I suggest a different thesis. My more theologically appreciative response is anticipated in the Philadelphia exhibit and in the new biography by Smith and Naifeh, *Van Gogh, The Life* (Random House, 2011). My view is mostly shaped by the life's work of the Ph.D. graduate of our theology program at Garrett-Evangelical Theological Seminary

and Northwestern University—Cliff Edwards—long time teacher at Virginia Commonwealth University in Richmond, Virginia. His many books—*God and Van Gogh*, *The Shoes of Van Gogh* and a new study of the scintillating correspondence of Vincent with his sister, Wil—are capstoned in his addendum in this book.

My thesis argues: 1) that while he was indeed sick in body, mind and behavior, this condition became to him a gift and creative invigoration, and his work continues to become a blessing to the world; 2) that he was religiously deep, a good theologian, worthy of the ministry to which he was called—even though the church said NO!; 3) that he was a kind and tender-hearted man—a genuine *philanthrope*; (4) that he did not kill himself but welcomed death in faith as he had endured suffering in life; and (5) finally, as for his art, the world has resounded with his praise, and his work is desired by the "greatest of these" who will pay one hundred million dollars for a few sunflowers in a vase, or by his own special "least of these" with a T-shirt or a magnetic miniature of "Starry Night" on the fridge.

I now flesh out these five points with reference to his religious and artistic work:

I. The Argument from Ecstatic, Autistic, and Authentic Being

My first assertion defends Vincent's authentic being—a wellness forged in the crucible of illness and suffering. Yes, he was sick and otherwise troubled—in body, mind, and behavior. But this being, while an ordeal for him, was transfigured into blessing for the world. Heidegger would have called his being—*sein zum tod*—life running toward death.

In this particular style and mode of being—in part heredity, in part environment and circumstance—shows that life is a raceway. When I asked my grand-daughter how old she was, she said 2—going on 3—then 3, going on 4, now 5, going on 6. Fortunately, she is not like her grandfather who is always moving to the next job, the next place, the next project—even though he does stop to smell the roses.

Apropos Vincent's "Sound and Fury" existence, let me flow on you a Faulkner-like stream of consciousness to flesh out this apologia for his being.

- Hypersensitive-hyperneurotic, hyperallergic—vasoconstriction is needed to cool him down—Sudafed, Wesley's dip in a cold mountain stream or Buddha's Nirvana.

- Retention-the roses and tulips hold their compact glory in this damp, cool, merry month of May until they burst into glorious self-expenditure.

- Still life—*la nature morte*—is for Vincent three sunflowers, one in bud, one in full bloom, one fading and falling in her rough, resistant way—"curse the dying of the light."

- Manic—a canvas a day in Arles, scraping off the mistake, then crashing at the Sister's Asylum at St. Remy.

- Then-rushing back to his Jerusalem—Paris—and his ruthless and relentless work—one a day for 90 days. His motto: "pray as if it is your first day—work as if it is your last"—finally stumbling down the steep ravine at Auvers-sur-Oise—then dropping.

- Writes to his theodicy–struggling sister Wil—that God's creation is a ruined canvas—it has to be destroyed and redone—To His all-provident credit, God knows it is spoiled and Jesus is the master artist—his persecution secures justice—his agony brings peace, cohesion and cosmos to the chaos (Col 1).

- His Opus seems to ask, "Why do you seek the living among the dead? He is risen!" "Why stand gazing into heaven?" He is leading you now—into Jerusalem, Galilee and in Pentecost impulse—"to the ends of the earth." He is a flaming Corpus Christi thinker.

- With the Apostle, he attests—"in suffering—always rejoicing" (2 Cor 6.10).

 Don Mclean summarizes in song:

 > Starry, starry night, paint your palate blue and grey, look out on a summer's day with eyes that know the darkness in my soul.

 > Shadows on the hills, sketch the trees and daffodils, catch the breeze and winter chills, in colors on the snowy linen land.

 > Starry, starry night, flowering flowers that brightly blaze, swirling clouds in violet haze, reflect in Vincent's eyes of China blue.

 > Colors changing hue, morning fields of amber grain, weathered faces lined in pain, hide beneath the artist's loving hand.

For they could not love you, but still your love was true, and when no hope was left in sight, on that starry, starry night you took your life as lovers often do, but I could've told you, Vincent, this world was never meant for one as beautiful as you. Now I understand what you tried to say to me . . . and how you tried to set them free. They would not listen, they did not know how. Perhaps they'll listen now.

II. The Argument from Prophetic Depth and Priestly Call

In our second argument, we find Vincent religiously deep and under priestly vocation. In his art, consider *The Peat Carriers, The Coal Miners at Borinage* and his *piéce de résistance, The Potato Eaters* (*Die Erdappeleaters*)—his "Last Supper."

By way of text, here are my reflections on the Borinage—ministry to Miners:

> There are many little protestant communities in the Borinage, and schools. I wish I could get a position as evangelist . . . preaching the Gospel to the poor—those who need it most and for whom it is so well suited—and then devoting myself to teaching during the week (L 153,154[9/5/'79, Cuesmes]).

"I felt more cheerful and alive than I have for a long time, because gradually life has become less precious, much more unimportant, and indifferent to me." This may be French *insouciance* or German *Gelassenheit*—letting go (L 154, Ibid.). The life-affirming side of this conviction resonates with that of the 1657 Hymn of Georg Neumark, set to the Cantata (#93) by J.S. Bach—"*Wer nur den lieben Gott last Will . . .*" which Vincent could have heard in divine services in Holland, Germany or France.

> The one who leaves all to the power of God, and hopes in His unwavering love,
>
> He'll give him strength whatever comes along.
>
> Who trusts in God through all his days, builds on the rock that none can move.
>
> Only be still and wait His leisure, and do thine own part faithfully . . .
>
> God never yet forsook in need, the soul that trusted Him indeed.

Vincent had flunked out of his prep studies for the Amsterdam Theological Faculty. He had applied for Missionary Training School in Brussels, with field work assignment in the coal-mines of the Borinage. He was first rejected for "neglect in his person." Having failed in academic theology in Amsterdam and in his application for formal evangelist studies in Brussels (as he would eventually in the Academe in Antwerp), he now pleaded to go to the Borinage as a preacher/ teacher/deacon—a volunteer-missionary to the poor.

First in Paturages near Mons—lodging with the peddler Van Der Haegan—it was said that "everyone knew him—he comforted the sick and read the New Testament to them." The evangelistic committee then sent him to Wasmes. Before long he had given away to the needy all of his few coins, his clothes, even his bed and he wore a rustic shepherd's shirt. Finally, they relented and gave him a six-month temporary appointment—at no stipend. We have the documents of this appointment and can only wonder whether the Presbytery asked—"After all—what can we lose with these wretched slaves down under the earth?"

Vincent perceived the world prophetically as he saw the stark discrepancy between good and evil, peace and injustice. One observer said that Vincent felt he had to follow the first Christians—to sacrifice everything. He preferred to go to the most unfortunate, the injured, the sick. His only reported conversion occurred in a man who cursed his abstinence and asceticism. The alcoholic, unbeliever, blasphemer was converted by Vincent's surpassing kindness. When the *Comité d'Évangelisation* found his behavior beneath dignity and out of order, they prepared to sack him. Papa came down from Nuenen and found his boy emaciated, sick, and starving. He led him out as a little child in front of a large group of starving and suffering faces—who had come to love him (Wessels, *A Kind of Bible*, 56, 57).

J.B. De La Faille, in his early first-hand recollections book, *Vincent Van Gogh*—published in French from Belgium—vividly describes the scene of the coal mines:

> There are signs of subterranean activity on the surface: huge cages, large pyramids of coal, twice as high as houses, reddish glowing lights in front of which float the gray vapors and heavy smoke. In the evening the windows of the public houses are lit up while the house-wives are busy in the kitchens behind (10).

In sum, in these great and stark inconsistencies of humanity, in the myriad colors of dark and light, the corruptions and the glories of human affairs find relief. England and Belgium gave him new eyes and a chance to remedy such ills in redemptive ministry which he performed well.

III. The Argument from His Being a Kind and Caring Man

For art, consult his works on Sien, his girl-friend rescued on the street in Holland, and her baby, in various works regarding a cradle.

Textually, I highlight a passage from his favorite book—one which expresses his "Life Mission." It is the overture to Victor Hugo's *Les Misérables*:

> So long as there shall exist, by reason of law and custom, a social condemnation, which, in the face of civilization, artificially creates hells on earth and complicates a destiny that is divine with human fatality; so long as the three problems of the age—the degradation of man by poverty, the ruin of women by starvation, and the dwarfing of childhood by physical and spiritual night—are not solved; so long as, in certain regions, social asphyxia shall be possible; in other words, and from a yet more extended point of view, so long as ignorance and misery remain on earth, books (and art) like this cannot be useless.
>
> Hauteville House, 1862

His long-suffering, obstinate character is attested to by the trail of his virtuosity which exudes his intent and performance.

IV. The Argument from His Life, Love and Death: Love (lebenstrieb and todestrieb/Freud)

The whole corpus of his art—including Vincent as Lazarus—and the entire substance of his correspondence—speaks of love, respect and thanksgiving to God for his life—making suicide unlikely.

Recent persuasion has moved from the tragic ending of a tragic life thesis to a willingness to believe that he did not kill himself. Theological scholars like me have always doubted the thesis of his *selbstmord*, aware of how inconsistent that would have been with the spiritual/ethical tenor of his life commitments.

Vincent did not have a gun. The site and trajectory of the lethal wound do not support suicide. I believe that he was harassed and taunted by teen-age boys—an accidental shot was fired into the air—it lethally wounded but did not kill Vincent. This all happened down by his room at the Ravoux Inn. It is more probable that two young boys, who had just been to the Wild Bill Hickok Rodeo in Paris and who had a revolver, were shooting into the air to taunt Vincent, when he was accidentally shot. The gendarmes asked if Vincent had shot himself and he answered "yes" to protect the youth. This argument aside, it must be admitted that Vincent thought that either he or his namesake-nephew would have to die, given the paucity of resources for life itself.

Here is the gist of my persuasion on this matter: My clue here is the correspondence around the well-being of nephew-Vincent. First, there was the genealogical connection. Our Vincent's grandfather was the progenitor—a minister-theologian trained in Leiden. His uncle Vincent (Cent) was an art dealer. Vincent's earlier brother Vincent was stillborn. Vincent now bore the name, the legacy, the expectation—the very flesh and blood of the lost, beloved son.

Now, as life waned in his so-long-awaited being, along came another Vincent and the child's life was threatened from the beginning. In (Letter 896 [7/2/'90, Auvers]), we find the child sickly and near death. "I have just received your letter in which you say that the child is ill. . . . I feel how dreadful it must be and I wish I could help you I will not conceal from you that I hardly dare count on always being in good health. If my disease returns you will forgive me. I still love life and art very much . . . I rather fear that toward say forty . . ." and his thought tails off. The chosen one—one born out of season, is blessed in the birth of another (replacement?) and his survival is threatened as is Vincent's own life—and he can do nothing to help—or can he?

In Daniel Boyarin's *Dying for God*—a study of religious martyrdom in the ancient biblical—Jewish and Christian—world, he recounts the agonizing report in Maccabees where the mother of five sons watches each of them threatened with ghastly death—by the official religion—Greek paganism, unless they disown the God and faith of Israel.

One by one, she calls on each to bravely lay down his life—for the sake of the confession. Like the suicide-martyrs at Masada, their lives are a sacrificial oblation to the holiness of the divine Name. Righteousness in destiny only sealed as "a greater love" prompts one to sacrifice all—to literally "love the Lord with body and soul (Life), mind and strength"—the

pivotal requirement of Torah, Prophet and Gospel of which the Martyr, Dietrich Bonhoeffer spoke—"when Christ calls one He bids him come and die"(*The Cost of Discipleship*).There are several distinct meanings of suicide—existentially or socially driven—in our languages—*selbstmord*, "laying down one's life"—these need to be sorted out in Vincent's case.

Reading between the lines, Vincent may have found himself confronted with such a sacred, faith-lineal challenge—where either he or the child must die. With Theo's imminent demise mounting in the background, and with the acute scarcity of funds to support these three lives—to which is added Jo's nursing, nurturing expenditure—a question of martyrdom—at least perceived martyrdom—may be arising. In a larger sense, we may ask whether Vincent "lays down his life" not only in fear of another seizure that will put him out of business for months—not out of triage judgment where one or the other Vincent must die—but for some holy cause. Edwards opens this issue in each of his books by framing Vincent's witness–as I do—in the context of Isaiah and the "suffering servant."

V. The Argument from the Global Reception of his Work

Here we base our argument on his complete art works and complete correspondence. I summarize my contention that he is a watershed in the history of art as he is in the field of presenting a life opus that is explicitly theological, pastoral and—to use his word—evangelistic. We have proposed and developed the thesis that Vincent Van Gogh conducted a brilliant ministry in Religion and Art. As Methodist Curate in England, a song of beauty and grace was planted in his heart. In Amsterdam, he struggled with official ministry and discovered he was meant for something greater. In the Borinage, he discovered a heart, pen and brush for the poor and vulnerable. In Antwerp, he learned to draw with life-like depth. Asnières taught him biblical meditation and to translate this to a vibrant screen. In Arles, his palate turned to the crimson tone of desperation and the bright Lapis/Sapphire/Gold of peace and glory. In Auvers, his ministry turned introspective and furiously beautiful. The Accession to victory and everlasting delight finally vindicated his witness to the world.

The evolving theology which unfolds during these short years of service involves the blessed assurance of an atoning God, the Convincing

Word of Logos theology and biblical learning, the descent of Emmanuel God and the Crucified One into the hovels of desperation and hope. Biblical grounding, natural revelation, and anguish conspire to accomplish sublime beauty as the God of the oppressed–the God of the Living—provides ultimate vindication and victory to Vincent's story.

We are introduced by this Ministry of Religion and Art to an animating God–One ancient and avant-garde—One for all time and for ours. In the poured out offering of Vincent, we have been offered the gift of Love—the Love of Light and Color—of Form and Movement—and we resolve to pass it on—for Love as Light and Life—is surely of God.